HOW TO
PAINT
WITH
A KNIFE

HOW TO PAINT WITH A KNIFE

By Coulton Waugh

WATSON-GUPTILL PUBLICATIONS/NEW YORK

Published 1971 in New York by Watson-Guptill Publications,
a division of Billboard Publications, Inc.,
One Astor Plaza, New York, N.Y. 10036

Manufactured in Hong Kong.

ISBN 0-8230-3880-7

Library of Congress Catalog Card Number: 70-145666

First Printing, 1971
Second Printing, 1971
Third Printing, 1972
Fourth Printing, 1973

For Odin, Phyllis, Bill, Diane, and John

ACKNOWLEDGMENTS

I'm very grateful to the people who needled me into starting this book and helped me along until I finished it. Head helper was my wife Odin. She was both intensely critical and intensely patient, a fabulous combination that was just what I needed. Besides, she did most of the dirty work. Chief needler in the beginning was my friend Ruth Larocca, who called for help in painting the Hudson River with a knife. I tried to explain, but it wouldn't do; I finally had to write a book—for Ruth, and all the others who might ask the same questions. I'm also indebted to Norman Kent for a helping hand at the start. He was then editor of *American Artist*, for which magazine I had written some articles. He suggested these might be amalgamated and extended into a book.

But it was Donald Holden, Editorial Director of Watson-Guptill, who really lit the fire under my brain and pulled this book out of it. My very particular thanks to him. A million thanks, too, to Margit Malmstrom, who edited the book and saved this poor author from being crushed under millions of publishing details. And a very appreciative word of thanks to Geoffrey Clements for his excellent color and detail photography.

Many thanks must go to certain old cronies, to Ray and Jeanne Wellington, Henry Cooper, Jean Steinhardt, Floyd and Gwenyth Clymer, Lillian Poulin, Ethel Stewart, Ira and Bonnie Newman, all of whom have encouraged me to germinate ideas by their philosophical firesides.

And many thanks to you, readers, for engaging to plunge into my book. May the painting knife reward you!

CONTENTS

HOW TO PAINT WITH A KNIFE

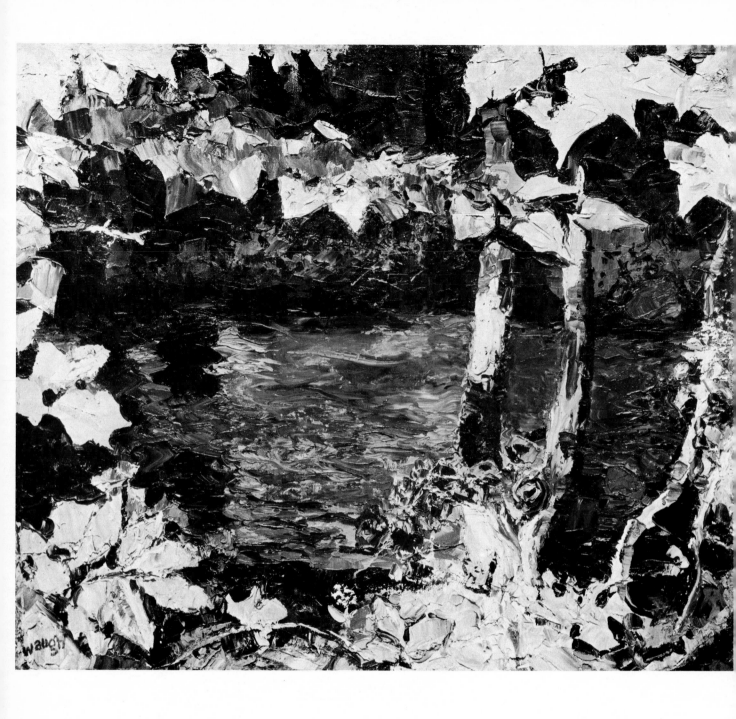

Leafy Brook, *20" x 24". Courtesy Grand Central Art Galleries, New York. One tends to dwell most, in painting, on those things which affect one the most, things of unusual beauty or interest. My brook is one of these subjects. Here, I was prowling along my brook in midsummer; I was aware of the dark, running water, but only as a gurgling point of interest, for my eye was caught by the brilliant halo, or frame, of the leaves surrounding it. I wanted to paint those leaves. I drew them in first, then used a painting knife to get the water in the center. Finally, everything was ready for me to paint in the main actors, the sunlit leaves, with strong strokes of the painting knife.*

1

INTRODUCTION

One of the fascinations of a running brook is that it pauses every now and then in little ponds. In these moments of quiet, the wobblings and coruscations of flowing water flatten to become up-turned mirrors which gather the immensity of the sky onto their polished surfaces. The brook pond takes on a double image: we feel its depth and sense the life going on below the surface, but we also see the radiation of the air above the reflections, the muted shapes of drifting clouds. I crouch beside my brook pond, mesmerized by this conjunction of air and water so vital to my being.

But I don't crouch very long. Time's a-wasting! I should be painting this marvelous conjunction, not contemplating it! Often, the need to earn a living yanks me away from setting up my easel; but there are times when the need for expression and the time needed to express it are, like air and water, also in conjunction. Wonderful times!

There's a certain period in the year when all artists should be abroad—early September. I step out through my door and am startled by the sudden hush of things. The insects have stopped buzzing; if birds call, their sounds are muted. The air seems filled with a kind of golden ether. Summer was busy and old, harsh, blustery winter is coming; but early September is a pause, as a brook pond is a pause. When I find myself with a few available painting days at such a time, I stretch a canvas, kiss my wife, and am off. Wonderful! I find myself crouching beside my brook pond again. I spring up to assemble my easel, fasten on the waiting canvas, break out tubes of paint, and squeeze them around my palette as fast as my hand can move.

Why all the rush? Because I so often find that the rare effects of nature that I'm after are very fugitive. And the rarer they are, the more fleeting they seem to be. This means I must seize them instantly by their beautiful throats and catch the germ, the inner significance, while my sense of first appreciation is still glowing and alive. When he first sees something like this, a rocket goes off in the artist's mind; he must get to work while the rocket is still in the air.

Now, one particular September afternoon, as I looked at the rare and complex beauty of the pond reproduced in color on p. 141 of this book, I was struck by my own sense of urgency to capture the effects in front of me. There was, first of all, the sense of the sky coming down; then the double image feeling in the water—the mystery of its depth and the mirror mystery of its surface. There was a point of distance where vague, light gold trees shimmered against a green-gold sky. There were the rich stone colors of the bridge, expressive of the stones themselves, but vibrating between red-violet, muted blue, and muted orange as I looked toward the light. And there was that extravagant fringe of water weeds, clumps of textures and colors—each with a shape, a color, a glitter all its own. In the old days, when I was painting with a brush and using painting medium in the conventional manner, I simply would have been unable to tackle as complex a thing as this. Some brush genius, of course, could have done so. I wish I could see a rendering of this scene by Claude Monet.

As much as I love the man, I'm not Claude Monet. I have my own requirements for color and texture, for sharpness and softness. Brushes, for example, would not give me the crispness of the foreground weeds, turning the tone beyond into a mirror surface by the force of contrast.

At one time, I would have been afraid of the complexities of this motif, but I wasn't afraid that September afternoon. I began work with the conviction that my feeling would be successfully expressed. Why this security, this conviction? It was because I was swinging a short, wide-bladed little painting knife I had become so familiar with that I knew it would be able to register all the subtleties of what I was looking at—the ball of light gold air, the mirror surface, the vibrating, distant trees, the staccato designs of the water weeds. My little knife gave me the results I wanted. And now it gives me confidence—on a much more difficult project—that I'll be able to reveal the secrets of the almost magical operation of the painting knife within the covers of this book.

I paint to please myself. I write this book to pass on the findings I've made in knife painting in the hope that they'll be of value to other artists and

students. Cross out that word "students." In my opinion, students are artists; why else would they be taking the time to study art?

FROM BRUSH TO PAINTING KNIFE

You may want to know how I discovered my particular use of the painting knife. The story starts twenty-three years ago, on a note of frustration, which was relieved by—but I don't want to spoil the suspense.

My father, Frederick J. Waugh, was a marine painter whose work is familiar to many of you. After his death in 1940, I transferred the contents of his Provincetown studio to my home near the Hudson River. While checking over one of Dad's paintboxes I came across an odd little tool. It was a small but broad painting knife of unusual shape—I'll give you details about it later. The blade had remarkable flexibility and spring. I looked at this knife carefully; I sensed it had something to do with a problem which was haunting me.

My problem was a dissatisfaction with the usual oil painting methods—the use of brushes and the diluting of thick tube paints with turpentine and painting mediums. When I found the little knife, I had one of my thin, weepy oil pictures on the easel. On the palette below was a whole ring of thick, brilliant gobs of oil paint freshly squeezed from the tube. I stood there, twiddling Dad's springy little knife (which he had rarely used, as far as I know). As I looked at my thin, weepy picture and then down on the rich tube colors, it suddenly struck me. It was a St. Paul on the road to Damascus kind of thing—a kind of mental thunderbolt. I haven't been the same since.

There on the easel were dull and lackluster colors and textures. Here on the palette were gorgeous squeezings of ultramarine blue, cerulean blue, clarion notes of cadmium red, rich alizarins, and yellows. *The beautiful colors belonged on the painting!* The function of the palette was to *supply* colors, not *display* them! A clean new canvas was standing nearby, and on an impulse, I picked up the paint-laden palette and slammed it butterside down on the clean canvas. When I pulled the palette off, those brilliant colors were on the canvas where they belonged! But one couldn't paint pictures by socking canvases with loaded palettes. I wanted that rich color, yes, but how was I to put it on? I realized that brushes would *not* be the answer; the colors would tend to muddy down from that all-out brilliance point.

My glance fell on Dad's funny little painting knife. I picked up a gob of heavy paint with it, slammed it on a corner of the clean canvas, and pulled it away. The paint was there in all its thick intensity, with all its original fire. I had found the technique which fitted my hand and my need; the frustrating search for a personal style was over.

I'm still using this technique, this style, today. This very technique, enriched with years of experience, gave me courage enough to tackle a motif of such complexity as *Last Light—The Stone Bridge* on p. 141.

WHY THE PAINTING KNIFE?

The details of my kind of knife painting will follow, but first I'd like to make several replies to a general question I'm sure many of you will be asking: "What special effects and qualities can we expect to get into our work which will make a study of knife painting worthwhile?" Here are some of the points of enrichment you may hope to gain from the study and practice of this particular technique.

Breadth: The painting knife approach sweeps away littleness of feeling. Obviously, you can't paint on the head of a pin with a painting knife. If you enjoy putting on the paint with a knife, it means there's something in you that responds to a big way of seeing things, and this is good. Oil paint itself is broad stuff; the painting knife is in tune with it.

Color: With a knife, there are no brushmark grooves left in the paint to throw tiny shadows onto your painting and cut brilliance down. A knife can lay a color patch with total color brilliance, can give you a 100% return on your pigment investment.

Cleanliness: Pull a dirty brush through a folded rag and it comes out dirty; do the same thing with a knife and it comes out clean. If it had been discharging fiery red, now it's ready to give out scintillating green. How can you afford to miss such a delicious experience as this?

Wet-on-Wet: The nature of knife painting is such that, by a process we'll detail later, one touch of perfectly pure pigment can be laid on another differently colored but equally wet pigment without a trace of fusion between the two. Think of what this means in terms of gleaming, glittering colors flashing on top of one another!

Texture: This is something completely natural to a painting knife, which can pile up pigment in all sorts of delightful ways.

Detail: In spite of apparent clumsiness, the knife can produce remarkably detailed effects simply by its own hypnotic method of impressionistic suggestion. By picking up big gobs of paint, one can hurl them on fast enough to reproduce the subject's wholeness. The knife painter often gets a sense of exhilarating wonder that he has been able to bring this big wholeness back through his narrow studio door.

These are only a few reasons why it might be worthwhile for you to study this way of working— a great many more will appear as we go along. I

want to make it clear that this book is not meant to be just a lot of words describing a technique, nor is it meant to be the story of my personal life. Its purpose is to help the reader toward trying out painting knife painting for himself. I've worked to give definitions and exercises which I've found to be of value during the number of years I taught art on the college level.

My book has another purpose, too. I've had a wonderful time over the years with my little flipping painting knives. I want the personal satisfaction of feeling that others—you, especially—will share this excitement and fun with me. We're painters together, off on a brilliant adventure.

Writing a book can be—well—tough, difficult. But the hope I've just expressed, that you'll be able to share my joy in using the painting knife, has made the whole effort well worthwhile.

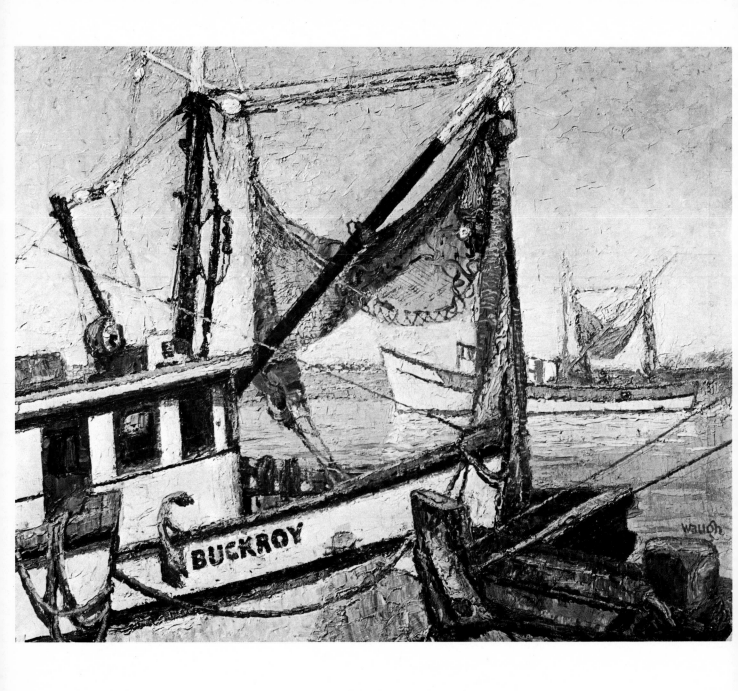

Shrimp Boats, *24" x 30". Collection Coulton and Odin Waugh. To love things is really to own them—I feel that I own all shrimp boats! There's a special and remarkable beauty about them. Those white-tipped masts and white hulls with their amazingly cocked-up bows bring back the feeling of the Mediterranean. Think of these whites vibrating against the fierce tropical Florida blue of the sky. And the other colors, too—reds and blacks and brilliant blues. I can never get enough blue, so you can understand my delight when I found a group of these fine craft tied up at Fort Myers Beach over the Christmas season and realized I'd be able to spend a solid three days luxuriating in painting this canvas!*

2 TOOLS AND GROUNDS

There are a great many ways to get paint onto canvases and panels, and there are a great many artists at work. The tools these artists use naturally correspond with the kind of inspiration motivating them. And in this book, we're considering broad, poetic motivation. Dealing with the minute is legitimate enough, but it's not within our field. The big sweep of the art spirit, all the phenomena of nature which can be expressed either realistically or stylistically—these lie within our sector. For this bigness of feeling finds a natural expression in oil paint, a medium without built-in outlines, a medium loose and seemingly filled with air. And of all ways of applying oil paint, the painting knife expresses this bigness the best.

My saying these things does not constitute proof, for verbalizing about creative matters is only partially useful. Because I want this book to be a book which works, I'll explain and demonstrate my various theses as I go along. But I must rely on you, the reader, to help me prove my ideas by squeezing them out on your palette and using them. Sit down with me and let's take the first step toward working together. Let's look at painting knives and find out how they work.

PALETTE KNIVES

First, we must clear up a confusion. People speak about "palette knives" and "painting knives." Are they the same? No, they're different; the two names refer—with certain exceptions—to different implements, used for different purposes. The palette knife is used to clean the palette, the painting knife is used to paint with. We must illustrate and explain these differences further.

With no job other than to scrape gobs of paint from a palette, much of which may be partly dried, the true palette knife usually displays little grace of design; it's an exceedingly plain Jane whose only virtues are stiffness and power. This knife generally extends along one axis, both blade and handle. The sketch in Fig. 1 shows how to keep one's knuckles free of paint, by bending the palette knife up so the hand is away from the canvas. Some flexibility is necessary for this. The palette knife has re-

mained an unprepossessing, stupid-looking tool until recently. Only a few months ago I found myself in need of a new palette knife, and made a stimulating discovery.

It was, I believe, in France that the idea arose of elevating the handle of the painting knife (I'm speaking of the *painting* knife this time) above the level of the blade, with a diagonally slanted metal connection in between. This removed the hand from contact with the paint below and was a very great improvement. The discovery I refer to was the finding of a knife with a typical palette knife blade, but mounted on a stepped-up handle like the French painting knives

"PALETTE BOY"

Here was something new. I found this little palette knife extremely useful around the place—indeed, I've gotten so fond of it that I've nicknamed it "Palette Boy." Fig. 2 shows its jaunty, unusual shape. The position of the hand—high up out of the way—gives the arm great power to bear down when scraping stubbornly dried paint, and the blade is arranged to be very strong just at the place the pressure comes. Tip the blade back to work on a hard spot, flatten it, and use the thinner front for removing wetter paint—a pretty bit of engineering.

I soon found another reason for appreciating Palette Boy. Its blade, so very strong in the right places, is also flexible in the right place—right up to a couple of inches from the tip. This makes it great for making sensitive color mixes, something far beyond the ability of the stiff snout of an ordinary palette knife to accomplish. Actually, Palette Boy is a great little knife to paint with, not just get you out of a scrape. Because of its even, springy tip, it has a certain neatness of touch—more so than the other knives—which you may employ to tone down the wild excesses of the other, more prima donna knife performers. Drawing it across or down from the top, it makes even stripes, easily fused into a controlled flatness.

Every painter needs a palette knife for scraping, and I would suggest that a Palette Boy might be

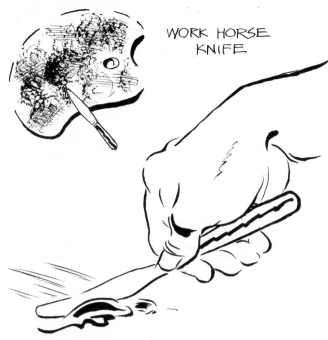

WORK HORSE KNIFE

1. Palette Knife *Strong and stiff, this work horse is good for scraping, but not for much else.*

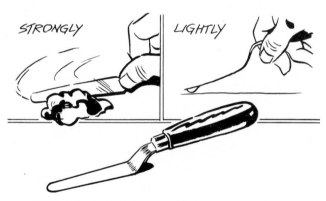

STRONGLY LIGHTLY

2. "Palette Boy" *This is also a palette knife, and very good for scraping, but because of its flexible tip you can use it for painting, too.*

LIGHT AS A LEAF

3. Painting Knife *Here's a true Painting knife. It's so light, so flexible, that it seems to fly as it brings air into your picture.*

the first knife you buy. It will show you how to mix as well as scrape, and you can experiment with actual painting as well, holding the blade almost parallel to the surface. Don't dig down with the tip as many beginners think they should—you can't distribute any paint that way.

But good little Palette Boy has a weakness. Though he can blend, adjust, and patch defects, don't expect him to give out much fire and fury on his own. The loading space on his blade is not large enough, not broad or long enough, to carry the generous amounts of pigment necessary to sustain the painting knife style at its impetuous best. This brings us to the star of our show. Ladies and gentlemen, let me present the painting knife!

PAINTING KNIVES

Take an average-size painting knife and bounce it inside your hand—what do you notice about it? It's light! The finer knives, with their very thin blades, are almost as light as leaves; and as a leaf twists and turns in the wind, so a light knife can twist and turn in the fingers of a painter, becoming almost a part of his muscular structure and connecting, in the most sensitive way, the discharging and manipulation of pigment with the impulses in the artist's mind (see Fig. 3). Sometimes, when these processes are perfectly synchronized, the paint seems to appear on the canvas as if directly out of the painter's mind and heart.

But airy lightness is by no means the only feature of the painting knife's performance. Consider a violin bow; here's a light and airy tool, famous for its production of floating, gossamer tones, for its whispering as if beyond the control of matter. But when Beethoven demands it, that bow will strike, the sparks will fly, the thunder shudder. So will our little painting knives thunder and strike if they've been charged properly and directed with the right feeling.

Slightly bend the blade of the knife you're looking at. If it's a good middle-size knife, its flexibility will impress you—the best knives will bend almost double. This elasticity or spring, combined with lightness, gives the clue to the sense of life and gaiety characteristic of painting knife work.

There are many kinds and shapes of painting knives; there's not enough room in this book to deal with them all. To give a hint of their range, I'm illustrating the seven knives I keep in a box in my painting table, which cover the range from very large to very small (Fig. 4). I don't suggest you buy all seven of these—when I paint outside, I only carry three of them in addition to my faithful Palette Boy. But I think we should look carefully at all seven. Tastes differ. You'll probably have individual things to express and a different style from mine. Within this group of seven knives, however, you'll probably find several which will serve your purpose.

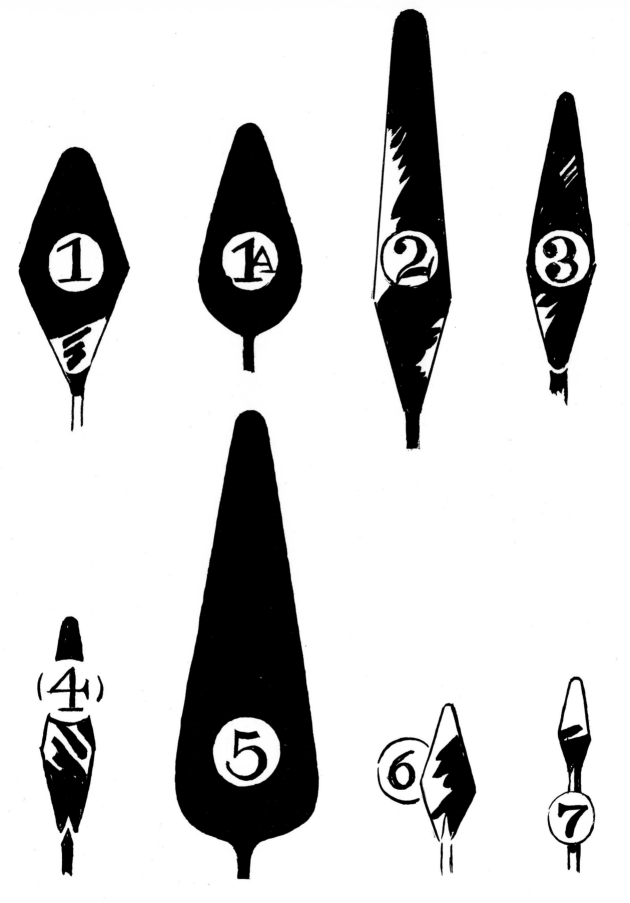

4. My Favorite Seven *There are many painting knives, but these will give you an enormous range of effects. They are (1) my London knife, (1A) a Magic knife, (2) Long John, (3) Arrowhead, (4) a good medium-size knife, (5) Big Talk, (6) a small, chunky knife, good for texture, and (7) Mini Squirt.*

ARCHITECT'S TRIANGLE

We'll examine the seven knives from largest to smallest. Before we take up the biggest knife, I want to call your attention to a tool even bigger. I didn't group it with the others because it's not a knife at all. It's a celluloid architect's triangle.

Some years ago, a student in one of my painting classes felt the urge to go on with the study of impasto pigment, but in a style distinctively her own. She liked to contrast large, rather flat areas of colors, subtle within themselves, with other subtle areas, and often flamboyant areas—a kind of stained glass done under the influence of impressionism. Becoming impatient with smaller textures, she kept searching for broader, wider application and discovered the use of the triangle. There's a certain spring in a celluloid triangle, though of course nothing of the energetic jump of the painting knife. This broad technique suggests the use of large canvases or panels.

"BIG TALK"

The largest of my metal knives (knife No. 5) is one I've nicknamed "Big Talk" (Fig. 5). This bruiser is no delicate leaf twisting in the wind; it's rather inflexible, with a mind and will of its own; it drags you around rather than dedicating itself to the expression of your soul. I have a feeling that I'm not man enough to master Big Talk—but I envision some huge, tremendous artist who some day may teach it to behave.

In the meantime, I find Big Talk very useful, as is the architect's triangle, in large impasto undertones on areas which will be further enriched by the flipping around of other, smaller, painting knives (see Fig. 6). A very beautiful, scraped effect can be achieved over coarsely-woven canvas by first loading the canvas generously and then scraping it off, so that the paint remains only in the interstices between the weaving. This will suggest the development of many other textures above it.

"LONG JOHN"

Coming down the scale of size from Big Talk, we come to knife No. 2, which is known around my woods and pastures as "Long John" (Fig. 7). This is one of the finest of all painting knives and I recommend it to you without reservation. My Long John knife comes from Italy and is full of Renaissance elegance and rhythm. It's twisty and very flexible, wide enough and long enough to carry a really large charge of pigment, produces broad but fluctuating strokes and stripes which have a drawing element to them, and has a particular looseness all its own that enables one to sketch with it (see Fig. 8). Long John *swings*. The other day I painted a 40" x 50" marine with this knife alone and it seemed to be swinging itself right in

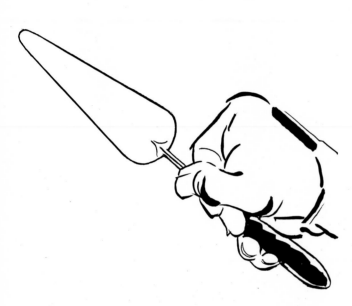

5. "Big Talk" *If you can swing this one, you're in for painting adventures on a grand scale!*

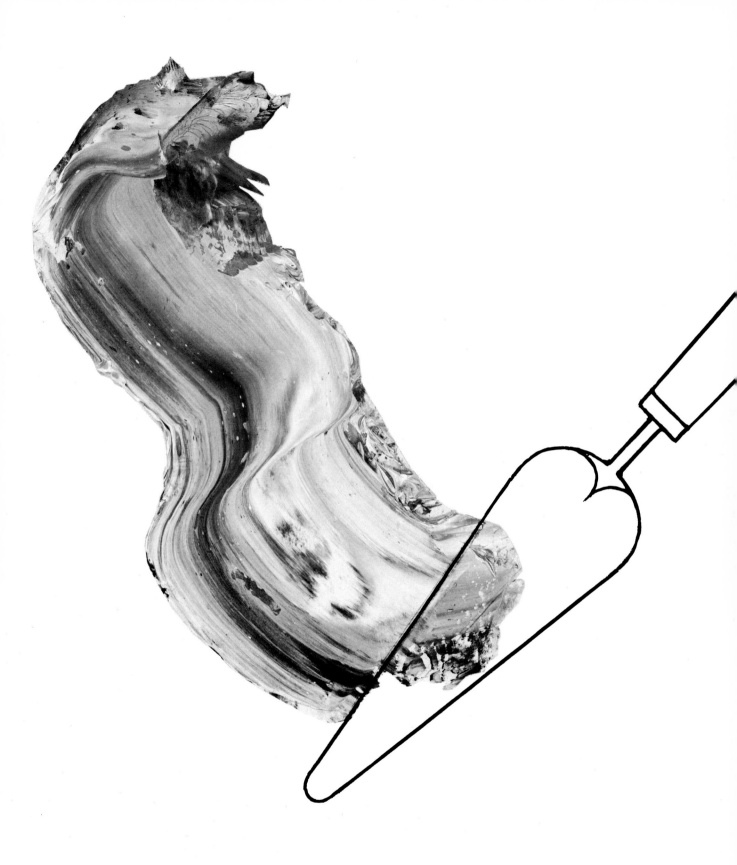

6. Pure Fun *I charge Big Talk heavily and turned him loose—see what I mean about adventures?*

phase with the advancing breakers. Whatever other knives you choose, I think you should have one of these.

"LONDON" KNIFE

In my introduction, I spoke of the discovery of my wonderful little spade-shaped painting knife found in a box of my father's painting implements (Fig. 9, knife No. 1). Hailing from London, about 1905, it's stamped "Winsor & Newton, England." This was the little implement which drew me into painting with the knife, and which has been my loving companion (or the other way around) for twenty-five years. If I had no other painting equipment but this, together with paint and canvas, I'd be well content. Its performance is illustrated in Fig. 10.

THE "MAGIC" KNIVES

Many people have asked me where they could get a knife exactly like mine and I wish I could give a reply. Perhaps by the time this book is in print a knife of the exact shape of my London one may be on the market. In the meantime, you'll be able to find many knives so similar (Fig. 9, knife No. 1 A) that their final performance will be identical to my knife's miracles. I call these the "Magic" knives. Their performance is illustrated in Fig. 11.

For the record, I present a picture and exact measurements of my London knife (Fig. 12). Bear in mind that a bit of grinding on stone or wheel might bring some of the other knife shapes in line with it. If you do this, watch that you don't get a dangerous, razor-sharp edge which could damage your canvas. A slight grind at a right angle to the edge will make it safe. You'll notice that my London knife is without a handle, the original one having been broken and removed when I discovered it. For awhile I used it that way, and then, motivated by some dim sense of tradition, I made a new handle. Now, the gleaming old knife looked handsome and workmanlike, but I soon found out that it was not working quite so well as before. Its quality of skipping through the air was missing, and I realized this had been one of the qualities which had fascinated me in the first place, and one of the main elements which had helped me develop a style different from that of other painting knife painters. Needless to say, I soon restored the blade to its original handleless condition.

The most important thing about this painting knife is the gradation of thickness of the blade, from the painting part near the tip to the end of the blade where the stem begins to lift up. Looked at edgewise, the tip half of the knife blade is thin as a hair, but its thickness increases rapidly toward the butt part and becomes conspicuously heavy as this joins into the piece which slants up. If you look at the blade edgewise and lift the tip with your finger, the tip half will round up to a right

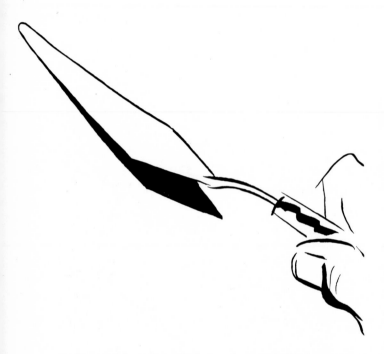

7. "Long John" *Beautiful, just beautiful, this long floppy knife and the way it paints.*

8. Sketchy *This Long John painting is the same size as the original, so you can see the poetic flip-flop of the knifestroke.*

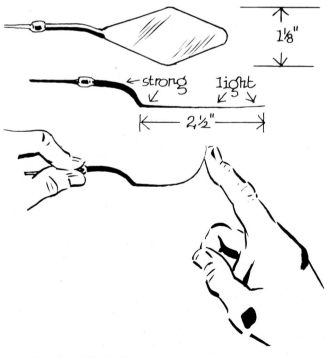

9. The "Magic" Knives *What other name can you give to these wonderful little knives? Knife No. 1 is my London knife; No. 1A is another Magic knife.*

10. Pursuit of Air *Here, I've asked my London knife to capture something of the beauty of light.*

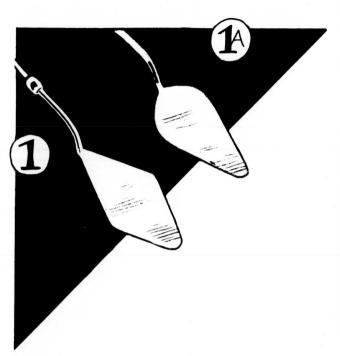

11. Happening *A Magic knife responds startlingly well to the painter's feelings—to demands for power, rhythm, texture. Note the wide range of effects.*

12. "London" Knife *Power at the base, extreme spring in the tip—that's the formula for this masterpiece of steel.*

angle with the lower part of the blade; you can see from the illustration in Fig. 12 that the lower part has not bent up in the slightest.

It's this engineering of the blade which gives the London knife its remarkable character. With the most delicate quality toward the tip, the strength and stiffness of the butt part give power. Delicacy blends with power in the middle, allowing all kinds of expression—something similar to the use of the pedals on a piano. When you shop for a Magic knife, try to find one which flexes and works in the same way.

Considering all the different and sometimes very refined effects I can get with my London knife, you may wonder at its widely rounded point. How could delicacy come from a clumsy tip like that? There's a curious fact about painting knives to understand here. The knife with the very delicate point is, paradoxically, just the wrong one to use to suggest the sense of intricacy—no painting knife can actually delineate detail—because there's not much room under the sharp point for pigment. Consequently, the tiny pile of pigment runs out before more than a few dots can be made. In contrast to this, the knife with a rounded tip can be charged with a much larger pile of paint underneath, and this can be touched to the canvas and moved around to suggest detail in a very convincing manner.

REMOVING THE HANDLE

I've already brought out the parallel between the violin bow and a light, flexible painting knife. To continue: I remember a remark in a book by the great violin teacher Leopold Auer in which he advises the student to resist the impulse to cling tightly to the stick with his right hand; instead, he wants the student to have the sense of spinning out the tone with his fingers. The illustration in Fig. 13 suggests a parallel: both violin bow and painting knife—if the latter be without a handle—can be suspended so lightly from the fingers that tones or colors seem to be produced from the mind and heart of the musician or artist, where the original impulse originated. A violin or a picture will then quiver with immediate sense of life.

A knife without a handle looks peculiar, and this whole matter of removing it may seem like nonsense to you. I think of it as a chance discovery, as a new tool which works better than the old one. Surely a tool is justified by its performance, no matter what its new appearance might be.

Should you, then, experiment with removing the handle from a Magic knife? I think so. These knives are inexpensive and I'd like for you to have two Magic knives, one with, and one without a handle. Then you can settle on the one you like best, perhaps using each one for a different purpose. I'm perfectly aware that there are many cases where one wants to get the power of the arm into the

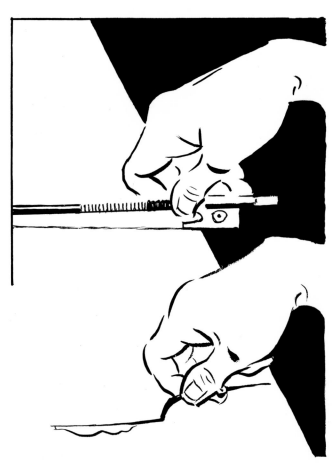

13. Lightly Does It *With a Magic knife, you can pull the color out as a violinist spins out his tone.*

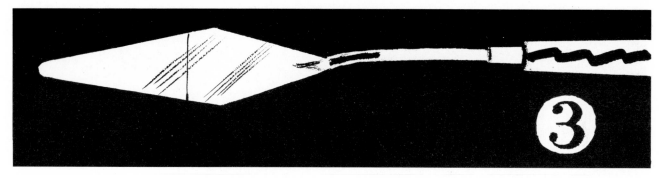

14. "Arrowhead" *Here's an aristocrat in the world of painting knives—subtle, elegant, yet bold and powerful when the occasion demands.*

15. Bold Plus *Surprising power and intensity can be seen in these knifestrokes made with the delicate-looking Arrowhead. The knife was heavily loaded with two values of paint.*

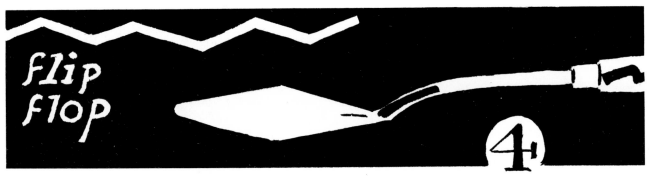

16. Lively *This springy little flip-flop knife No. 4 is great fun to use. I think of it as an impressionist tool for vibrating aerial effects.*

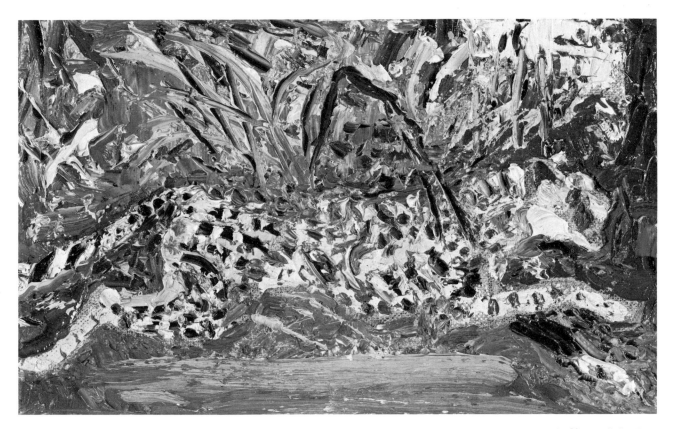

17. Speed *This cheetah's moving fast, but hardly faster than knife No. 4 did when capturing the sense of action in this little sketch.*

stroke. For this, a knife with a handle is better than a knife without.

Magic knives can give you an astonishing range of effects, but I don't intend to describe or illustrate these effects here—I want to keep them for Chapter 5 on painting knife exercises, where you'll be demonstrating them for yourself. In this chapter, we're simply acquainting you with the various painting tools so that you'll be able to put together effective equipment. Now it's time to find out something about knives further down the scale of size.

"ARROWHEAD"

The next to consider will be knife No. 3, which I call the "Arrowhead" (Fig. 18). My wife Odin, a dedicated portrait and landscape painter, is a devotee of the Arrowhead. Odin has a fine Italianate hand, and it often surprises me that she uses the painting knife in her portrait work. She likes the delicate point and the light, straight side; she can put on great big squares of paint or delicate dots, as in the highlight of an eye. Difficult as this is, highlighting with a painting knife seems to make the eye sparkle. She also spreads the flesh tones with her Arrowhead, sometimes smoothing them over with a big brush.

If the Arrowhead has refinement, as Odin finds, it also has breadth and sweep, for the blade is wide and long enough to take large charges of pigment (Fig. 15). This knife is a very versatile all-around tool. Consider it—it might be the one which fits your temperament.

BIG LITTLE KNIFE

Small, but not ridiculously so, knife No. 4 is a nice little instrument adapted to pictures of 20" x 24" size and under (Fig. 16). It has a good spring in its blade, producing rich, neat blocks, and a long tip which gives good striped effects (Fig. 17). Balanced loosely between thumb and forefinger, it can skip like a leaf with the tempo dear to this writer, whose best fun is painting the wind whistling over his farm.

THE MINI KNIVES

I think a great deal of the fun of working with a painting knife comes from an enjoyment of its hearty, big quality, its freedom and sweep. The tiny mini knives cannot give this freedom, because the very small amount of pigment which can be lifted under their micro blades restricts the amount they can spread on the canvas. All one gets is one little lozenge, or a few dots, or a cute little quarter-inch block. How can you bring down the great sweep of the sky that way?

In spite of these nasty words, mini knives are very useful in a number of ways—I would certainly recommend that you try some of them. Take knife No. 6 (Fig. 18). It looks stiff, puritanical, withdrawn. But load its quite wide little blade with good gobs of red, white, and blue, so they lay side by side. Put the knife down on the canvas on one straight side, the other slightly lifted—and draw it sharply across three-quarters of an inch, then lift up. Wow! A happening! It's a dramatic, color-modulated little mosaic, bold and strong, yet on a very small scale. The sketch in Fig. 19 gives a feeling of the enjoyment I had in reducing an evening conception of my farm bridge and pond to fit the format of mini knife No. 6. It gives texture; it gives a picture quality.

"MINI SQUIRT"

It seems a mere toy, but knife No. 7 (Fig. 20) has special potentialities which should lead us to investigate it. In a moment of blindness, I nicknamed it "Mini Squirt," but I found later that Mini Squirt does several things well and bravely, although in its own tiny way (Fig. 21).

With its rounded point, Mini Squirt lays a nice fat dot of paint, gives a good stripe, and produces, when used from side to side, a neat little half-inch block. Better still, this little thing will take you into close places, allow you to alter and adjust, pare rough touches out, and soften up edges or sharpen detail.

Sharpening details is the Squirt's greatest danger. When you go poking around, trying to adjust the details of painting knife painting, you're very apt to carve the life out of it. What I enjoy having the Squirt do for me is lay mosaics of tiny color blocks, which overlap each other to produce full consciousness of the color vibration already in the painting. There are many places, even in a good-size painting, where the vibration of these little blocks will help to build in life and air. They'll allow your painting to "breathe."

CHOOSING YOUR KNIVES

Which of these knives should you select in order to try out painting knife painting? If I were forced to choose one single knife, it would be the Magic knife. Almost any effect can be achieved with it. Yet, since knives are inexpensive, I would very much like you to have a few more: the trusty Palette Boy, the suave, exciting Long John, the beautiful, sensitive Arrowhead. With these four you would have a splendid kit, and you could use others as your command of painting knife painting increases.

Let me leave the subject of painting knives after this hint: they don't like to go to bed with dirty paint clothes on. They're extremely easy to clean when wet, very hard to clean when dry. Keep them sparkling all the time and they'll work much better for you.

18. Chunky *This is mini knife No. 6, but it has a soul—if you can key yourself down enough to find it.*

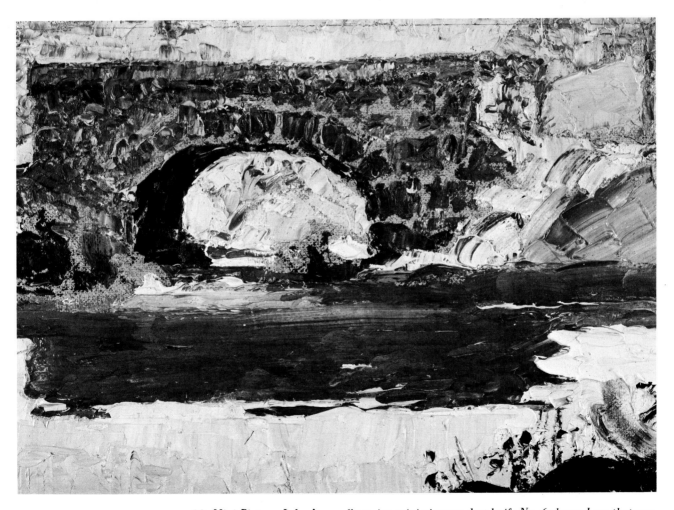

19. Mini Picture *I don't usually paint mini pictures, but knife No. 6 showed me that you can catch the bigness of nature in a small way. The secret is Nature's Scale (see Figs. 30 and 31).*

20. **"Mini Squirt"** *What a disrespectful name for such a brave little number! Don't scoff at it—it can show you a tiny thing or two.*

BRUSHES

Are there any other tools which can supplement the knife in the production of a beautiful, rich oil impasto? Of course there are, the first type being brushes (Fig. 22). We must remember, however, that this is a book about the painting knife. Thousands of books about the noble art of brush oil painting have been written, but here, brushes take a second place.

As I see it, big brushes are extremely useful to the knife painter in laying down large tones, such as backgrounds. And especially in situations where the light effects are changing. You can load a big brush with a lot of rich impasto and get it on while the effect is still quivering before your eyes—then you're ready to lay in the gorgeous blocks of contrasting impasto color with a painting knife. I never use turpentine or medium in the paint when I brush in these backgrounds. You might produce some beautiful effects this way—but that's just the trouble, you get tempted to leave them. Then you have to live with them forever after. They destroy the "surface tension," the sense of total weave, the mystique of the impasto.

My smaller oil brushes, so long, so apparently uncontrollable, are "riggers" or "stripers"—brushes used in lettering (Fig. 23). I use such brushes as they were *not* meant to be used—as free, wild things, held perhaps by the end of the handle, turned loose to give me the sudden glitter of sunlight flashing through a thicket, the unexpected calligraphy of grasses in winter snow, or spring buds bursting with energy. We'll have special practice material on this subject shortly.

Shall I whisper it, or shall I mount a housetop and shout it: *wash those brushes after using!* First with turpentine, then with warm water and a mild soap.

PAINT SQUEEZED FROM THE TUBE

One day I was demonstrating the fun of painting on a sanded gesso ground when there came a need for showing how impasto paint lines could be produced on such a ground. Unwisely, I hadn't tried this out beforehand, but I had unlimited faith that my floppy brush technique would continue to work. Rolling the long brush in thick impasto, I flopped it on. Nothing happened.

One feels a bit embarrassed when a thing like this happens before a college audience. I attacked again; again, results were negative. Getting desperate, I seized a full tube of Prussian blue and squeezed a fat black line right out of the tube onto the canvas (Fig. 24). Wow!

A response spark went circling around the room. I felt it, went on drawing with the squeezed black lines. I've used this method as an accessory to the painting knife ever since. I wish I could claim to have discovered this method of impasto calligraphy, but I can't—Van Gogh mentions it in his

21. Surprise! *You'd think little Mini Squirt would only be able to do beadwork, but here's breadth in miniature—and breadth is what makes painting knife work so fascinating.*

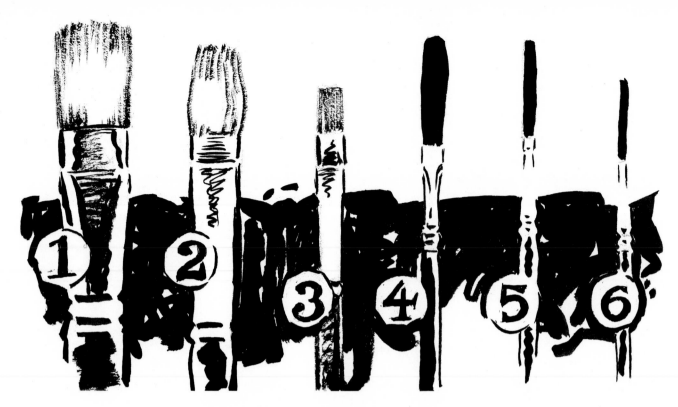

22. Brushes *These are noble auxiliaries to your painting knives. Brushes 1, 2, and 3 are bristle brushes; 4, 5, and 6 are long floppy "riggers" made of oxhair.*

23. Fast *When my two favorite bristle brushes lay the ground tones, they really go, and I get on to the knifework in a hurry.*

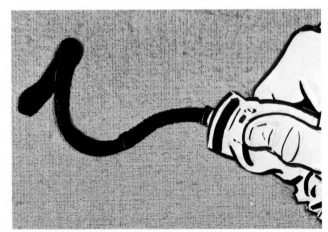

24. Paint Squeezed from the Tube *Here's a very special calligraphy—one simply squeezed from the tube. This technique is definitely not for the faint-hearted!*

letters. I'm a Van Gogh buff, and it was probably because of this that the method came to my rescue at that desperate moment.

If you try this—and please do—you've got to nerve yourself for the plunge. Nothing happens if you're timid, or if you start thinking of the cost of paint. Seize a new tube which has a lot of paint in it, swing your arm sharply and rapidly, and keep squeezing. It will work if you get into a strong mood and keep above it. Good luck!

USING YOUR THUMB

Another essential painting tool, producing curiously opposite results from the squeezed tube, is your thumb (Fig. 25). I would strongly advise you to take your thumb along on your painting excursions; keep it handy at all times. As a rule, I'm suspicious of techniques which flatten oil pigment down too much—they tend to squeeze out the air. But one can apply new, more airy tones with God's beautifully engineered tool, the thumb. Use it lightly, and you'll make marvelous transitions which seem to slide the light over the top of the paint. Thumbing down impasto pictures too much tends to destroy their quality, but the thumb is a fine thing to keep in reserve when you need a sophisticated nuance.

EXPERIMENT WITH PAINTING GROUNDS

We seem to have arrived at a point where I begin asking you to do things—I think you'll have more fun and learn more from this book if you play along. I'm only a ringmaster; it's you and the materials which are the performers.

I'd like to ask you to run an experiment which will give you a basic understanding of painting grounds and of the difference between brush and painting knife application, knowledge which I hope will broaden your approach to this subject. You'll need the following things: a small piece of glass, a piece of unsized, plain canvas or linen—but almost any kind of heavy cloth will do, a piece of artists' prepared canvas or a small canvas panel—sold at art supply stores, a folded newspaper, any kind of palette you happen to have around, a tube of ultramarine blue oil paint, a large paintbrush, and a painting knife.

GLASS

Slap a good brushload of undiluted ultramarine blue onto the glass and stroke it around. The glass is nonabsorbent; it sucks nothing out of the pigment. You'll notice it's difficult to adjust the strokes so the sparks of glare don't destroy the total sense of dark. Now lay some slabs of smooth, heavy ultramarine blue on the glass with the painting knife. You'll notice it's much easier to keep a consistant dark without shine. I want you to notice

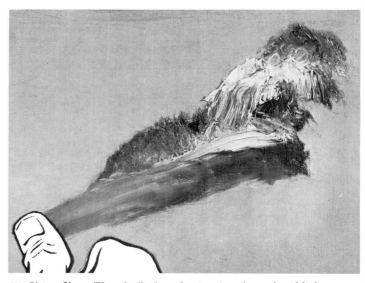

25. Using Your Thumb *God made the thumb—and padded it—apparently for the job of the painter working with impasto oil colors. This beautiful tool should be used with discretion, however.*

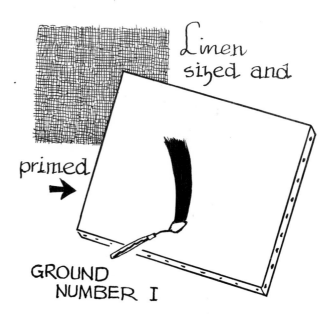

26. Stretched Linen Canvas *In my opinion, this is the perfect ground. Its spring matches that of the painting knife, and between the two the paint can really spark.*

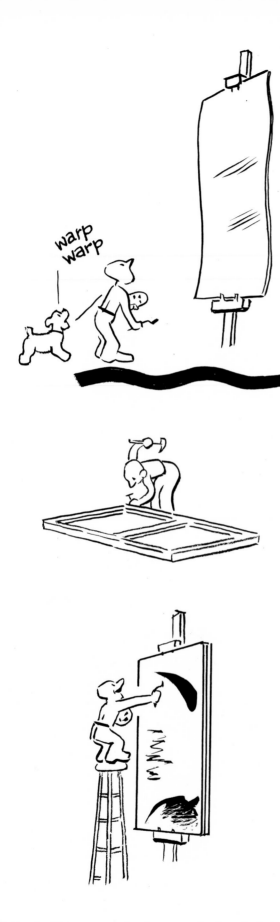

27. Panels *These can make fine grounds, but don't loose sight of the menace—warping—and its solution, shown here.*

something else about the surface—it's smooth, mysteriously beautiful, something akin to enamel, or to the lustrous surface of some handpolished bit of antique furniture. This built-in beauty of the paint itself is, I think, one of the greatest arguments for using the tool which displays it to its best advantage.

UNSIZED CANVAS

Try similar notes on the unsized fabric. You'll notice a striking difference: because the fabric is so absorbent, it sucks the paint into itself and grays it down, takes that lustrous surface I mentioned out of it. This is particularly true of the brush touch—the knife touch will still show some surface richness.

SIZED CANVAS

Now we try the two methods on the bit of artists' sized and prepared canvas (Fig. 26). The effect is beautiful in both cases. The shine of the brushstrokes is not nearly so annoying and the knifestroke, as usual, looks great. I think this will help to show you the superiority of well-sized and primed art store canvas over any other surface. The manufacturer, I believe, is better equipped than the painter to balance the value of absorbency against nonabsorbency and to determine the best sizing and priming. If you want to size and prime canvases yourself, there are many textbooks you can consult. I'm more interested in giving you what I know about actual painting.

NEWSPAPER

Now try the strokes of brush and knife pigment on the folded newspaper. The newspaper is just the opposite of the glass—it's extremely absorbent. The brushstroke sinks in and grays at once—the knife stroke looks quite rich and lustrous at first, but gradually sinks in and loses its strength. After awhile an oil ring may appear around the knife's impasto, showing how much oil is being absorbed. This should prove that a ground should not be too absorbent. Again, art store canvas has exactly the right degree of absorbency.

MASONITE PANEL

You'll gather I'm for canvas as a painting ground for knife work. Are there any exceptions? Perhaps one—the very large picture, say 50" x 60" and larger. Stretchers for these huge canvases often have to be handmade and are very expensive. Also, it's difficult to stretch them properly. I think the practical ground for huge canvases is the Masonite panel. Using the size 1/8" thick, it can be cradled, or edged with wooden strips about 21" long x 1"

wide in the back (Fig. 27). Glue these strips to the Masonite or fasten them from the front with small brads at the edge, where they won't show. The strips are important to keep such a panel from that terrible and all-too-prevalent malady of the painting board, buckling.

I suggest a light sanding on the Masonite (you'll be using the smooth side) to be followed by several coats of the wonderful modern acrylic gesso, which will give you a splendid ground. By crisscrossing successive brushstrokes you can build up an interesting canvas-like texture; you can also get a sandpaper-like effect by lifting the gesso brush up and down. Sand can be sprinkled on wet gesso and swirled around.

PLYWOOD

Good 1/8" plywood also makes a good, large painting ground. Heavy grain showing through several coats of gesso is often a nuisance; check in your lumberyard for a clean piece. Warping is a big problem—the best solution is to cradle the panel on the back, using good-size strips, with a crosspiece if it's really large. The cradling should be done before applying the gesso, as otherwise you may have a serious warping problem.

Some artists, who keep very cool and never throw nervous fits, like to mount canvas on large panels by sticking it down, often with lead white, which is applied to both surfaces. The canvas is then gently patted and flattened down from the center outward. If this is successful, it produces a very fine surface. But buckles and air bumps may appear which resist effort and tend to shorten your life span if you're the nervous type. I love the canvas surface, but I go for a Masonite panel on the big ones.

LINEN CANVAS

The kind of canvas you use reflects your taste and pocketbook. I think linen is best, even if it's a bit more expensive than cotton. It's said to last longer, and in an oil painting it seems reasonable to employ materials which will carry your artistic message over the longest possible span of time. Also, there's something beautiful, and hence stimulating, in a linen canvas. As to the weave, this again is a personal matter. I don't care for the very fine weaves — I can't feel my knife gripping them. I usually use a middle weave, enough to feel the grip of it, not heavy enough to be obtrusive. Recently, I've been experimenting with coarser textures in canvas, however. Since the painting knife is such a strong, bold tool, I believe its effects look very good on a rough-textured ground. The feeling of weave is very pleasant in connection with paint, suggesting a sense of unity in the picture. As time goes by, I expect to make many pictures on this heavier material.

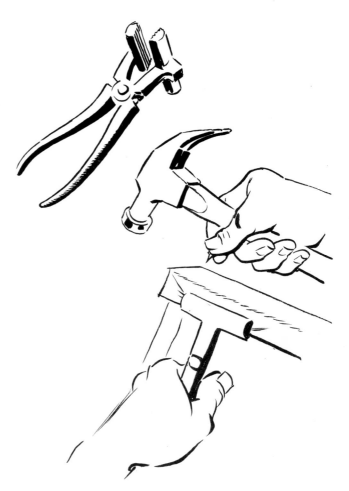

28. Stretching Canvas *Put in a tack, hammer it in; get a new grip with the pliers and pull the canvas taut; grasp a new tack, hammer it in; move on.*

29. Canvas Panels *These are very useful in small sizes. Here's a weakness of canvas panels and its solution.*

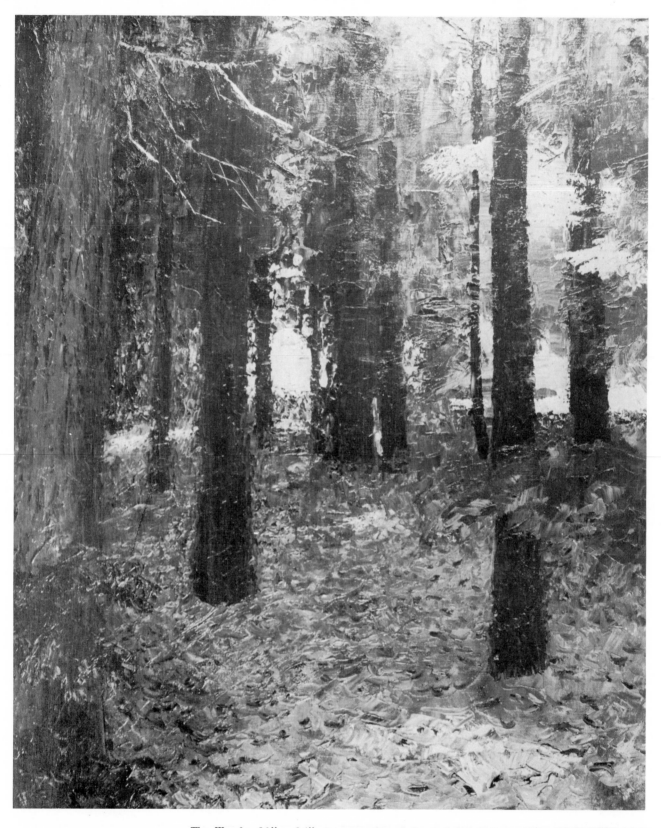

The Woods, *20" x 24". Courtesy Grand Central Art Galleries, New York. I feel in the woods a certain softness, a protectiveness, a sensation which I think is expressed in this painting. This softness is emphasized by the soft-edge quality of the painting knife work and by the feeling that the light from above is infiltrating only softly. Spots of light touch places on the forest floor so gently that they're barely noticeable. Perhaps we don't think about this consciously, but the feeling is that we're being protected by some kind of leafy canopy way up above us.*

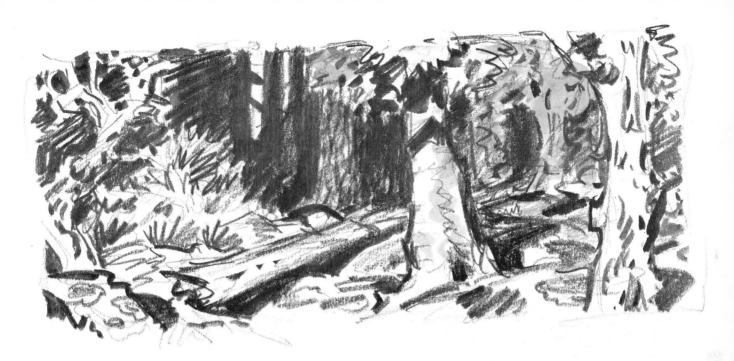

30. Too Many Centers of Interest *This is a pencil sketch for a woodland picture. What's wrong with it? There are too many centers of interest competing with one another and pulling your eye from side to side.*

31. Nature's Scale *Here's a section taken from the center of the woodland sketch shown in Fig. 30. It has more feeling of the bigness and the mystery of the forest because there's only one center of interest and your eye isn't confused.*

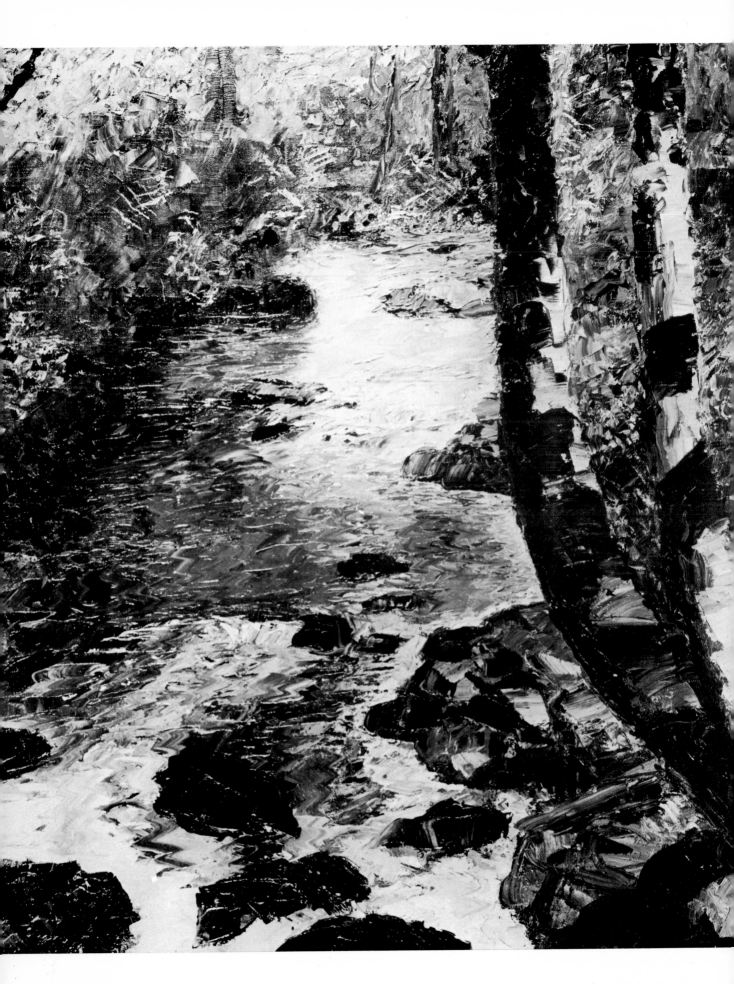

STRETCHING A CANVAS

Personally, I prefer to stretch my own canvas. You can get many kinds of stretched canvases these days, sometimes even in the supermarket. These are great, especially if you're in a hurry to get out somewhere and paint — but they're expensive, and the canvas used is often uninspiring. Besides, stretching one's own canvas is fun and exciting — my imagination starts painting the picture as soon as I start the process. I illustrate my pet method in Fig. 28. The equipment needed is a pair of canvas pliers, a screwdriver for lifting tacks, medium-size tacks, a pair of scissors, and a hammer.

Put the stretcher bars together, checking with a T-square to be sure the corners are true. Lay the canvas face down; adjust the stretcher on top. Mark 1½" on the canvas all around the stretcher and cut the canvas on this line. Lay the canvas face down again, put the stretcher on top, pinch the canvas up around the edges, and tack in the four centers, driving in the tacks halfway. Now you can pick the canvas up and sit down comfortably, with hammer, tacks, and canvas pliers close to your right hand.

You'll do a better job if you start stretching the four corners at this point, putting the tacks in halfway. Then go back to the centers, removing the tacks one by one, restretching, and driving the tacks all the way down. Do the same at the corners, then fill in the empty spaces. Now turn the canvas back up on the floor and finish the tacking as shown. Be sure to drive in the corner wedges (keys), which will be used for tightening the canvas later if any sagging occurs, put them in as the sketch shows — otherwise, they'll probably split.

CANVAS BOARD

What about the canvas-covered boards one finds everywhere in the art shops? I think they're very good for the beginner and they make good grounds to carry on sketching trips. But, attractive as the surface of these panels is, the supporting boards have a very serious weakness—rain or dampness may well disintegrate them. And when the support goes, where's your picture? A suggestion for overcoming this weakness might be this: when you have pictures painted on canvas panels which you feel are good enough to preserve, get some stretch-

ers of the right size and attach them to the back of the panel, using small finish nails (Fig. 29).

SIZES YOU NEED

What picture sizes should you start with? I'll outline a program of grounds and sizes applicable to your work as you follow the unfolding suggestions for practice in this book.

For the exercises in Chapters 5 and 6, you might get several pads of inexpensive canvas-grained paper, specially prepared for work in oil, and measuring about 10" x 12". Date and save these sheets — they'll be interesting to you later to remind you of things you've learned.

Chapter 7 involves real honest-to-goodness painting from objects. Canvas panels size 16" x 20" are appropriate here. Paint sitting down at this stage if it's more convenient.

Your work with the Demonstration chapters is very important. I'm hoping your ambition will lead you to acquire and use a truly professional setup (see next chapter). Enlarge your format at this point and work for greater breadth of vision on a larger size — I suggest 20" x 24". Use canvas board if you want, but why not stretch a real canvas and paint a chunky little masterpiece on it?

Here are some larger, post-graduate sizes for use when you're through with this book (or, hopefully, before). These are based on the availability of stretchers in these sizes in most stores, and on a similar availability of frames. Next up from the 20" x 24" size is the interesting 22" x 28" size. This is a very good overmantle proportion, and the sideways extension suggests the vastness of rivers or the sea. I often use this size vertically for painting my brook—I like the way the brook and I wind around in it. Sizes 24" x 30" and 25" x 30" are the classic outdoor painting sizes; and they give a sense of *nature's scale*, or what you see between your fingertips when you stretch your arms straight out (Figs. 30 and 31). Even if you paint larger than this size, carry out the same four or five big units you see in a 25" x 30", and you'll have nature's scale all the time. I think of this even when I'm painting small pictures. It makes for big seeing and feeling no matter what the size; go for this bigness and you'll never be pinned down as an amateur. Above 25" x 30", there are the well-known 30" x 36", 30" x 40", 36" x 48", 40" x 50", 48" x 50" (the largest size practicable for canvas stretching) and 58" x 64" sizes.

For outdoor sketching, I suggest that you start with 12" x 16" canvas panels (which fit the classic paintbox described in the next chapter) and that you graduate to larger sizes and a standup easel just as soon as you feel you have the confidence. Whatever size you use, remember these four or five big units of design. See it big, feel it big, paint it big!

Pools and Shadows, 22" x 28". Courtesy Grand Central Art Galleries, New York. This is different from the rest of my brook paintings. This brook is almost total iridescence instead of brooding depth. As I looked suddenly out into the more open, lighted part of my little stream, my eyes were dazzled by a jumping sparkle of yellow-green fire; and against this, here and there, was a stone or note of dark which registered intense red-violet in contrast.

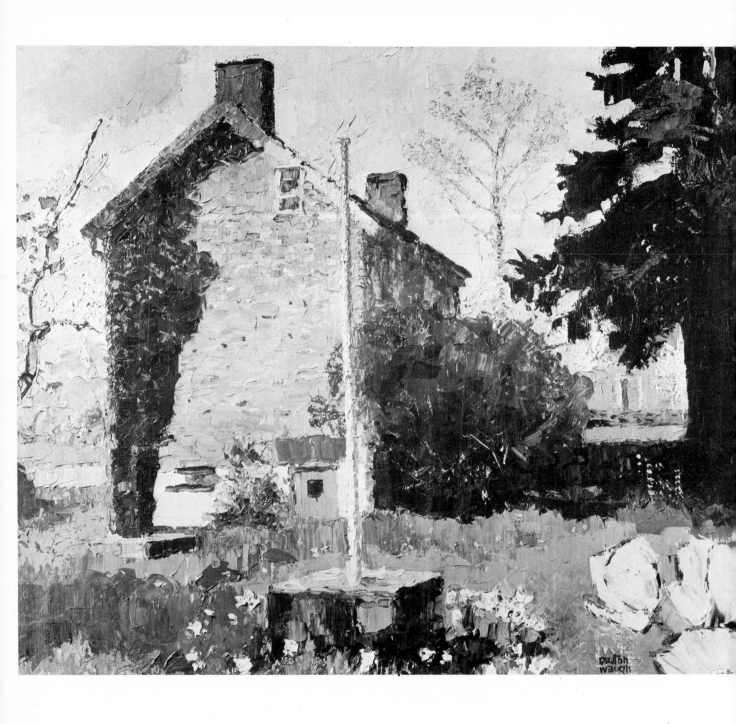

Little Farmhouse in Spring, *25" x 30". Collection Coulton and Odin Waugh. This house, like the painting itself, is in Odin's and my collection—it's our home. The time, a brilliant spring afternoon; the air, incredibly pure and dazzling. These are the things I tried to paint—the toy-like clarity of simple objects swimming in clear air. The luminous sky has a trace of viridian green, not blue, in a whole lot of white. The little door leads to the barn studio, my studio, until Odin kicks me out—then it will be her studio until I kick her out! It's a great system. And we're both learning to be outdoor painters!*

If you're going to come outdoors with me and wallow around in the sunlight, you're going to need sturdy equipment, capable of being taken along in a boat, stowed in the trunk of a car, carried easily by hand. This last suggests that, though strong, such equipment should not be too heavy.

PAINTBOX

Your outdoor oil painting equipment is almost certain to be organized around the classic 12" x 16" paintbox (Fig. 32). Such boxes, obtainable at any art store, are ideal within their limitations. The hinged upper half has grooves to carry three 12" x 16" painting boards, and it has a brass do-hickey which holds the upper part at a convenient painting angle.

The lower part is generally divided by crosspieces into four areas. The one closest to the handle is used for brushes and painting knives, generally wadded down with clean pieces of rag. Next comes two sections, in which you carry a small can of turpentine (for finger and brush cleaning, not for paint dilution), a small bottle of painting medium (for those addicted to the stuff), medium cups which slip on the palette, and charcoal for sketching first layouts. The long cross area in back holds the colors—a pound tube of white and ten or twelve studio-size tubes of the other pigments.

This standard box is a wonderfully complete and compact little outdoor painting plant, just by itself. It will stow away anywhere; if it's kept all charged up, one can rush out to seize some rare effect, some never-before-seen color relationship. Then, later, in the studio perhaps, you can use the sketch you've made to work out a full picture on a larger scale.

LAP PAINTING

As happy as the 12" x 16" box is—as a bit of equipment capable of really digging into the heart of nature—it has some very serious defects. Where are you going to put it so you can paint with

freedom? On a log or stump or outdoor hunk of something which happens to be precisely the right height? Such exactly adjusted hunks are rarely found in nature. So what do you do, sit down somewhere and hold the box on your lap?

I think many people do just this, and what's more, I think it's responsible for much, if not most, of the bad outdoor painting we see around. Consider the situation I've illustrated, or rather symbolized, in Fig. 33. Here, in the glowing late-afternoon radiance on the Hudson River, the sky, land, water, and trees fuse together into something large, something which expands your chest, and makes you breathe more deeply. And what's our little artist doing? He's hunched and scrunched over his paintbox, holding it in his lap; his spine is curved the wrong way, pushing all that beautiful air out of his chest instead of drawing it in. Maybe he's a good artist, but he's not good enough to know that you can't get the bigness of nature by working with your nose six inches away from an itty bitty panel. Chances are, when our artist sets up his sketch on the studio shelf and steps back to look at it, he'll realize that he left the Hudson River outside rather than, as he had hoped, carried it into the studio with him.

There's clear and simple blame to be assigned for such a failure. If you paint sitting down, you're naturally going to paint your picture to look good at a close viewing distance. This is very fine if you're doing an illustration to appear in a book or magazine which will be studied from the same close distance. But, as I pointed out a moment ago, your oil sketch is going to be hung on a wall, looked at from six to eight feet away. The adjustments you made on location will not give your picture enough carrying power and punch to take your message eight feet across space.

SMALL PANELS

Another weakness of the paintbox is the small size of the panels. A highly experienced artist can do masterpieces on this scale, of course, but it's too small to generate masterpieces in most artists. Our

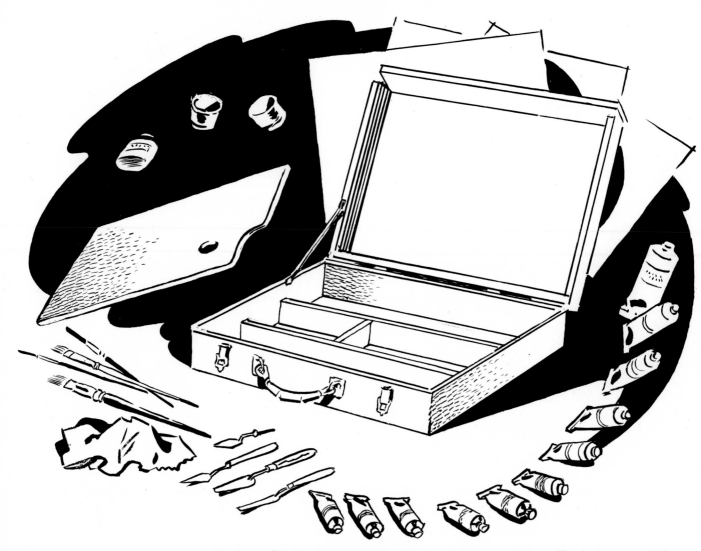

32. Classic Paintbox *Indoors or outdoors, we all use a paintbox. Here's the classic 12" x 16" paintbox exploding its contents—it's a studio you can carry with one arm.*

33. How Not to Paint *Swing that knife! Wait—how can he swing anything, all scrunched up like that?*

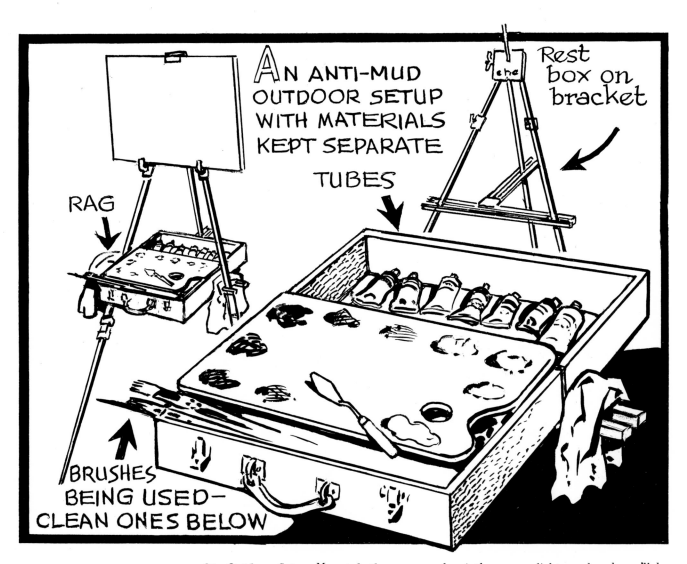

34. Outdoor Setup *Mount both canvas and paintbox on a light easel and you'll be comfortable—able to walk back and forth, swing an arm. Without the inner bracings shown here, the whole thing would collapse.*

35. The Right Way *Now you're out there painting—isn't it terrific?*

roving eyes see things bigger, and our arms, whose bold swings are so thrillingly registered through the medium of oil paint, are cramped down to a point where all they can do is twitch helplessly. To paint with true excitement, we need canvases at least 16" x 20", 20" x 24", or larger, as noted in the last chapter.

So we have these two weaknesses of the otherwise wonderful paintbox, the two mini effects coming from lap painting and the overly small format of the panels. Can we override these defects without losing the basic simplicity and compactness of the paintbox, so suitable for outside painting? Yes. Study the drawing in Fig. 34.

SETUP FOR "REAL" PAINTING

Here's a setup I've used for many years and tried out under all kinds of outdoor conditions. Rushing streams have attempted to pull its tripod apart without success, cows have nuzzled at it, winds blown, rain poured. It's light, amazingly light. Yet there's a principle in it which makes it remarkably strong.

As you see, I've added a sketching easel to my paintbox, this being easily capable of holding up a really good-size canvas, such as a 25" x 30". But this is no ordinary kind of sketching easel. Most of the sketching easels I've seen in action are so feebly engineered that one could knock them over with a balloon. But, as I said before, there's a power principle built into the easel I use. Look at the upper right-hand side of my drawing and you can see how it works.

After the three legs are extended and the easel is set up, a front crosspiece, itself in two parts, is connected, pinching around each easel leg and fastened by thumb screws. Then the back brace goes on, with a metal tongue which fits into the middle of the crosspiece, and whose backward extension pinches around the furthest easel leg. It's also tightened with thumb screws. Now the power principle is in action; the light, wobbly easel has turned into a rigid tripod. Open your paintbox with the back down, and it will be just the right size to slide on top of your inner braces. The effect will be as seen to the left of Fig. 34.

Now, please study the large paintbox in my drawing: it shows how the materials can be arranged to preserve freshness of painting by keeping them apart—as soon as your paint-smeared materials get snarled together, everything turns to mud, including your mind. Notice that paint tubes in use are lined up at the back, that brushes in use lie with painty tips over the edge of the box, and that the clean brushes are stored below. The ends of the front crosspiece which project on both sides make natural hooks from which to hang clean pieces of rag.

Next to my discovery of the startling effects produced by the flexible, broad, flat painting knife,

it was the realization of the total control over my materials this particular setup gave me which released the surge of joy I've felt for years while working outdoors. A violinist could do very little without a good violin; here, it seems to me, is equipment which, as far as equipment goes, is on the near edge of perfection. There are important points, however, to be made about using this setup in the open which shouldn't be disregarded.

SETTING UP OUTDOORS

The drawing in Fig. 35 illustrates several points about using the braced-easel setup outdoors. Notice that the canvas is in the shade. This is of great importance; paint with sunlight on your canvas and it may look very brilliant outdoors, but take it inside and the brilliance winks out. This is because much of it was supplied by the sunlight itself. But paint in the shade and you'll have to use brilliant enough colors to overcome the shade — and then, when you get that picture indoors, the glow will remain. What could be more exciting than carrying the glory of sunlight indoors and hanging it on your wall?

POSITION OF THE CANVAS

In my drawing, I show the shaded canvas against a sky background. This was done to make a point of the shaded canvas—but it's not an ideal arrangement; the sky is too dazzling. Try to arrange your canvas so that while it's shaded, it's against some background of neutral value—and color, too, if possible.

Please notice that the canvas is tipped forward at the top. This is most essential, because otherwise the shine from the gleaming surface of the pigment would strike the painter's eye and he wouldn't be able to see what he was doing. I strongly advise against buying an easel which only allows the picture to be held straight up or tilted back. Notice, too, that our painter has chosen a spot where it's possible to walk back from his easel once in a while to check on the carrying power—that is, how his picture will look at the distance it will be seen from indoors.

PACKING AND CARRYING

What about carrying all this equipment out to some spot in nature where you want to paint? Won't it be impossibly clumsy and heavy? It won't be, if you've packed your gear together in the right way. You can start with the sketched suggestion in Fig. 36. First, everything is put back neatly in your paintbox according to the arrangement suggested at the beginning of this chapter. You'll notice the palette is held down by little metal pins on the sides and that there's a little metal do-hicky to turn over in front. Be sure to use these holders, as the

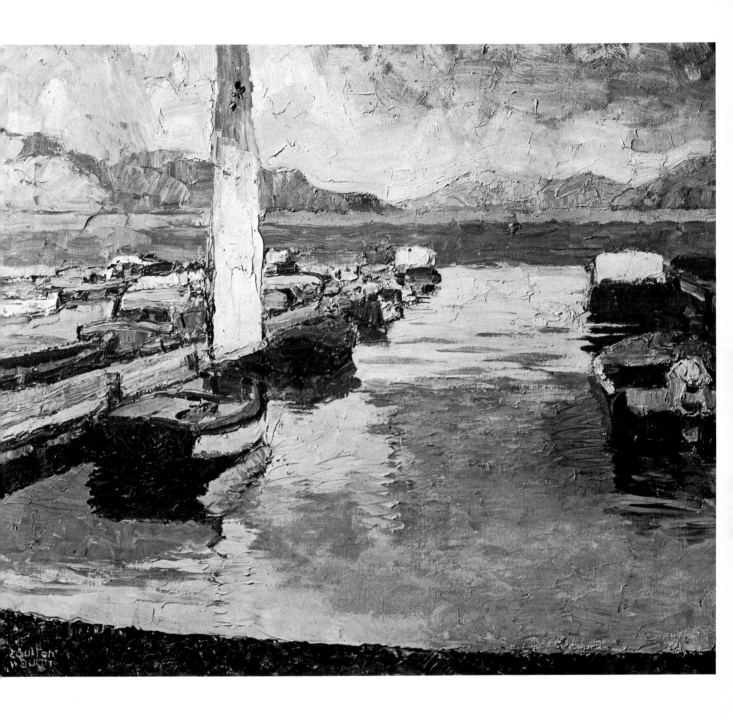

Otsego Rain, 25" x 30". *Collection Mr. N. F. Viek. Otsego Lake, which James Fenimore Cooper took as the setting for the prowlings and philosophizings of his* Deerslayer, *is a distinguished bit of water. Called "Glimmerglass" in the Cooper books, it is glassy and it does glimmer—with odd colors, too, such as certain strange, muted blue-green streaks, very fascinating to paint. Here, as my little boat the* Claude Monet *lay along the dock, I began to paint. Rain was in the making. I went on painting, however, rain or not, and I'm glad I did—for the picture registered a sequence: first a sunny day, with Glimmerglass busy glimmering; then the sense of heavy overcast as the rainclouds moved in, beginning to obscure the mountain at the end of the lake; then the fat raindrops splashing on my piles of fat pigments, along with the glittering of the sun.*

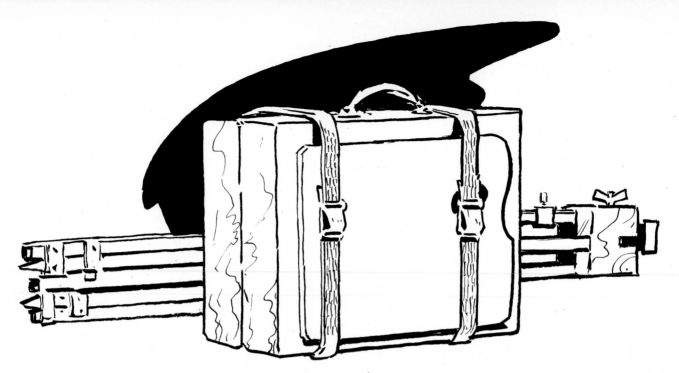

36. Packing and Carrying *It takes a bit of time to pack up like this, but you can finagle such a package through brush, woodland, or across a creek.*

37. Wheel Deal *You can find garden carts or dollies like this at garden supply stores. Notice how the folded easel slants across and is held by one strap.*

palette will hold everything below in place. Next, unfasten the braces from the easel, shorten the legs, and place these parts together, fastening them with a strap in the middle. Stand this package next to your paintbox. I always carry one or two spare paper palettes. After using, I transfer any good paint to the wooden palette inside the paintbox, and peel off the smeared top. Then I put my paper palettes together and place them on the free side of the paintbox, using two broad straps to fasten the whole package together. Now it can very easily be lifted by the handle on top of the box, and my canvas—dry or wet—can be carried in the other hand. I'm off.

WHEELS

God bless the ladies—they make wonderful outdoor painters once they've worked out some of the problems. And one of these, perhaps, is that my gear package may be a little heavy for them. Of course, they'll generally be going by car to the subject motif and then can usually tote the packed-up equipment down the road a bit or along the beach or lake front. But, girls, I suggest you experiment with one of those little gadgets on wheels, such as the ones many housewives trundle along after them. The easel package can stand upright and, if the paintbox won't fit in, it can be strapped on outside as Fig.37 suggests.

HAZARDS OF OUTDOOR PAINTING

Before we leave the outdoors, there are several situations I want to warn you about. I also want to give you several suggestions about how you can turn artistic danger into artistic success. One example is that in painting outdoors, you're going to find a time will come—perhaps an hour after you begin or a bit more—when the light has shifted enough to change the original effect entirely. What to do?

Don't follow the changes. This will kill your picture. Now is the time you must go on with a memory of the first effect; after all, your mind will be saturated with it. Stay with that first idea, forget the new appearance of the subject. I often turn my easel in another direction so I won't become confused.

There's still another plan: pack up your gear, rush back to your studio, and go on from memory there. I love to do this. The studio concentrates, deepens, and sharpens my memory. Its steady, unchanging light gives me a critical means of extracting the most value, especially in terms of color, from that first impression.

Above all, whether in front of nature or in the studio, train yourself to stop at the first slackening of conviction or hint of fatigue. Don't paint after this — the sacred freshness will go. Turn the picture to the wall or get out of the studio. Coming back

the next day, you'll have a new, strong memory of the original effect and a fresh, inspired eye. Put the two together and wonderful things may happen!

SETTING UP INDOORS

Fig. 38 shows what the bare minimum of an indoor studio might be. I'm not always an outdoor painter; I love to set up still lifes inside, casting mysterious shadows over them by partially blocking out the light—think of flowers in their true, impressionist colors sparked in by the painting knife in front of Rembrandt-colored shadows—what a rich, tasty idea!

A concept of living color like this asks for, it seems to me, the minimum of decor and diversion. I prefer the simple, monastic setting my sketch indicates. I expect something to burst into that studio, but it should be on the canvas, not anywhere else.

LIGHT

I want you to notice several points about this studio setup. The skylight is on the north side, giving steady, critical light all day—no sun comes in to unbalance the color. (Above all, I love to paint sunlight, but I must check under a north light to see how well I've made my sunshine.) This skylight starts from about shoulder height; my canvas is placed at a diagonal from it and tipped slightly forward. This arrangement avoids specular shine from the paint.

PAINTING MATERIALS

What's that on the table? The same basic paintbox we've been getting lathered up about! Just set up your basic box on a table handy to your easel, with the light coming over your left shoulder, and you're in business. I've put the clean brushes in a jar to one side and there's a string under one edge of the table to hold clean rags, ready to be used.

EASEL

The easel is a standard studio one. You can use the outdoor easel if necessary, but this larger one is a very good investment. If you buy one, be sure there's an arrangement to tilt the canvas forward, and that it has equipment to move the picture-holding crosspiece up and down, so you can work with different sizes, including really large ones.

PAINTING TABLE

For artists who spend much time painting inside, I recommend a more elaborate setup. The painting table is a splended thing: it gives a larger mixing area, it also gives opportunity to group your equip-

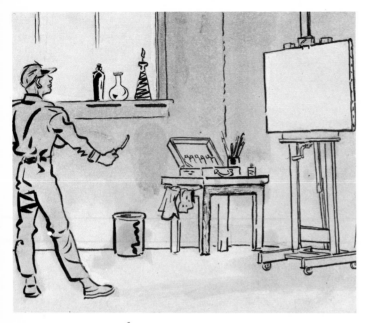

38. Indoor Setup *A critical north light—always the same—simple surroundings, paint, knives, and inspiration. The perfect setup.*

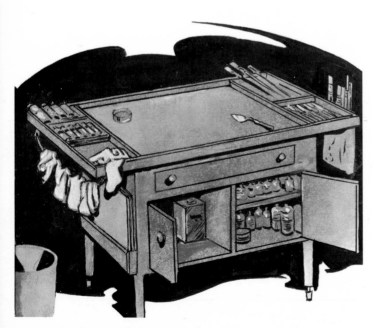

39. Painting Table *A glass palette, knife and brush compartments, tubes of paint, rag, turpentine, mediums, and varnishes all on hand. A painter loves a setup like this as a sailor loves his boat.*

ment more freely than in the cramped compartment of the paintbox.

Henri, Bellows, Hawthorne, my father Frederick J. Waugh—they all used organized painting tables. But the artist who, to my knowledge, carried table organization to its highest glory was that wonderful painter, Edwin Dickinson. I had the happiness to have known Dick intimately in the early years at Provincetown and to have been an habitué of his various studios. Dick had hardly any money to live on in those days, but he made no compromise with his painting—to paint to sell was something he would not do. As a result, he had to go without what are usually thought to be luxuries—yet the equipment in his studio gave the impression of something rare and precious, even if arranged from the cheapest materials. He had made a large easel to hold huge canvases, on which he would sometimes work years at a time. He made the easel roll obediently around his studio at a touch.

In front of Dick's easel was his painting table. Dick had served a hitch in the Navy and had absorbed the Navy tradition of extreme neatness, a useful but unusual trait to be found in a life dedicated to art. His palette was a large slab of glass, and after cleaning it following the day's work, he would insert under it perhaps a rose, or an El Greco reproduction, or more likely a photo of the death mask of Beethoven, at whose altar both Dick and I were serving boys. All Dick's equipment was housed in his painting table—the various trays, drawers, and gimmickries—which seemed a working symbol of Dick himself. It gave a hint of the studious but deeply imaginative procedure which led to his unique paintings, paintings which celebrated in their special way the high beauty of the most ordinary things.

Memories of Dick's table, the painting table used by my father, and several such tables I've worked on from time to time, are combined in the sketch in Fig. 39. Notice that the spaces on top carry out the separation of materials worked out in the paintbox: the tubes being used, the particular bit of rag, on the left; the brushes being used, as well as the palette knives, on the right. Out of sight, to the right rear, is a hanging bag for the main supply of paint rags and a hanging canvas pocket to hold clean brushes. Hanging from a wire to the left is a supply of small pieces of rag, instantly available. This is a top "must" in my color brilliance system. An outside wooden pocket on this end holds one or more paper palettes for extra mixing space. The drawer holds the reserve supply of paint tubes and below is space for turpentine and various varnishes. I keep a can of wonderful hand-cleaning gel here, the kind that whisks off all paint from hands in a few seconds—I strongly recommend it, both for inside and outside work. It's available in paint and hardware stores and is a strong factor in keeping up that cleanliness which is such an important business in painting.

PALETTES

I take palettes very seriously. When going the rounds in college classes, I often used to look at the state of the student's palette first; it frequently gave me a hint of his mental process, that is, whether he was painting joyously and happily, whether he was timid and withdrawn, or whether he was simply slipping into the mud. There are four kinds of palettes we should think about.

WOODEN PALETTES

The first species is the small wooden palette which comes with the 12" x 16" paintbox. A nice little number, although hopelessly inadequate in point of size, especially for us paint-hungry knife painters. A raw wood palette is more pleasant to use if rubbed with a little linseed oil, that delightful smelling and suave liquid which holds within itself the secret of the most beautiful patina in the world.

With all the glory of hand-rubbed linseed oil, our little paintbox palette can serve only certain of our needs. Stopping to scrape out new clean space slows the pace of your painting time, the time for speed and passionate attack.

PAPER PALETTES

The solution lies in taking along one or more paper palettes, the kind which you can make freshly clean again simply by tearing off the top. These paper palettes rank high in my regard. Say your main palette is filled with deeper colors and mixes and you need to concentrate on the infinite purity of the sky. The slightest muddy note in those high, pure tones will ruin the sky colors; you need more; you haven't room to mix more; you want to work fast because you see it exactly in your mind; so you grab a perfectly clean paper palette. Glory be—you can clean your knife in one swipe, and the air of our little planet goes vibrating onto your picture (Fig. 40).

It's a great luxury to have a paper palette for darks, too. As the sketch suggests, I drop them around on the grass and play on them as an organist uses his various stops.

DISADVANTAGES OF PAPER PALETTES

I have to admit, however, that paper palettes have two, mean, built-in weaknesses, against which you must guard yourself. Dampness or rain—any water — is deadly to them. They form into horrible rolls, which destroy their working surfaces; and, worst of all, this destruction goes right down to the bottom sheet. The remedy: wrap them in a bit of plastic sheeting. Their second weakness is just as bad. These palettes are stuck together on the upper side and the left side; the lower right corners are loose

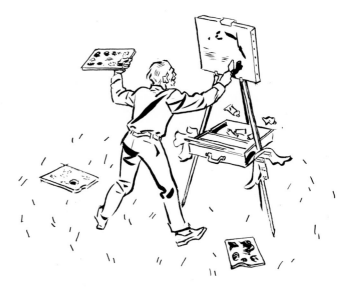

40. Paper Palettes *I carry several paper palettes so I'll always have a clean mixing space available.*

41. Be Prepared! *Paper palettes are extremely vulnerable to weather. Here's a solution to wind. For a problem with dampness, wrap your paper palettes in plastic sheeting.*

42. Arm Palette *This is too symbolic a picture, no doubt, but I hold the arm palette in mystic veneration. Besides, it's terrific to use.*

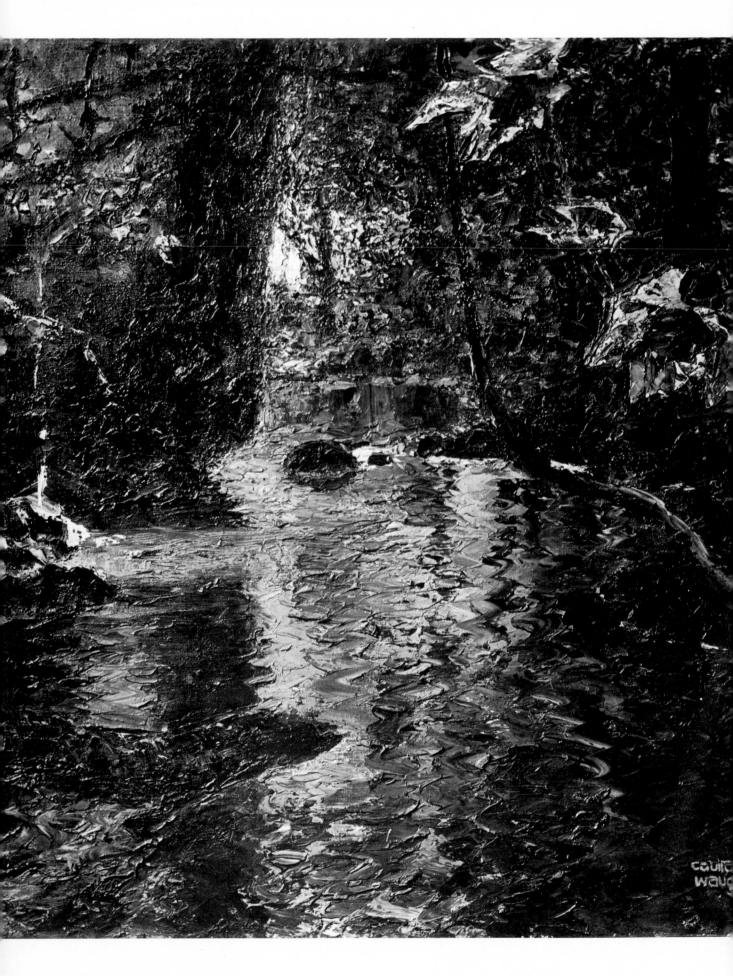

so you can tear the sheets off. So what happens when the wind blows? See Fig. 41. Consider that the top palette might be covered with paint. Why comment on the solution? Just carry a clip or clothespin in your paintbox and bless the day you read this book! As for the palette connected with the painting table, it might be of glass, perhaps sheet glass. Keep it loose so you can lift it up and insert a sheet of cardboard underneath tinted with your favorite color.

ARM PALETTES

I've saved the best palette for the last, suggesting that I regard this type with more than utilitarian attachment. It may be said that the great arm palette is but a sentimental relic of earlier days, to be associated in memory with berets cocked to one side, flowing neckcloths (they probably doubled as paint rags) and huge meerschaum pipes barreling out tobacco smoke. I admit there's sentiment here, so I'll make the most of it. My arm palette makes me think of Velazquez, Frans Hals, Rembrandt— but is that bad? Friends, these were glorious impasto painters using that fantastic medium, oil, which can trap living air. If such association relates us to the best of the past, I say it's for me.

To dramatize my conviction that oil painting, while resting in the past reaches into the future, I've drawn my arm palette in Fig. 42 as a pure white surface, rather than suggesting the grayed or woody tones characteristic of these palettes in the past. The big arm palette has a very large mixing area. I admit its shape and size make it impracticable to lug into the woods and meadows; it's, rather, something for the indoor studio. But consider that you can hoist it up on the bend of your arm and walk back from your canvas—try that with your painting table—and that you'll be carrying your pigments along with you. You can mix a tone with the advantage of distance from your picture, holding a dab of it up on the knife for trial by contrast; then you can walk up and apply it, moving back again for final evaluation. There's a curious interest and pleasure, too, in having your colors so close; holding the palette vertically, you get a picture sense out of it, you feel more deeply immersed in an experiment with pigment.

And as you lift up your big, noble palette, you have a chance to appreciate and enjoy its magnificent sweeping lines, the rhythm of its balance. What has this to do with the picture you're making? Everything! The practical has little to do with this business of painting. We're making useless things—useless except that they get the human spirit off the ground. And that's one of the most important things in the world.

Whatever inspires the artist, therefore, gives value to whomever is able to tune in to his work. If the big arm palette inspires him with the glory and honor of a still-living craft, isn't that a most reasonable reason for using it?

Shadow (Left), 25" x 30". Collection Mr. and Mrs. Ira Newman. This is a kind of classic among my brook pictures. My brook is the place I love to go on a hot day to get out of the blinding light, the place where it's fun to hide and philosophize—and, above all, the place where it's fun to paint. When the water in this pond invited me to jump into it, I considered the picture finished!

43. We're Off! *I was heading for my brook when my wife Odin made this sketch. Thanks, Odin, you recorded one artist exactly as he wished he could be!*

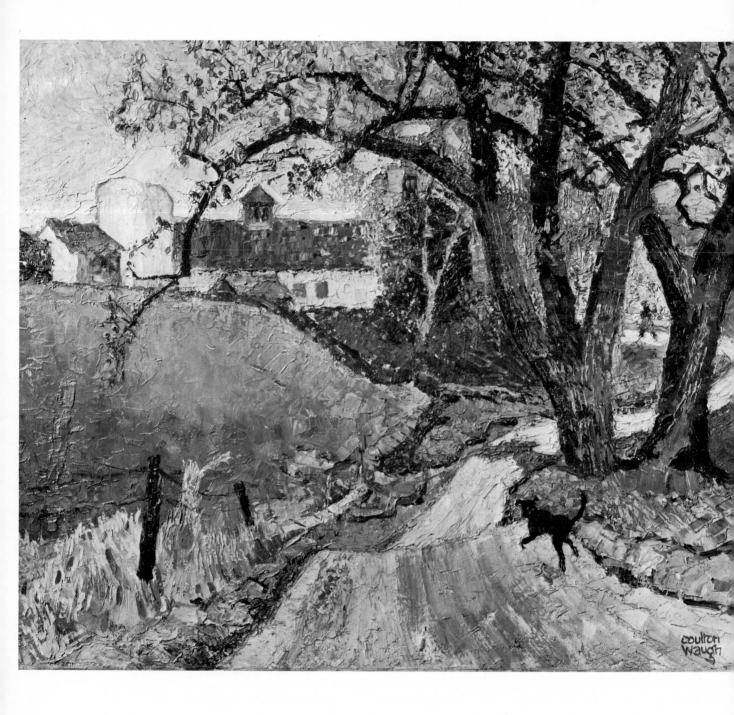

The Neuner Farm, *25" x 30". Collection Coulton and Odin Waugh. This is a farm close to mine. The time of year is spring, when "farmer's green" touches our fields here—a green more luminous and fresh than other greens—a truly wonderful green, nourished by dark manure. Any little dirt road is magnificent at this time of year. I worked outside painting this picture, savoring all the patches of local color dragged over by spring's light blue air. The huge trees are Balm of Gilead. Little spring-yellow green leaves flicker over them, and my painting knife joined in the flicker, moving as lightly as a leaf in the wind.*

4
PAINTS, MEDIUMS, AND VARNISHES

Artists' paints, as Fig. 44 shows, may be of several different kinds; yet all these kinds use the same basic set of pigments or powdered color. It's the vehicle, the liquid in which the pigment is ground, which varies with each kind of paint and gives it its special character.

Considering paints especially adapted to use with the knife, we can dismiss watercolor as being, precisely, too watery, and we can dismiss tempera and its allies, gouache and casein, as lacking the body to give substance to the knifestroke. The mixed technique, beautiful as it is, involves the use of thin oil glazes, and so has only a historic relation to the use of a painting knife. We're left with oil and acrylic.

I've made my choice between these two eligible media and am very happy with oil paints. Yet I'm quite aware that there are special charms to be found in acrylic paints as well. Before I discuss oils and acrylics further, I want to pinpoint a certain characteristic of my own chosen medium which to me is a determinant of the whole painting story. Will you forgive me if I introduce a bit of art history?

TEMPERA

We go back to Italy before 1400 A.D. Pictures painted by such masters as Cimabue were executed not in oil but in the medium called *tempera*, in which the color pigment is suspended in an *emulsion*, meaning a watery substance containing fatty particles. Milk is an emulsion; the old Italians used the yolk of an egg. One can mix a color pigment into an emulsion and, using a fine-point brush, execute strokes of great sharpness and finesse—which is the secret of the amazing clarity of detail in these old paintings.

But the strange and baffling thing about tempera is that the colors resist being mixed into each other (Fig. 45); they're haughty, unfriendly, aloof. When tempera-using Italians needed delicate transitions—say a glow of red in the cheek of some lovely Renaissance angel—it became necessary to lay extremely fine hatchings of one color over another.

The old boys became fiendishly expert in this and managed to get transparent skin tones as delicate as flowers, all without any actual intermixing of the pigment. But this method was very laborious.

You'll understand, therefore, that the Italian art world was ready and waiting when, around 1500 A.D., word came that certain Flemish artists had discovered a new liquid vehicle in which colors could be mixed—this was linseed oil.

LINSEED OIL

Linseed oil possesses the quality of producing perhaps the most beautiful patina in the world. A complaint or two may be lodged against me because of my insistence on the importance of linseed oil—critics may point out that poppyseed oil also enters into the tube paint story. I admit this is true, but I don't think it very important. Poppy helps to produce good, short, buttery paint, but on the other hand it dries more slowly than linseed. My major point is that modern tube paints are extremely well balanced as they are. And there's no question of the crucial part linseed oil has played in the oil paint story—the lovely stuff.

When hand-rubbed into wood, say on some piece of old furniture, linseed builds into a surface not sharp and rigidly glassy like varnish, but smooth, soft, and exquisitely lustrous. What was discovered was that linseed oil took the basic color pigments, the same ones which had been used for hard, difficult tempera, and breathed them out in infinite subtleties, serving as a loving and understanding catalyst when two or more of these colors were blended together—for blended they could now be, as the Italians realized to their delight.

EXPERIMENT

But the oil paints of this time, though composed of the same color pigments and linseed oil which we use today, differed from modern paints in very important particulars. I hope you'll join me in a little experiment here, which will cast a lot of light on the whole matter of pigments as used with the

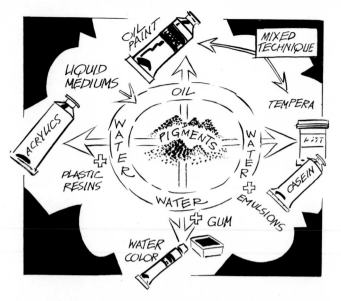

44. Paints: an Overview *All these different kinds of paints are made from the same pigments.*

45. Tempera Discord *This little sketch is symbolic of the problems of the early Italian painters, whose tempera colors didn't like one another.*

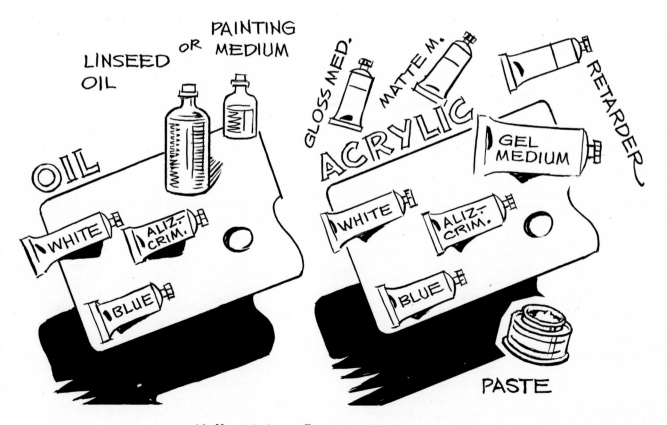

46. Materials for an Experiment *For the experiment in oils, use linseed oil or painting medium; for the experiment in acrylic, you'll need acrylic paints and acrylic gel.*

painting knife. I'll ask for only fifteen minutes of your time.

You'll need a paper palette, a little linseed oil or oil painting medium (1/3 linseed oil, 1/3 varnish, 1/3 turpentine), and a small amount of black, alizarin crimson, and ultramarine blue oil color. If possible, I'd like you to have the same setup in some brand of the new acrylic colors. You'll need, in place of the linseed oil medium, a tube of acrylic gel. Other acrylic accessories it might be good to have would be a can of acrylic modeling paste, jars of gloss and matte medium, and some retarder to increase drying time (Fig. 46). We shall come to the experiment with acrylics on p. 64.

OIL MEDIUM

Pour out a little linseed oil or oil painting medium on a plate or white palette and rub it around a bit with your finger. Get the feel of it, examine it (Fig. 47). Do you see why the Italians fell in love with it? It has such a luscious feel, not sticky or gummy, but gracious, pleasant; even its smell is delicious.

OIL PAINT

Now put a squeeze of black oil paint, just by itself, on a white palette. Start rotating it around with your finger, noting how workable it is. Work it away from the main pile as shown in Fig. 48. Keep drawing it out until there's only the most delicate shade of gray. What has made this subtle manipulation possible? It's not the pigment itself; a black pigment mixed with tempera vehicle would never work like this. No, this effect is possible because the black pigment, before being confined in the tube, had been ground in linseed oil, and it's the linseed oil which is responsible for spreading out the pigment grains in that marvelously smooth manner.

BINDING MEDIUM AND OIL PAINT

What happens when oil colors become blended together? Take a clean palette, lay out a smear of linseed oil, and a squeeze each of alizarin crimson and ultramarine blue (Fig. 49). Touch your fingertip to the oil, then touch it to the edge of the alizarin crimson paint pile. Look, a brilliant pink crimson leaps out from the original dark color. Put a trace of this into your smear of linseed oil and rotate it. Now you'll be working with a highup baby pink; add a bit more of the main color and take it down through fiery pinkish red shades; add more, go all the way down to the darkest tone. Notice how brilliant and bright all these tonalities are, even the dark ones—this is a big point I want you to observe. What's caused all this brightness? There was no white added—the brightness came because of the transparency of the color, the whiteness of the palette underneath, and the re-

47. Lovely Linseed *What beautiful stuff—clean, limpid, easygoing, friendly to both colors and artists.*

48. Oil Paint *This is black oil paint, rubbed out onto a white palette with the finger. What makes those delicate shadings possible is the linseed oil in the paint.*

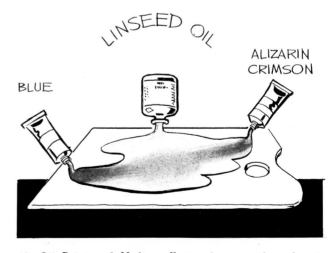

49. Oil Paint and Medium *Fusion between the colors is what gives oil paint so much of its charm. Experiment—find out how much colors mixed in linseed oil seem to enjoy each other.*

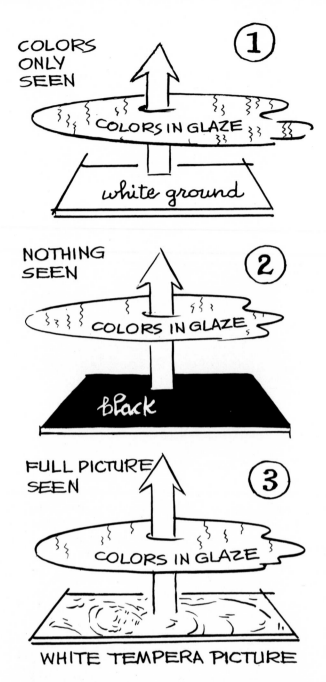

COLORS
ONLY
SEEN

① COLORS IN GLAZE

white ground

NOTHING
SEEN

② COLORS IN GLAZE

black

FULL PICTURE
SEEN

③ COLORS IN GLAZE

WHITE TEMPERA PICTURE

50. Mixed Technique *Here's an inside look at the system of painting used by the Italian masters, to help you understand the oil paint story.*

markable nature of the oil medium, which allows such delicate transitions.

BLENDING OIL COLORS

Now go through the same bag of tricks with the ultramarine blue oil pile—you'll get a gorgeous blue shade toward the violet, with wonderful aerial tones, when diluted with much oil. Now take a fingertip of this blue and touch it into the pink experiment. Do these colors withdraw from each other as they do in tempera, shout insults and defiance at each other? Not at all—they fall into each other's arms, amalgamate with brilliant ease, construct flower-like violets of the greatest finesse and beauty. This wonderful fusing quality was what sold the Italians on oil painting. It's what sells the oil medium to me for painting knife work.

Let's pause for a moment, for this is the key point of the oil painting argument. We've proved that the fine pigment grains flow along in a linseed oil mixture until they thin out smoothly to a tone which is only a breath, that they amalgamate with grains of another pigment in the same silky manner—all this, mind you (and please do mind), under the complete control of the artist's hand. The fusings so beautifully seen in our transparent experiment will work just as well in opaque impasto, when different colors and values are swirled around with the painting knife.

MIXED TECHNIQUE

Let's get back to the Italians. With all the beautiful fusions their transparent oil paint made possible, they found something lacking (Fig. 50). Colored glazes had given beautiful colors when on a white ground (1), because the light from the ground had set the colors on fire. But these old painters wanted realistic pictures, and you can't get realism with bright colors alone. Furthermore, if you substitute a black background under the colored glaze (try it), nothing whatever will be seen (2). To make the new discovery work, some new manipulation of glaze or ground was necessary.

The Italians must have wondered what to do. How could these beautiful fusions and colors be applied to actual drawing, modeling, value? No one seems to know for sure, but many think it was the Flemish Van Eyck brothers who worked out the first practical answer to this question. They wanted the fusion, they had to have white underneath, and they wanted precise drawing and modeling; they put these needs together and decided to draw and model underneath with variations of white tempera and glaze over this with transparent oil colors, so the white would set the glaze afire (3). So arrived the magnificent *mixed technique*, two mediums in one, the glory of the early Renaissance (Fig. 51).

51. The Good Wife of Ghent, after Roger Van der Weyden's Portrait of a Woman *Based on the original, this painting was done by the author according to the principles of the mixed technique.*

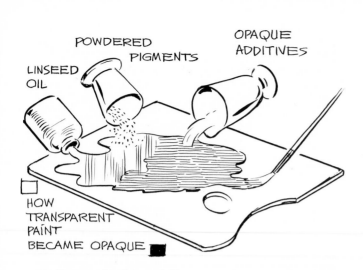

52. Opaque Oil Colors *Adding opaque white makes a striking change in transparent color. Take a brush and experiment with this to see what happens.*

53. Fluid Oil Sketch *This free sketch by my wife Odin shows the possibilities of the older, more fluid oil technique.*

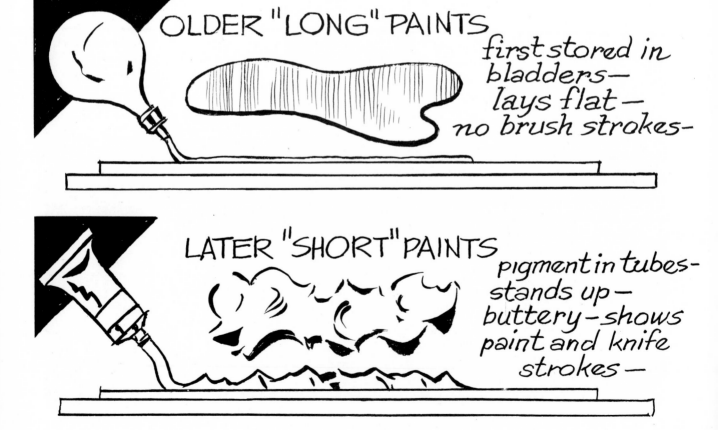

OLDER "LONG" PAINTS *first stored in bladders — lays flat — no brush strokes —*

LATER "SHORT" PAINTS *pigment in tubes — stands up — buttery — shows paint and knife strokes —*

54. The Long and the Short *Additives stiffened the older, syrupy paint to make it register the artist's feeling more closely.*

OPAQUE OIL COLORS

But even with the beauties of the mixed technique, something was still missing. With all that transparent color, the system was too laborious. At the same time, white lead, an opaque material which has great body and covering power, was coming to be used in many ways around artists' studios. It was inevitable that painters would get the idea of introducing opaque white in varying degrees into the transparent overpaints (Fig. 52).

Take a touch of your oil white and mix it into a bit of the pink you made before. It will make the pink lighter, but it will introduce a certain new heavy brilliance; if you want a darker pink, just add more of the basic alizarin. Now, using a soft, watercolor-type brush, paint the mixture out flatly, avoiding brushstrokes and ridges. See what a suave result you're getting and how easy it is to do? Work a little blue into it—you'll realize that the light and body is now in the paint itself, rather than in the white underpaint. Notice that with this kind of opaque paint you have very much more control, for you can put one color over another.

Many wonderful old master pictures were done in this way. Yet there was still a minus value in it. The colors used were thin and syrupy; it was difficult to put a light tone over a wet, dark one. You can approximate their problem by putting out a bit of wet, dark-value oil color; then, mixing a little linseed oil medium into a much lighter tone (to approximate the more fluid paints of the earlier time), try, with a brush, to superimpose a few lines on the darker paint below. It's difficult—it seems impossible. The lighter color sinks into the darker. Putting in white makes the higher color more solid, but it's still difficult to get a clean, crisp effect; also, it's making a new color, one, perhaps, which you may not want. From these experiments with syrupy colors you may, perhaps, find a clue to the weepy, washed-out look of so many amateur paintings: the artists are lacing them so heavily with oil medium that all force and punch have disappeared.

In spite of what I've said against the old syrupy colors, many beautiful oil pictures were made with them. As my wife Odin and I were talking this over, she was experimenting with syrupy colors on a white palette (Fig. 53). "I can see the old boys really had a lot of fun working like this," she said. Looking on her palette, I saw she'd sketched free impressions of our two children in the thin oily technique, with a little opaque white added here and there. The result was tender and haunting, and I've reproduced this sketch, cut from Odin's palette, to give you some idea of the possibilities of earlier styles in the long type of oil painting.

FROM LONG TO SHORT

We've arrived at about 1800. Painters were beginning to discover the fun of painting outdoors. But the thin, syrupy colors of older days, of the consistancy called *long*, had to be stored in bladders and were very inconvenient to use when in the field. Result: paint manufacturers began to look for more practical containers and discovered the tin paint tube. In order to keep the paint inside flexible for a long time and to keep it from separating when being squeezed out, they began to make the pigment stiffer by using extenders or additives. Now it was *short* instead of *long*. The artists loved this new paint. It meant that lighter color could now be much more easily touched over deeper tones. And there was something else, the *stroke*, the particular calligraphy of the particular artist, now for the first time was becoming clearly visible and acting as a determinant of his particular style. Furthermore, the loose, rough, variegated textures of nature now could be suggested with a fidelity which was at once true to appearance and true to the poetic feeling of the artist (Fig. 54).

The striking transition from oil painting of the 18th century type, with few hints of brushstroke, to a 20th century short pigmentation, is shown here by two pictures painted by my father, Frederick J. Waugh. The earliest, a portrait of the author in his long-haired period, was executed about 1901 (Fig. 55). The other picture, a salt barque lying in the harbor of Gloucester, Mass. (Fig. 56), was done in the summer of 1910 (I know, because I was sitting in Dad's rowboat at the time, watching the artist at work). Here's a change from controlled paint, allowed to register only the slightest impasto effect, to an impressionistic rendering in which strong impasto tells the story of light and reveals the artist luxuriating in it for its own texture and interest. All this change in nine year's time! It's a rough parallel to the pigmentation changes going on in the art world during the same period.

Have we arrived at the end of the story? Regarding the paint itself, yes, but in relation to bringing out all the possibilities of this paint, no. We've been speaking of paint used with brushes. But brushstrokes make tiny grooves. These throw little shadows, which in turn cut down the brilliancy of the color and light. Also, with a brush, it's still difficult to lay one bright color on top of another when both are wet; the two are apt to fuse just a bit. As a result, vibrating impressionistic color effects, with one color glittering on top of or close to another, are rarely realized at their full potential with brushes alone. Something else was needed— perhaps you've guessed what it was.

Take your knife, smooth out a good dab of ultramarine blue just as it comes from the tube. Look across it—do you see that beautiful, special luster which we spoke of as characteristic of linseed oil and of pigments ground in linseed oil? The grooves of the brushstroke tend to mar this luster, while the painting knife stroke, with its production of an enamel-like surface, tends to display it in full richness. Surely this is one of the great arguments for wedding short pigments and the use of the painting knife (Fig. 57).

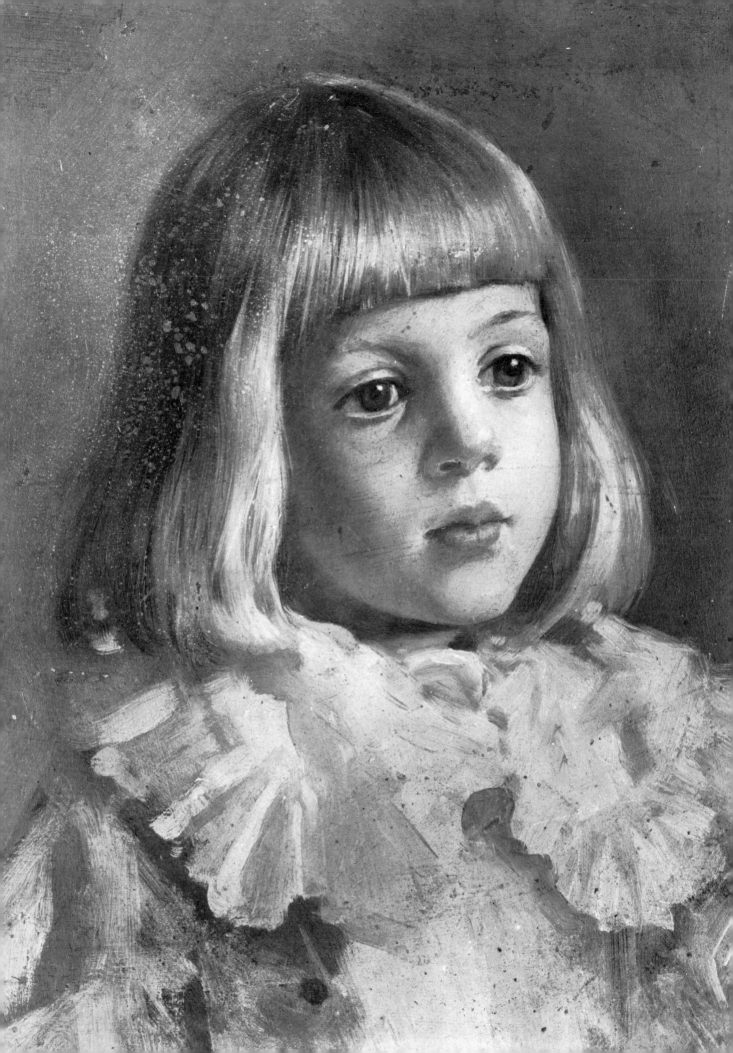

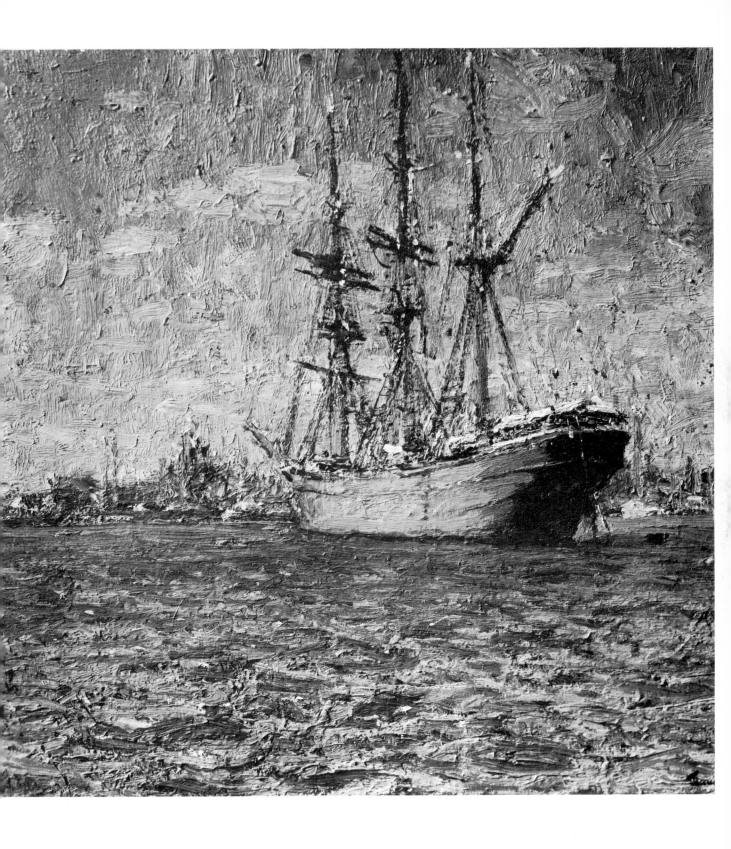

55. Portrait of the Author, 1901, *by Frederick J. Waugh (Left). This little portrait painted by my father was done in the older, more detailed technique made possible by using long pigmentation.*

56. The Salt Barque, 1910, *by Frederick J. Waugh (Above). Notice the difference in technique between this painting and the little portrait painted nine years earlier. Here, the technique is impressionist, making use From the Edwin A. Ulrich Collection.*

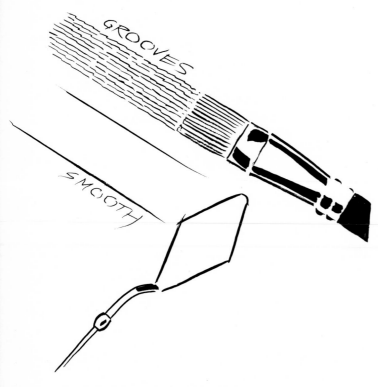

57. Surface of a Painting Knife Stroke *Brushes are great, but they have their limitations. Just give us knife boys a chance, and we'll spring something new!*

THE AGATE EFFECT

Mix some white and alizarin crimson to make a fiery, pinkish red tone. Pick up a dollop of this on the underside of your knife; lower it lightly on the wet blue, keeping the blade full; draw it across sharply but lightly a quarter of an inch, then lift suddenly. A bright, unfused bit of pink should be tingling on that blue—each color sparking up the other. That's reason number two for using the painting knife with oil paints. Now pick up a good-size dab of dark blue on one edge of the underside of your knife and a dab of the bright alizarin crimson on the other—get a bit of pure white in, too, perhaps in the center (Fig. 58). Turn the knife over and drop it down on the palette so it rests on the straight part of its top edge, the other edge, the one toward you, being slightly lifted. Now slide the knife rapidly back and forth on that top edge, moving it down as you continue sawing with it. About two inches down, lift sharply. What's there? I don't know exactly, but it will be reason number three for using the painting knife!

If you've done this right, some kind of exciting paint pattern will be revealed. The big feature will be a *marbleized* effect, the bright colors zigzagging back and forth, distinct from each other, yet wonderfully softened and fused where their edges connect. It will have the beauty of agate or other semiprecious stones, and the colors will seem to have created this beauty by themselves.

Now clean your knife and rub part of your agate colors together. You'll see how softly and easily these colors melt into each other before they finally merge as a flat tone. Even here, there will be something distinguishing the luster of the surface of the pigment (Fig. 59).

There are many more arguments for using oil paint, undiluted, which will appear during the course of this book, especially in relation to color effects. I've brought up some major points, however, and I feel I can rest the case for oil paint at this point. Now let's look into that striking new medium—acrylics.

CHARACTERISTICS OF ACRYLIC PIGMENT

The difference between oil and acrylic pigment is deep and basic. Oils are made from natural materials, this applying also to the mediums used with them. The acrylic paintmakers have taken the simple little oldtime powered paint molecules, mixed them with strange "concoxicants"—I can think of no other word—and handled them roughly in the new chemical process called *polymerization*. In place of a lot of amiable but weak little molecules there emerges the giant polymer molecule, and this strapping thing starts to push paints around in a new way.

Let's run a test with acrylics and see what's happened to paint. On p. 55, I gave a list of the acrylic accessories it would be good for you to

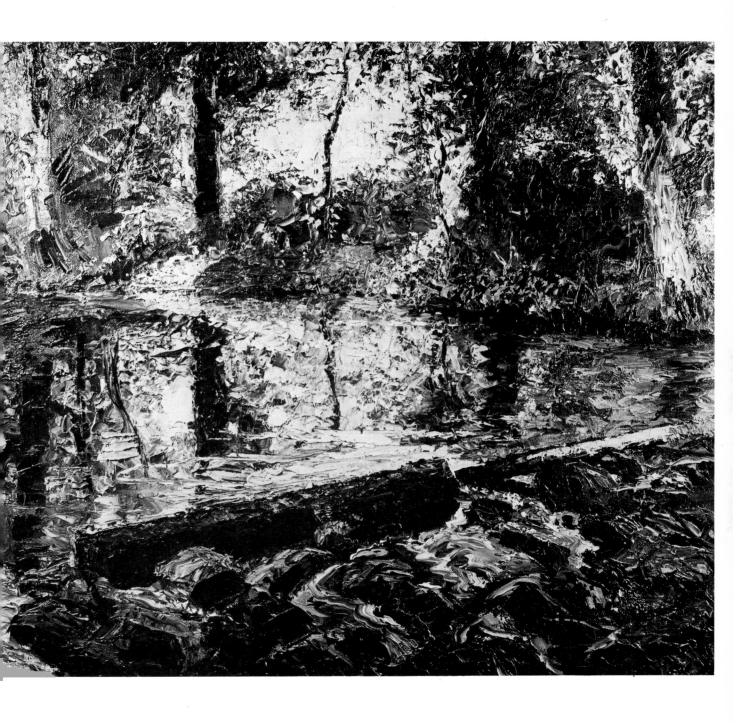

Swimming Hole, *20" x 24". Courtesy Grand Central Art Galleries, New York. Just about my favorite thing is the sparkle, the excitement, as I look toward the light. The treetrunks, branches, and heavier leaves make dark patterns; the gay, robust light comes right through the translucent leaves, turning them into stained glass. I look for this effect everywhere and in all seasons—even in winter, where an occasional leaf may still fire with an even richer accent against the muted woods colors. But this picture is total glitter— trees, water, everything. It called for extremely heavy, loose knifework with my full complement of painting knives.*

SOMETHING'S GOING TO HAPPEN !

58. The Agate Effect *What's going to happen here? Load your own knife like this and see for yourself!*

have. If you can't find them all, you can probably get a set of colors and a tube of acrylic gel. This will suit our present purpose. You'll also need acrylic white.

An important point to be made here is that in this book we're concerned with impasto mediums, the kind of paint thick enough to be picked up and manipulated with the painting knife. But the claim is made that acrylic can work in *any* way, and its backers specifically speak of its ability to produce rich impasto knifework. For this reason, I think we should look into it carefully and impartially, and make tests and experiments from which to draw conclusions.

To begin with, let's run a test with acrylic black, and compare it with the similar test we made earlier with oil black. Squeeze out a good pile of acrylic black on your palette and start swirling it around with your fingertip (Fig. 60). It moves around pretty well at first, but as you work away from the main pile, you find out something striking about acrylics, fast. The color doesn't seem to want you to manipulate it; it sets up an angry resistance, grabs fiercely to the ground, and as you try to push it out, just suddenly stops. That's it. Fight it as you will, the big molecule will go no further. But perhaps this negative result is only true of black. What about the colors? Let's try them and see.

ACRYLIC GEL

Using a white palette, squeeze out a pile of ultramarine blue and another of alizarin crimson. According to the labels, the gel medium makes the colors brush out. The impression given is that gel works with them in something the way painting medium works with oil paint; perhaps it's this which will make them handle easily. Squeeze a good bit of this gel out and look at it closely. It looks whitish, but it's transparent when spread out. Work a bit around with your finger, as we did before with the oil medium. Does it behave in the same way? Not at all. There's something very different, very strange about it.

BLENDING ACRYLIC PAINT AND GEL

Acrylic gel has none of the pleasant, easygoing qualities of linseed oil, none of the charm. Like the black pigment, it clings stubbornly to the paper, doesn't want to slide, is sticky. Rub some of the ultramarine blue around with your fingertip. Any improvement? No, it's just as stubborn and obstinate as the gel. You'll find the same thing true of the alizarin crimson.

BLENDING ACRYLIC COLORS

When we got to this point with the oil medium, remember, we rubbed the colors together and

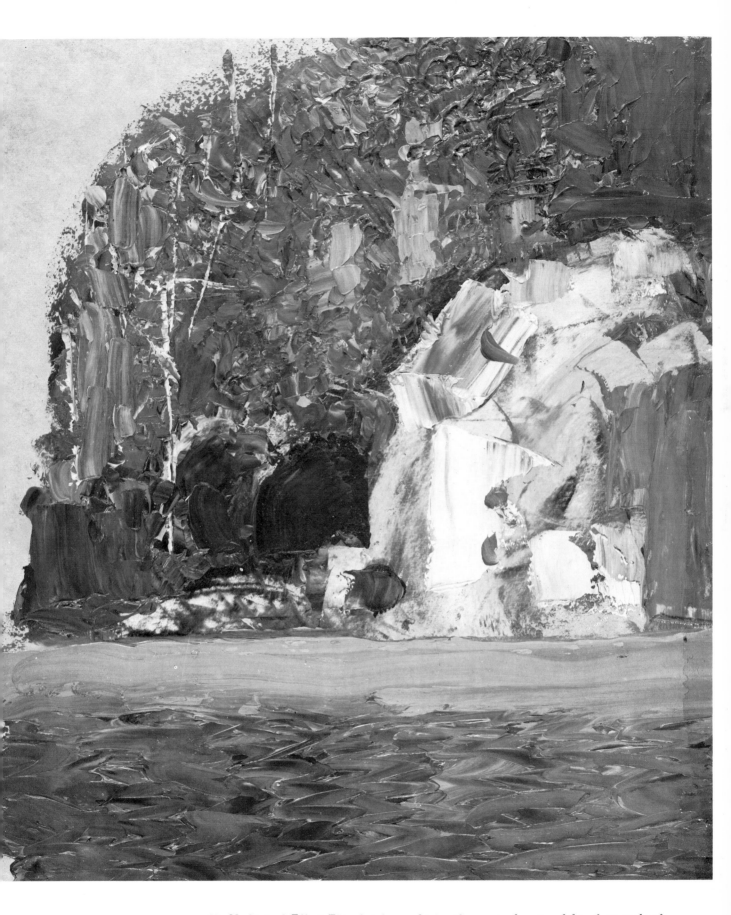

59. Marbleized Effect *This sketch, combining the sense of near and far, sharp and soft, will give some ideas of the possibilities of impasto knife painting.*

60. Acrylic Paint *This is black acrylic paint. Compare it with the black oil paint in Fig. 48. Do you notice any difference?*

61. Acrylic Paint and Water *Throw water over your acrylic paints and they come to life—acrylic is a water medium!*

discovered a lovely, gracious violet. Now try doing this with the acrylic pair. *Ugh!* What a result! You get a kind of faintish violet, a vile violet (pardon me), but these acrylic colors seem to hate each other so much they don't want to be seen on the same palette together. Try to force them to fuse and you get a little dingy mud. Now try mixing the gel with these obstinate colors. Any improvement in ease of handling fusion? In ability to spread out? I, for one, don't detect it.

At this point you may rebel and throw the acrylic tubes, and the gel, too, out the window. Don't. The acrylic molecule may be thumbing his big nose at us, but let's meet him on his own ground.

ACRYLIC WHITE

Work a little acrylic white into each color. This is *much* better; the dark tube pigments leap into fire, as bright and exciting as oil. But still, even now, they tend to keep to themselves. They don't want to spread, they don't want to fuse. Trying the gel with them helps very little; that gel doesn't seem to want to act like a medium at all. I confess I was very discouraged when I first reached this point. Why go further, I thought? Why not turn thumbs down on acrylics and go back to live happily ever after with the beautiful, easygoing oil medium?

ACRYLICS AND WATER

I remembered, just in time, a vital point about acrylics—they're a *water* medium. Water! Perhaps that was the answer! It was (Fig. 61). Take a big brush, dip it in plenty of water, and splash it over your piles of acrylics. Wow! The whole picture changes—beautiful colors flood out over the palette, they fuse together; you can work them in transparent washes, or introduce white, making beautiful airy scumbles. So water is the answer, I said to myself, but how is this related to painting with a knife?

Get some fresh tube acrylic on a clean palette, pick it up with your knife, work it around, and see what happens. You'll find it can be very easily applied, if you get it on before it begins to dry—acrylic retarder will help here—but the marbleized effects so charming in oil impasto just don't happen. Yet, as you go on experimenting, you'll find certain other compensations.

ACRYLIC KNIFEWORK

Acrylic knifework will give very sharp, crisp edges. The very fact that the colors don't want to fuse tends to lead to broad, simplified effects. And the fact that the colors dry so quickly means that you can very quickly relieve too flat a passage by applying a new color on top, producing exciting variations.

When I reached this point, I began to find a new painting concept rising in my mind. It wouldn't, probably, be one which would supersede, in my own affections, the marvelous workings of oil paint. I imagined I'd still feel (and I do) that oil is the best paint medium for the exclusive use of the knife painter. But I saw a striking new development coming, and I felt the need to get with it, to understand it. I could test it only by painting a new picture, by exploring all of its possibilities.

What I had in mind was a design composed of a patchwork of a few big areas, each of which could be laid in rapidly with thin acrylic wash, using water; as soon as these began to dry (it's a matter of minutes with acrylics), I would return to enrich the colors and textures with knifework, also using acrylics, this time right out of the tube. For a theme, thinking of big swinging areas, I blocked out a marine of a big wave in distant sunlight against a windy, dark gray sky, with a turbulence of rocks and swishing surf in the foreground. To begin with, I got a big brushload of that deep gray and started to whoosh it on, lifting up diagonally to the right.

Unexpectedly, again, when I thought I was going to lay a more or less flat gray, and that the life and excitement in this sky would come later when I came back with knife and heavier paint, I found that what I was putting on was nothing connected with oil painting as I had known it. This was *watercolor*, the classic effect one gets when working with lots of water on wet, heavily grained paper. But the grainy feeling seemed charged with the passing of wind; distant spume moved through the air. It was a happening.

The wave went the same way, and the surf below, sloshing over a partly submerged reef. For the rocks, I seized my knife and blocked them in with swift attack. This part at least was true painting knife work; if not with as many color changes and textures as in oil, at least with a sudden sharp broadness of its own. Ordinarily, in oil, I don't go for very thick painting contrasted with very thin stuff, all on the same canvas. But this was different, and I began to realize the difference was that I was painting in acrylic; the medium seems to hang together, whether thick or thin. The effect is somewhat flat, and since there's so much white and water, somewhat chalky. Maybe it's frothy and watery, but look at what I'm painting—foam and water. It's not the perfect system for me, but I think the dual melthod I've outlined—the big washes, the return with opaque strokes or scrapings—points to interesting developments, and so I've illustrated my acrylic marine painting in the demonstration on pp. 211-215 and in the color reproduction on p. 135.

WET KNIFE ACRYLIC TECHNIQUE

I was soon to find what I think is an even better way of combining acrylic knifework with water.

The idea that water unlocks the flexibility of acrylic, makes it live and fuse, impressed me very much. I was standing over a palette laid out with acrylic colors, holding my broad little knife, very shiny and clean. I saw a clean saucer. "Suppose there were clean water in that saucer?" I said. "Suppose I slipped my knife into it, shaking off the surplus, just leaving a skim? Suppose I picked off the tops of the acrylic piles—would the skin of water make the acrylics fuse, without destroying the impasto body too much? Here goes!"

So arrived my wet knife acrylic technique. Others, perhaps, have discovered this, but I didn't find it in a book. It works. For the first time in experimenting with acrylic impasto I got fusions, delicate lines, and hatchings; a degree, at least, of manipulation. It isn't, in my opinion, as fresh, free, thundering, and wonderful as oil paint, but it's more than darn good and some genius may come along who can fling the thunder into it. Meanwhile, I illustrate a little sketch of my brook (Fig. 62), in acrylic wet knife, to give you some idea of how it works. Try it—but don't overdo the water, or you'll lose the painting knife impasto so important in painting knife work.

To sum up the oil/acrylic debate: I think acrylic has certain advantages. It's nontoxic, as opposed to the poisonous nature of oil paint; it's easier to clean—as long as you don't let your brushes get dry; it's more flowing and breezy for certain subjects and tends toward broader effects. But oil paint is far more controllable, much more pleasant to use, and has a richer and more lustrous surface. Above all, oil paint pigments love each other and work into each other with a finesse apparently impossible to obtain with acrylic.

DRYING TIME OF OIL

Any comparison between oil and acrylic is bound to involve drying time. Oil dries slowly, on the theory that the average oil painter wants to keep working wet-on-wet for several days—certainly I do. I hate the idea of my picture starting to dry while I'm still working on it; I want to be able to come back to it the next day with a new blast of energy and be able to fuse new paint to old without the cracks showing. I'm always looking for a unity of feeling, and to get this I don't want to be pushed or hustled along by the paint. Oil will start drying after a few days, but it gives you enough time to spin your first enthusiasm over a wet-on-wet period. When the first stickiness or tackiness appears, of course, you must stop and wait until the surface is dry before you can go on. Paint over oil when it's tacky and your paint is very liable to crack.

DRYING TIME OF ACRYLIC

Acrylic, however, has great appeal for those who like fast drying—and apparently a great many peo-

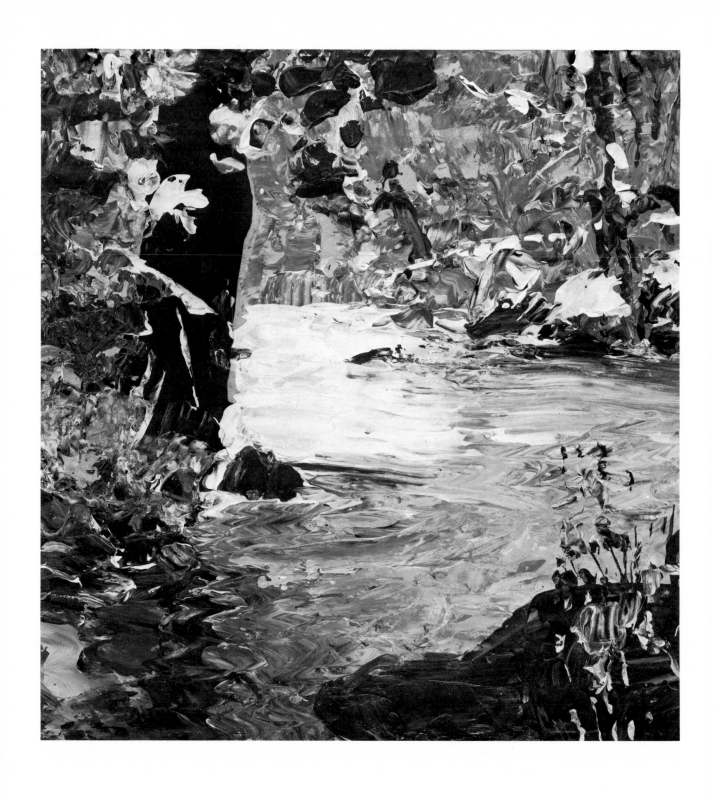

62. Acrylic Wet Knife Technique *Here's my little brook, painted in the acrylic wet knife technique.*

ple do. Pictures which dry at once don't mess up the car or house and are more practical to handle in a house without a studio. Also, many artists like being able to go back almost at once over a sketchy start with new overpaintings.

I feel there are many advantages to the knife painter in slow drying—but this is only my opinion. Your tempo and your temperament may be different. There's only one way to find the right medium for your individual need, and that is to try both oil and acrylic, to try them out *thoroughly* and then settle on the one which is most free and natural.

PAINTING MEDIUMS

We're scheduled to cover painting mediums in this chapter—I mean the liquid ones one is supposed by custom to mix into one's paint. It's easy to dispose of this subject in regard to the heavy impasto oil knifework this book is about. The best painting medium for this is no medium at all.

The point here is that the paint as mixed in the tube has been perfectly balanced by the manufacturer; it has just the right amount of inert additive and of linseed oil. It comes out stiff enough, fluid enough, richly colored enough. My technique is based entirely on the idea of using this magnificent material in the form in which God and the paint manufacturers have deigned to present for our enjoyment.

OIL MEDIUMS

While paint straight from the tube is much the best for the knife painter, there are two fluid accessories to oil paint you'll need to have around for special purposes. One is *turpentine*—get the best artists' kind, not the cheap bulk stuff. Turpentine is an all-purpose solvent for oils; give your brushes a first wash with it after painting; use it to wipe paint spots from clothing. It's also extremely valuable in making thin, colored washes over which to paint in oil impasto—use a big square-tipped bristle brush for this. A point here is that an entire turpentine wash will dry almost immediately.

Another useful oil accessory is *painting medium*, generally 1/3 linseed oil, 1/3 varnish, and 1/3 turpentine. For reasons already given, I don't recommend that this be mixed with the paint—it will destroy the impasto—but there are times when a little glazing or scumbling may be done, say over a bit of too-harsh color, without loss of paint character.

ACRYLIC MEDIUMS

As to acrylic mediums, I've shown that water works the best for me. The acrylic white is wonderful for bringing paint colors to life, but it lightens them, and so can hardly act as a medium in the darker range. An interesting acrylic accessory is the *modeling paste*, prepared with marble dust to give

thickness and impasto quality. It can be built up into a very heavy impasto and the colors can be mixed into it—that is, simply, flatly. But this paste has several drawbacks, as I see it. It tends to crack if piled up too heavily, does not encourage color fusions, and tends to produce too soft or rounded edges. The best way to use it is to mix it 1/3 acrylic gloss medium to 2/3 modeling paste. This mixture will check cracking and give a sharper impasto edge. However, I don't find this comparable to oil impasto—it lightens the colors too much, resists color fusions, and dries much too fast for my money.

Several other mediums are provided by the acrylic manufacturers. One of these, *acrylic gel*, we've already encountered (see p. 64). There is also a *gloss medium* and a *matte medium*. One can mix colors with these, but I don't find they make the colors more workable; they simply make them dry either shiny or flat. Later, we'll consider these two mediums used as varnishes.

OIL VARNISHES

Varnishes are important and deserve careful consideration. Let's take oil varnishes first—acrylics have different varnishing problems. Please distinguish sharply between the two different kinds of oil varnish: one kind comes in a spray can or bottle and is labeled *retouch varnish*; the other is simply labeled *varnish*. This is much more important than many artists, especially many beginners, realize. These two varnishes, even if similar in makeup, are used at different stages in a picture's career (Fig. 63). Both these varnishes are made of the resin called *damar*. But in the retouch, the varnish will be cut down by a volatile ingredient, so it will soon evaporate, whereas in regular varnish, the mix is much heavier, so it's there to stay.

When an oil picture is first painted, on the average slightly absorbent ground, the colors are all glossy and give the depth and brilliance desired by the artist. After a few days, however, most oil paintings will begin to sink in to some degree, that is, they'll develop dull spots. The very dark areas, especially, will become lighter and grayer; the gloss will almost disappear. Not only will this dull the picture, but it will disturb its fundamental relationships. You may get disgusted with a perfectly good painting if you fail to understand this. Look slantwise across the painting; it should show a gloss. If there are dead, sunken-in spots, it's time to go to work with retouch varnish.

If sprayed lightly over the picture a few days after painting, the dull spots will get their gloss back; the whole thing will have that fresh, exciting look again. But don't overdo it. Look on the can to see how far away you should stand while spraying, and don't get closer—that way lies catastrophe.

What about regular varnish? It's too heavy to use on those dull spots; save it until the picture is absolutely dry—in the case of impasto, about a

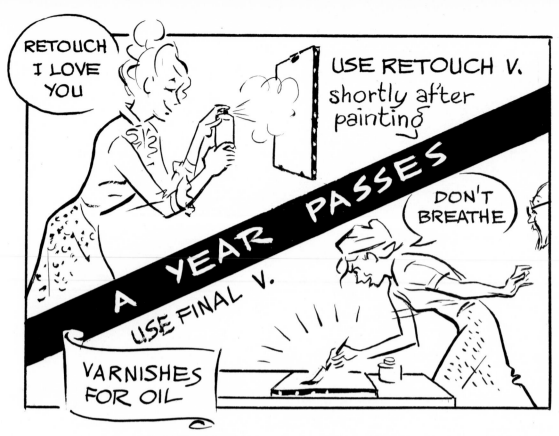

63. Oil Varnishes *I love retouch varnish too. It makes it so easy to bring dead spots on the canvas back to life.*

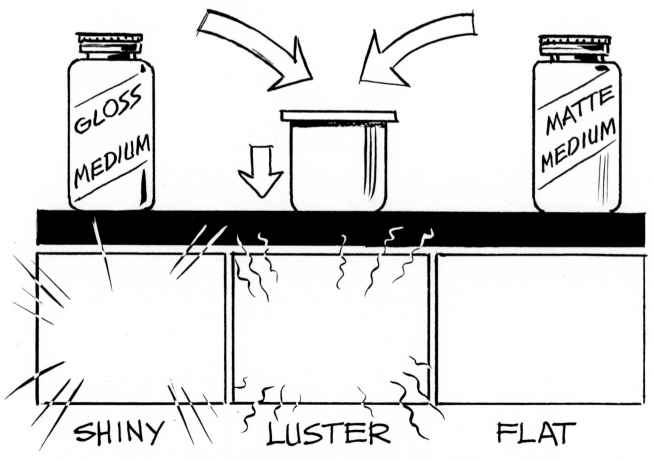

64. Acrylic Varnishes *These are nice because they enable you to balance your painting so easily between a high gloss and a matte finish.*

year. I suggest a very thin layer of damar, cut 50% with turpentine, which will give luster rather than a cheap, hard shine. Spread it on carefully with a very clean brush in a dust-free room, and on a dry day if possible. Varnished pictures will take several days to dry; be careful that dust does not settle on them in the meantime.

ACRYLIC VARNISHES

When we come to consider acrylic varnishes, we're gazing at a more pleasant picture than that represented by the paints themselves. Acrylic varnishes are remarkably good and very easy to handle. The two kinds are identical with the two mediums already mentioned: gloss medium and matte medium. Mixed in the paint, these are mediums; spread over the paint after it's dry, they're varnishes. Both are very transparent. If they don't mix well with the color as mediums, they spread over it very easily as varnishes, bringing back the first richness of the color. What I like particularly is that you may choose your own degree of shine; either very shiny (gloss) or dull (matte). You can mix them together to get an in-between luster, thus bringing the acrylic surface much closer to the luster of oil paint (see Fig. 64).

Personally, I have a feeling that acrylic should not be too heavily varnished, since, after all, it's a water medium. There is an airiness which may be lost if too much varnish is used.

TEXTURING WITH SAND

Both oil and acrylic lend themselves to experimentation. I've often used sand in painting. I sprinkle fine sand around on a panel with a wet gesso ground, swirling the gesso to obtain striking textures. Although it's difficult to do, I've sometimes worked over such a ground with heavy impasto oil, using a painting knife. The self-portrait reproduced in Fig. 65 was done this way, and I think it's one of my best texture effects. It takes heat and fury to make the paint pile up that way!

SAVING PAINT

What's the best way to save paint for the artist who's working in paint-devouring impasto? First, in both oil and acrylic, keep screwing on the tube lids after using. This is especially important when using acrylic, which dries so very fast. You should have a porcelain palette with wells and put your pigments out in the wells, covering them with damp rags which you keep wet while working. You can save what's left over by covering it with plastic sheeting or spraying water over the whole works. Metal cookie tins can be used in the same way.

CLEANING BRUSHES

When using acrylic, be sure to have a good-size tin full of water, and get in the habit of dunking your brushes and knives as you paint—you'll have the devil to pay if those brushes get hard. If your oil brushes get hard, soak them in one of the new heavy-duty cleaners one can get in the supermarket. But it's much better to respect them enough to dunk them in turpentine after using, finishing with a mild soap and lukewarm water. This should be a fine moment in an artist's day, especially if he's looking at a sparkling new picture as he cleans up.

CARING FOR YOUR PAINTINGS

First, a point about yellowing. Impasto oil paintings will lose some of their freshness with time; it's also true that if impasto whites are too evenly smoothed out with the knife, yellowing may come to the surface. But the various paint vibrations we'll mention in this book help prevent yellowing.

Another relevant point: a newly-painted picture should have a period of soaking in daylight. Turned to the wall too long, it may go dull; but get it in the light for awhile and it will usually brighten up again.

A lot of the darkening seen in oil paintings is due to plain dirt and old varnish. Fortunately, both can be removed; check any book on restoration. Preserving impasto oil paintings under plastic sheeting to keep out dust is a fine idea—another modern technical discovery, like the mixing of modern tube paint, which can be of real assistance.

65. Sandy Self-Portrait *In a moment of exhilaration, the author blasted out this self-portrait on top of a heavy sand ground.*

Sun Brook *(Right), 25" x 30". Courtesy Grand Central Art Galleries, New York. This was done on one of those hot July days when the painter lugs his apparatus into the darkest and coolest-looking patch of shade down by the brook. I was painting with my easel's feet in the water, and my own, too. As I wibbled and wobbled the water coming toward me, always turning darker, I thought to myself: what a sumptuous thing to be doing, to be in the shade on a hot day, with the brook entertaining me with musical gurglings!*

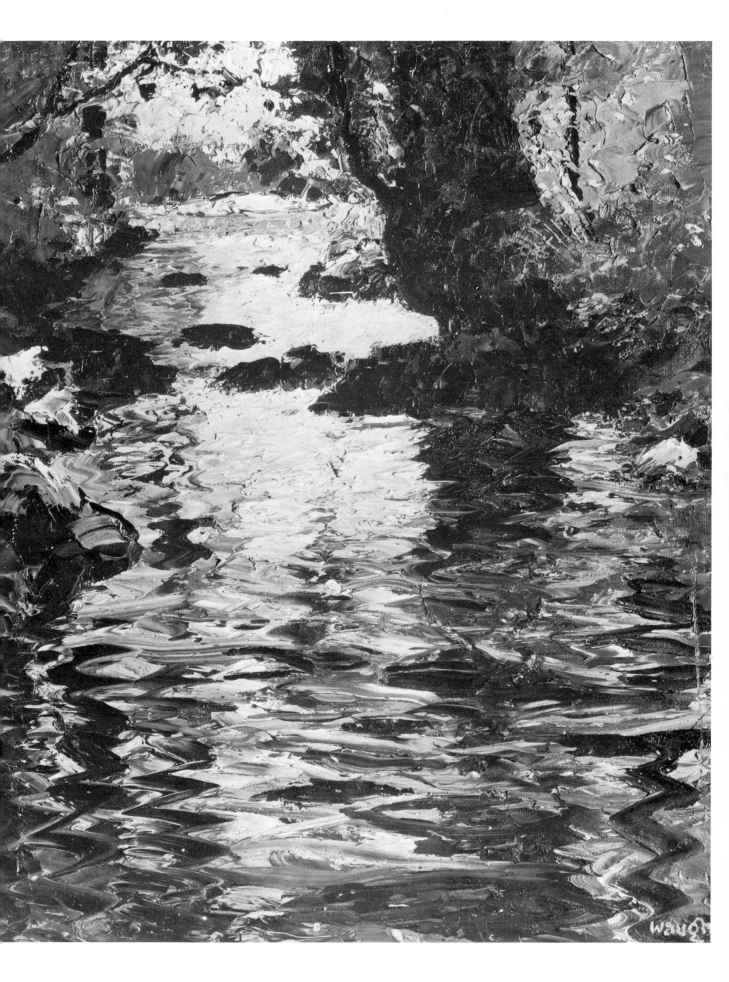

From the Fields, 22" x 26". Collection Mr. and Mrs. Robert Burwick. What splendor from such simple things! I underpainted this picture in thin but deep turpentine wash tones, then flung on extremely heavy paint, trying to match the textural vibrance of the wild flowers. The ball thistles are a fine example of turning your wrist as you pounce the edge of the knife up and down.

5
USING
THE PAINTING
KNIFE

In this chapter and the next I'll analyze and diagram the painting knife techniques which I think are the most vital and valuable ones, and I'll squeeze the neck of each one trying to make it deliver up its secret. I hope that the pictures and text will make these findings clear—I invite you to sit down with knife and paint, to test them out one by one. This will mean effort on your part, but my ambition is that you'll be rewarded in the following three ways.

First, I believe you'll be able, with only a little practice, by working directly from this book, to produce the effects I show. Second, I hope you'll be stimulated to experiment further in the field of each effect—to get that wonderful surge of excitement when you take some bit of knowledge and improve upon it, add to it, make it serve your own personal expression. Third, I have faith that the foundation approaches we investigate here will enrich your power in the making of actual pictures, and that's what we'll be doing a couple of chapters ahead.

PAINTING SETUP FOR EXERCISES

I illustrate a suggested painting setup in Fig. 66. To work on the first stroke exercises, you'll be more comfortable sitting at a table, with a drawing board on your lap. For exercises swinging your arm, stand up, with the work flat on the table below. As you start with things like still lifes, stand up and work at the easel; this is the final method which broad knife painting calls for, so you should get used to it. One can walk back easily and naturally to see how the work carries, another thing you should get used to. The sketch shows this book propped away from the palette; it would be good, too, to wrap a bit of cellophane around it—I wouldn't want it to get smeared up, after all the trouble I've gone to writing it!

CLEANING GEL

One *must* keep hands clean in such an operation— the secret is that can of cleaning gel on the table, with paint rag nearby.

66. Painting Setup *You have three basic choices in your painting setup: you can sit at a table, you can stand at a table, or you can stand at an easel.*

67. Values *As you can see, a lot of color can be suggested with only black and white.*

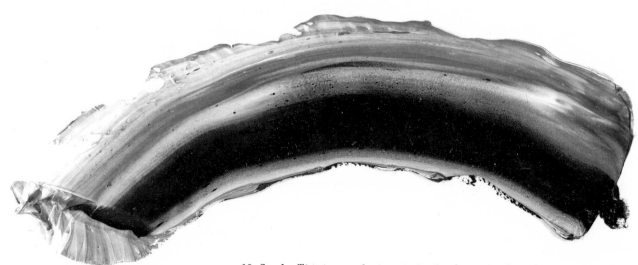

68. Stroke *This is your basic painting knife stroke, full of power and thrust.*

PALETTE

A wooden palette is better than a paper one for this purpose, for the paper ones develop unprintably bad rolls and ripples. To work well with a knife, paint must be flexible, as it is when fresh from the tube; if it gets stiff, work in a little linseed oil or painting medium (1/3 linseed oil, 1/3 varnish, 1/3 turpentine). If you want to save paint overnight, better keep it under water.

WORKING IN GRAYS

If your mixes get muddied, don't throw them away, save them on one side of the palette—you can use them for making various grays, since in these two chapters we'll be working in a range of values, black, gray, and white. Strong, decided values can have great beauty in themselves; they give power, force, punch to oil painting, and the painting knife is highly adapted to putting out force and punch. You'll want punch in color, too, and your color work will be stronger for a value experience. So, I think you'd be wise to string along with me on the black and white thing, with the myriad grays which can be added (see Fig. 67).

But I'm a color man, and I can understand if you feel the itch to render my illustrations in color. Go to it! But do them in black and white first; you'll be getting two rich experiences instead of one.

GROUNDS

What grounds should you use? The perfect ground is a small canvas panel, size 9" x 12", such as you can get in an art store or sometimes in supermarkets. I suggest you use these for final versions of the effects, the ones you'd like to keep. For practice, use sheets of opaque typewriter paper, held down on a board with masking tape; blow a little spray retouch varnish over this paper and it will take the oil very well.

PAINTING KNIVES

As to knives, I'd like, if possible, for you to try these exercises with at least three types: a Long John, a Magic knife, and an Arrowhead. Try out any other knives you have to see how they work. Be sure to remember to clean your knives with a rag between effects—make them shine like slivers of silver!

THE PAINTING KNIFE STROKE

If the ability to produce pure, exhilarating color is the richest gift the painting knife brings to us painters, the power and life of what I like to call *stroke* is not far behind (Fig. 68). The painter's feeling blazes and jets; his knife can catch it at its

heat and get it quickly down through stroke. My way of painting is based, first, on the modeling and building power of broad strokes which create the sense of mass right away; and second, on the light, free, flickering, smaller touches of the knife as it returns over the broad masses to arrive at finish and detail by impressionistic suggestion. I think stroke leads toward all the other painting knife effects, so it makes sense to start a study of these effects with the ancestral one from which the others sprang.

Stroke is a bold, courageous thing. You have to take yourself by the neck and jump in the pool. A newcomer to knife painting is likely to view the tool at first with a kind of suspicion—he has no idea what's going to happen. He dabs the tip of the knife gently, very gently, in a minute squeeze of pigment and then suddenly dashes it point down toward the canvas, jerking it instantly away as if it had been his finger on a hot stove. He seems baffled to find only a little grimy smear on the spot he touched. What's wrong? Everything. We must learn from this.

MIXING YOUR PAINT

Please squeeze two good-size piles of black and white onto your palette. Take about half from each and mix them together to make a deep, rich gray (Fig. 69). Important note: don't grind these colors remorselessly down until they're a flat, dead gray, like housepaint. We're not housepainters, nor are we in the business of manufacturing lifeless surfaces, like plastic. We want our surfaces to have a breatheable quality, and this means we prize a certain fluctuation, a certain looseness and vibrancy; indeed, we use oil color precisely because its impasto quality is so well suited to produce such vibrancy. So, stop mixing at a point before the parent pigments have merged into a flat, stillborn gray.

MAKING A STROKE

Now, check the illustration in Fig. 70. In Example 1, the gray is mixed and the knife (previously cleaned) is moving over the pile with its outer right side tight to the palette. Now turn the knife over and look at it (Example 2). A neat, thick roll of paint will be lying on the underpart, coming exactly to what is now the outer left edge of the knife blade. In Example 3, the knife is reversed again and the charged edge is laid down tightly on the canvas; the other edge, the one toward you, is slightly lifted. Now! Lock your wrist, and using a bold, sharp arm movement, move down and across (Example 4). As you do this, keep the knife clinging to the canvas and gradually lower the edge toward you until the knife is lying flat. When you've moved about 1½", lift abruptly, so you'll get as clean a lower edge as possible. You should have a

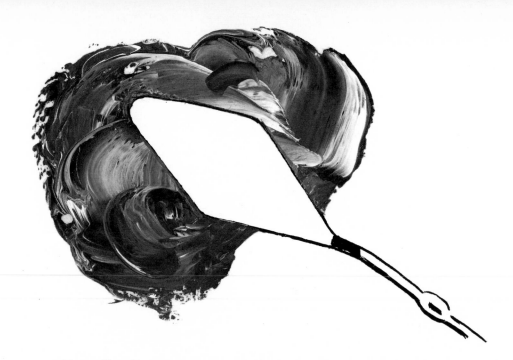

69. Mixing Your Paint *Using a clean knife, pick the colors you want from squeezed piles. Lay them down together, and mix by rotating a flat knife over them.*

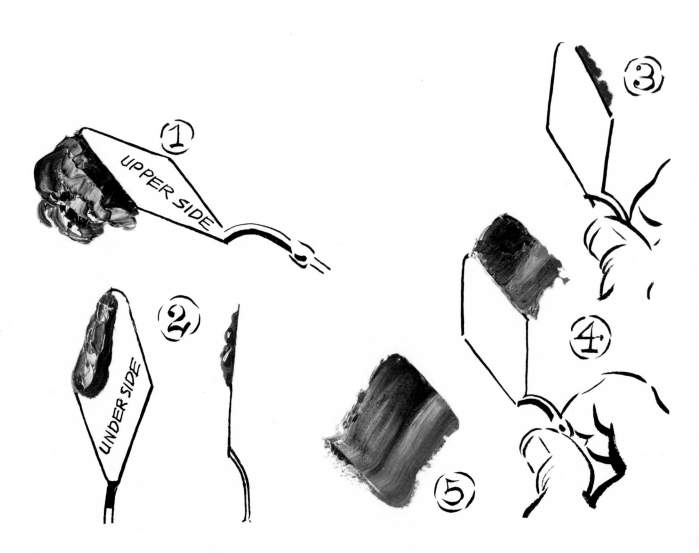

70. Making a Stroke *This may take a bit of practice, but stay with it.*

fine knifestroke of pigment lying there, something with style and character (Example 5).

I've described this stroke in detail because I'd like you to try it right now, and keep at it until you get a clear-cut result. This may take a number of trials, but if you check every step you'll get the knack of it soon enough. Remember, don't just put the point down; keep the knife flat on the canvas as it moves, and get the idea of a continuous, clinging contact—like buttering bread. Try this stroke with a lighter gray, with black, with pure white. Get into the habit of wiping the knife between chargings.

You may wonder why I pick up a thick ribbon of paint on only one edge of the underside of my knife. Why not on both edges? Why not cover the bottom completely? Later on, we'll work with both of these last two situations; but first, I want you to get the concept of the stroke by itself. It's much easier to control the squareness of the stroke, to give it a sense of movement, using one charged side. It may be only a blob of paint, but there's a certain *drawing* element involved; you're making that stroke go somewhere, say something. Strokes used like this aren't simple decorations or textures; they're the part of the knife technique which implies purpose.

RETOUCHING THE KNIFESTROKE

Should one retouch the stroke after making it? There may be missed places, large gaps. A few of these don't matter; indeed, when you come to making color strokes, one over the over, you may find that looseness in the individual stroke will result in enrichment of the total color effect. Too large a gap may be caused by either not enough pigment or not close enough contact. I think that a stroke, once having been made, is itself a new creation. It's difficult to retouch a newborn baby—moving the ear a bit, for example—without losing the baby; it's difficult to retouch a newborn stroke without losing its freshness, which is often the same as its life. If you're dissatisfied with some stroke, lay a whole bold new one on top—something possible when working with the knife, which glories in wet-on-wet. I've done this many times, often noticing how the new strokes are enriched through vibrating with those lying underneath.

LARGE KNIFESTROKE

Although big and strong-looking, you may be thinking, these were only 1½" strokes—how long could they be stretched out? Load your knife more heavily; try it. You'll find such strokes as those in Fig. 71 quite easy to produce. With still more pigment and a big knife like Big Talk, they can be stretched to 6" or more. But the average large stroke you'll be using is hardly liable to be longer than 3"—this seems about right for the natural

movement of the hand. Beyond that, one moves to other strokes, often changing the direction.

BLOCKS OF PIGMENT

A powerful, useful brother of the rectangular knifestroke is the smaller *block*. As Fig. 72 shows, it's made in the same way as the longer stroke, but the knife is lifted from the surface sooner, resulting in a square of pigment. These blocks suggest stonework and give a feeling of strength, of something which can be used to build with, and that's just how to use them. I often enliven flat vertical areas with blocks of texture and color. Not only do blocks suggest something solid, but they can blaze out with gleaming notes of color—portions of strong color which will act by themselves and take their part in a whole canvas as well. I use them a great deal for rugged outdoor effects; they make rock chunks in rocky sea paintings and rough bark in trees. Wherever they are, they create texture and strength. Look for blocks in the various illustrations in this book. And practice doing them. Fig. 73 shows various richly marbled effects and the different chargings of the knifeblade used to produce them; Fig. 74 shows smaller blocks produced by the smallest of our painting knives. Even if blocks, in themselves, don't move, I think of them as stepping stones over a brook—the eye jumps from one to the other. Remember the value of blocks when we come to our study of color.

You'll have noticed these were straight lines we've been working with and may be wondering if a painting knife works as well with other kinds of lines. Yes, it does; but there's a special reason why I'd like to stay with straight lines a bit longer. "Straight lines," said Gaugin, "are infinite." Streak a long straight line across your canvas and you create the horizon, the edge of the earth; you're defining something about our planet (Fig. 75). Reach up with a straight line and you're indeed pointing at the infinite. I often think that the power, the importance, of these types of long straight lines is that they create the backdrop for our adventures in life, which might be more appropriately symbolized by zigzags and spirals.

Whatever the symbolism, the painting knife seems to love to move by sharp, straight lines, and I'd like you to practice these strokes. Also, learn to change the direction of your wrist continually while painting. Try hitting in from another side, another angle. I'd like to have you remember, too, that oil paint is an extremely gooey medium and you're liable to find yourself, quite suddenly, in the soup; if this happens, remember what we say here. Put a few big, bold, clean straight strokes of some exciting clear color across that soup (you can do this because of the way the painting knife works wet-on-wet) and they'll probably straighten you out—wipe the bright blue off your nose, and you'll be in business again!

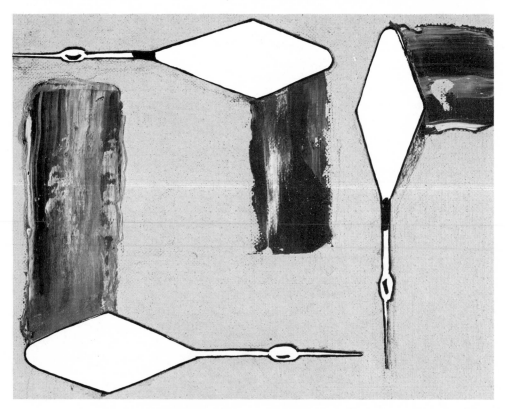

71. Large Knifestrokes *Use more paint, more arm movement, and you'll get a longer stroke—it's as simple as that. Try strokes going up, down, and across.*

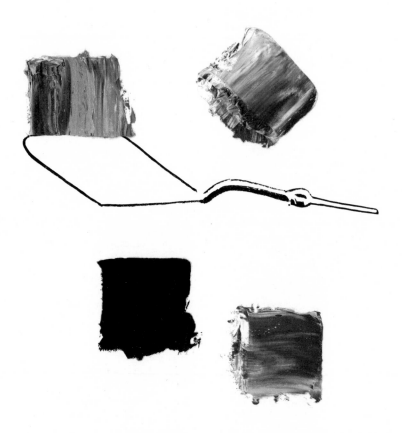

72. Blocks of Pigment *Charge one underedge of the knife. Lay it down. Pull it across. Lift it up when you've made a square. Think of these blocks of pigment as beautiful tiles.*

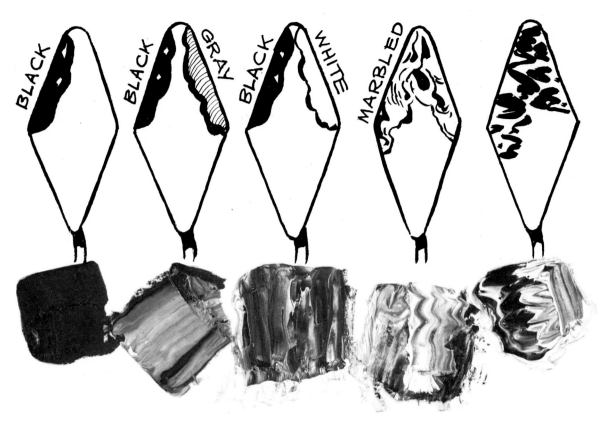

73. Color Blocks *I hope this illustration will suggest the infinite number of effects made possible by charging a knife with several tones of color.*

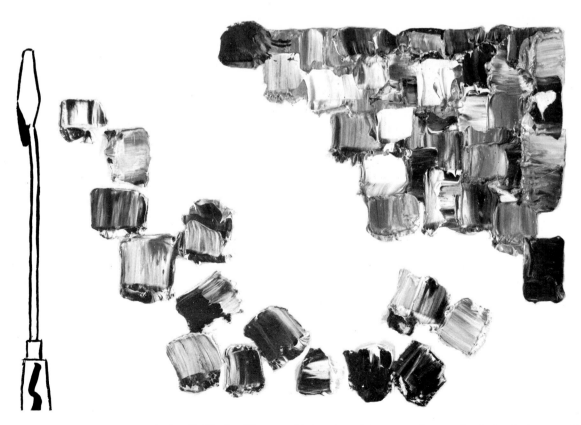

74. Small Blocks *Who would imagine this most minute of painting knives could make blocks of such power?*

75. Straight Lines *First with a square-tipped brush, then with a painting knife, make a number of straight line experiments. You'll be able to sense the power inherent in straight line forms.*

WET-ON-WET

I want to use the straight line stroke still one more time: to demonstrate that proud specialty of the painting knife, working wet-on-wet. Please use a canvas board for this experiment; you may want to date it and keep it for reference. Notice the gray undertone in Fig. 76. It's an attractive way of establishing a wet underlayer over which you may work with heavier paint. Consistent with our general desire to maintain a paint surface, an impasto, this was done without diluting the pigment. I used various leftover bits from white, gray, and black piles and spread them broadly without too much mixing, then turned the knife blade sideways and scraped off the paint, left to right. Large areas can be treated like this; sometimes this method can be used for underlying color effects. In the present case, after putting on the other strokes, I found the underlayer a bit flat, so I returned and thickened it up at the end.

Now lay a strong stroke of darker gray over this ground. You're painting wet-on-wet; you'll find the knife will slide easily if you use a quick, light stroke and don't grind it in too much. Clean the knife, charge it with pure black, and make a bold stroke across, lapping over both the lighter ground gray and the darker stroke gray. This will probably be easy—but there's something more difficult to come. Clean the knife *very* carefully; the trick won't work if there's the slightest trace of dark.

Ready? Pick up a bar of the purest white with this shining, utterly clean knife; take a breath and bring it lightly but boldly down, right across all those wet, wet, dark darks. If you have a gleaming, pure white slab lying there, give yourself an "A." You'll have taken a most important step in knife painting.

Knife painters use the feature of one wet note of color lying on top of another wet note, without the two fusing, all the time; we regard this as the holy of holies of our craft. It will work most wonderfully with color—for here we can lay some brilliant color, say a touch of cadmium red light, right on top of the exact complementary, the color most removed from it, in this case a vivid, pool-table green.

Of course, you may not have marked yourself "A." In place of this gleaming white slab, your slab may be drab, pockmarked with gray or black. If so, don't lose heart. This stunt is really a difficult one. Like all difficult things, it deserves practice. Please practice this a lot. If you failed, it was probably for one of these reasons: (1) knife not *absolutely* clean; (2) white pile not entirely fresh; (3) digging down with the knife; (4) too slow, heavy, indecisive a stroke. Clean painting like this is an act of command. You must tell the paint to behave. If it won't behave, try again. Master it.

When you've got a good result, pick up your panel and twist it around in the light. I want you to notice the physical gleam of the paint, the special

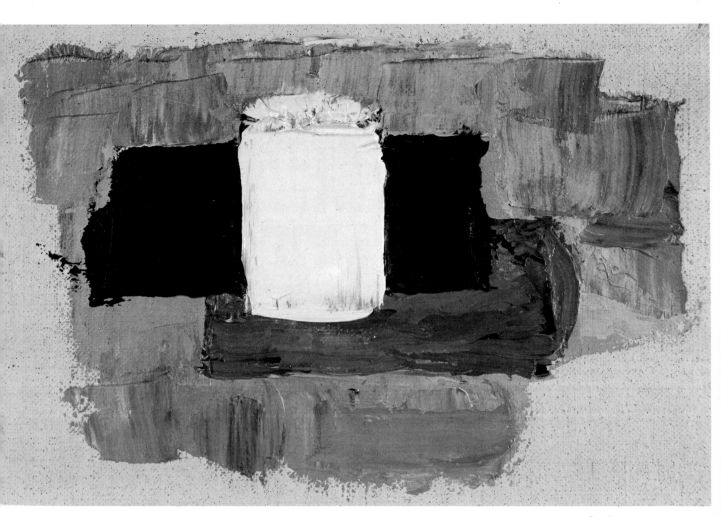

76. Wet-on-Wet *Check the text for the method of laying various notes of color or tones on top of one another while still wet. It's a neat trick, and extremely useful.*

linseed oil luster. One of the reasons for using such big strong strokes is that they display this luster particularly well. I like to think of your pictures as surfaced with such richness and charm.

At this point, we're going to free you from the tyranny of lines going straight up or straight across. As I noted before, these set the stage, but they're not the actors, and they're not *life*.

DOT-PATTERNS

The illustration in Fig. 77 presents two dot patterns—the same dots, but arranged so as to seem totally dissimilar in character. Study Dot Pattern 1. How formal, rigid, it is! This is because the glance from dot to dot works either up or across—we're in the world of the stage set. Then look at Dot Pattern 2. This is life; this is the actor coming to dance before the stage set. It's the shouting of happy children—our glance jumps diagonally, this way, that way; it's the action common to all people as they move, using the back and forth, diagonal, zigzag rhythms of the body; it's the heartbeat, the pulsations of poetry, of music, of the dance, something above all devoted to expressing joy in living. This is what knife painting is about.

What's that? Do I hear drums? It's just the next illustration coming up (Fig. 78). Its simple, joyous message is the zigzag, back and forth movement in Dot Pattern 2. This movement implies a joyous state of mind, an extremely good state of mind to be in when you're painting. There's an endless number of ways to express this happy rhythm with a painting knife. Try our dancing stroke and then cut loose—any size, tone, shape—only make them all *dance* together!

As we begin to open up the vein of freedom which is implied in this rhythmic, jigger-jagger approach, we'll come to certain other important painting knife procedures which call for understanding and exercise. One is the bending of straight lines into curved ones; another is the reduction of the width of the stroke until it finally becomes *line*. Let's take up the curving stroke first.

USING YOUR ARM

Nature has been very kind to us painting knife artists. We're equipped with extremely effective built-in compasses in our shoulders, elbows, and wrists which enable us to swing such a tool as a painting knife in free but very convincing half-circles. Lock your wrist and elbow and swing your arm in a circle from the shoulder. Do you see what a natural, easy movement this is? With my size arm, this gives me a half circle about 20" in diameter. If I now swing just from the elbow, I get a smaller, 16" half-circle. A swing just from the wrist gives me a 5" half-circle. Please try these three swings on your arms; they may be a bit different from mine, but they'll be the natural way your arm wants to work. You'd be very wise to build these

three swings into your painting—they'll bring ease and conviction to your work.

CURVING STROKES

Fig. 79 shows a quarter-circle wrist swing from my particular hand. Please try this. Since the stroke is quite long, more pigment should be picked up by the knife blade. I charged my knife with black toward the tip and then with a medium gray, and I didn't touch up the missing parts of the black, because I like the decorative effect.

To the left of the hand in the curve illustration is a fascinating little twiddle which looks like a snail shell or a bit of soft moss upside down. You do this with the wide-bladed Magic knife (or something similar) and the secret, after generous charging, is to put the knife down on the canvas from the top, allowing its spring to flatten out the outer part when it's spun around with a circular wrist movement. Try to keep the tip in its original place—the knife rotates around the tip. Again, please try this. Do a lot of these cute little snail shells; get the easy looseness of it into your hand.

I use these circular strokes a great deal. Since I love to paint in shadowy, mossy woods, these strokes give me a way to approach the character of the richly molded forest floor, or of the lumps of vegetation which spring from between cracks of ledges decorated with lichen patterns, touching or dotting them afterward to suggest the beautiful lichen texture. Here, in painting the woods, the straight strokes used in tree forms complement, or contrast with, the soft rounded ones of the forest floor below them. You'll find such contrast of strokes of the greatest value.

THE FLUTTER EFFECT

Our experiments with zigzag and curved line approaches will bring us now to a characteristic and specialized effect. We come to the point where we turn our knives free, allowing them to flutter the paint on lightly, as if from far up in the air. We're like circus performers: some of us have done our acts on the heavy ground, whereas others—painting knife painters who have come to this point—are about to climb and start swinging far above. I've symbolized this idea in the free sketch of a swinging monkey in Fig. 80.

The mission I've given my monkey is to carry on the feeling of Dot Pattern 2 even further than did the dancing boys. The strokes under the boys are still definite, straight. But the monkey's world is one of dissolving rigidities. Everything is beginning to rip around. Yet the world of this sketch is not really out of control; it's controlled by the natural limits of the painter's wrist—if it goes the limit one way, it tends to swing back to the other side.

This is an interesting thought. It suggests that the wrist may be depended upon to create light, swinging patterns of its own. I speak of such wrist

77. Dot Patterns *Dot Pattern 1 implies straight lines, up or across. These are strong, but tend to look rigid. Dot Pattern 2 is full of action, fluidity, life!*

78. Zigzag *The dancing boys, Jig and Jag, are telling us that life has a back and forth movement, the same way the heavy strokes of paint are going. They're right!*

patterns as the *flutter*, because they suggest the light fluttering movement of a butterfly. The flutter is extremely useful to us knife painters. Here's the way to go about experimenting with it (Fig. 81).

Put a canvas panel or other rigid surface on your easel—paper palettes are no good for this, as the surface is too rippled. The flutter works best when the painter is standing; also, it works much more easily on a wet surface than on a dry one. Mix a medium gray and spread a flat, good-size area of t on your surface. Then mix two other tones, a dark gray and an off-white. Pick up some of the dark; wring your wrist to loosen it up. Hold it above the toned part of your panel and move it lightly down, fluttering as you go, letting your arm and wrist move in different directions; don't dig in and don't guide the knife—let your wrist movement make the shapes. Then clean the knife and do the same thing with the white. The real fun is going to come when you try this with color.

HEAVY FLUTTER

I illustrate a heavier kind of flutter in Fig. 82, piling the paint up, tossing and whirling it around in all directions. This may look like a haphazard way of painting, but actually it *is* under control. It's got a swing and rhythm because the wrist is doing it. I use heavy textures like this a great deal; they give marvelous color depth and suggestiveness; you can tip them into nature with the slightest suggestive hint here and there, or you can simply enjoy them as rich texture and color. These fluttering strokes are narrower than the broad ones we started with. It's time to look at the really narrow knifestrokes and see how to make them and use them in the composition. I speak of these as *stripes*.

STRIPES

Stripes lay ribbons of pigment of different widths, all tending to elongate. Most are made in a different manner from the stroke, being fed out from the tip of the knife as it's drawn backward. As stripes become narrower, they change into another extremely useful knife effect, into *line*; but this, in its narrower widths, cannot be fed out from the end of the knife; it's produced in another way, from the sharp straight edge of the painting knife. We'll come to this a little later; right now, let's consider *stripe*.

LOOSE STRIPES

Fig. 83 displays stripes from some of the knives we've been talking about. In Example 1, the stripes were made with one of my favorite knives, loose, floppy Long John. Notice the ragged-looking tree-trunk to the extreme left. This was done by charg-

79. Curving Strokes *Flip your knife back and forth, but do it with a curving movement. It's all in the wrist; elbow and arm work together.*

80. Monkey Around *Here's Dot Pattern 2 in action—our swinging gibbon goes looping through the jungle in graceful half-circles.*

81. The Flutter Stroke *I call this the flutter because it suggests a butterfly's flight. The looser your wrist, the better.*

82. Heavy Flutter *These are extremely heavy wrist movements. The paint is heavily piled on the full underside of the blade with several colors or tones. This gives me thick texture—I use it frequently because I love its heady, all-out effect.*

ing both of Long John's underedges with variegated tones, and, after laying one edge down tight, snapping it across about ½"; then I moved the knife up and made another crossstroke, continuing in this way to lay a broad stripe which has fascinating treetrunk textures. I love to use this effect for weathered timbers, pilings, and so on. But Long John's more natural stripe is shown to the right, above the number. These soft stripes are fed out from the tip, the long way, with the blade richly charged along its length. This is a kind of sketching stripe. Like all the painting knife stripes, it's a bit unpredictable and lacking in clear-cut definition; think of it as many stripes which build toward a total effect in an impressionistic way. Besides the stripes, one can pat or dot the paint on from Long John's tip; I've used it this way a number of times in the realistic sketches in the next chapter. This knife works best if charged across the full underblade, but not too far up—use the more flexible two inches from the tip. Such stripes are made with a less jerky movement than the strokes; one uses a slower, more clinging contact. Remember Long John when you want distant effects.

TIGHT STRIPES

The stripe in Example 2 was done with the Arrowhead knife. It makes perhaps the neatest stripe among all the knives. Charge it generously across the blade, and draw it down so the paint comes from the tip. The stripes in Example 3 were made with a Magic knife. This knife fails to perform well with a long stripe; its blade is too short. The stripes here were done across, like Long John's treetrunk. What this knife can really do is manipulate shorter stripes drawn away from the end, perhaps 2" long. Used this way, the knife works in innumerable ways, suggesting wonderful detail. Like the other knives, the Magic knife really is magic when it's used for what I call *dry stripe*; stripe motions with a perfectly dry and extremely clean underblade. Used in this way, a knife can erase one's faults, fuse colors, and quiet down overly harsh edges.

With all that I've said, we've got to admit that knife stripes are uncertain and undependable. There may well be times when you feel the need for a ribbon of paint which will act more under your control. For this, I make stripes with a little square-tipped brush—it can pick up an impasto which will fit in with the effect of knife painting. Be sure, however, not to overdo brushwork. And keep these brushstrokes loose. Make them snap!

SPARKLE

Now we come to something fascinating, something I'm sure you'll enjoy, for it will lead you to the production of striking and unusual painting knife effects; and, almost better, it will take you outdoors to search the edges of fields and brooks to find new inspiration for using them. This is the exploitation of the striking potential of painting knives to create the most delicate paint lines, tiny provocative lines which can crackle with a kind of saucy spark all their own. It's my belief that these are the most delicate lines possible in oil paint; it's the straight, steel edge of the painting knife which alone can realize them.

Which of your knives has the longest, straightest edge? Say you have one resembling the slender, graceful Arrowhead. A number of most interesting edge effects can be produced with such a knife, two of which are shown in Fig. 84. To the left is a very modern effect, decorative and striking. To produce it, first lay down a scraped middle-value tone. Then charge the long, straight underedge of your knife very heavily with white, press the edge down firmly, and lift it up sharply, pulling the white up as high into the air as possible; keep repeating and overlapping.

Using the Arrowhead edge with a much lighter charge, just a neat, narrow ribbon on one side, will bring us to a different realm of painting and will get us right down on our knees among the weeds and tiny grasses, refreshing us with a new point of view rarely taken advantage of. I used both Magic and Arrowhead knives to do the seedy-weedy picture to the right. I felt a great joy in doing it, a decided kinship with the Japanese. I would like you to try a lot of little seedy-weedies. See how fine you can get those lines. Notice how you can change direction while doing them, making large curves. Get the feel of this and you'll be able to introduce sparkling foregrounds of this type into larger paintings, pushing the distance far away.

SHOULD YOU DRAW WITH A PAINTING KNIFE?

I think I can hear certain growlings and grumblings from my readers. "Those edge lines and stripes are nice but they have a weakness. When do we get down to something we can manipulate, something we can *draw* with?"

You anticipated me—I was coming to that. But you've brought up a big point and I want to thrash it out with you. Does one, should one, draw with the painting knife? And I can imagine some people thinking, "Hey—maybe that's it—maybe one doesn't draw at all—it would make it so much easier—maybe painting with a knife is just a fun thing, like making mud pies." *No, no, no!* That's not what I mean at all! If you just wanted to make mud pies you should have bought a cookbook.

ARE THERE OUTLINES IN NATURE?

When we think "drawing," we associate it with some quite neat and precise outline which delineates, more or less realistically, some object in nature; the assumption is that natural objects possess a kind of string or wire thing around them, which looks like a charcoal or pencil line. I've looked for

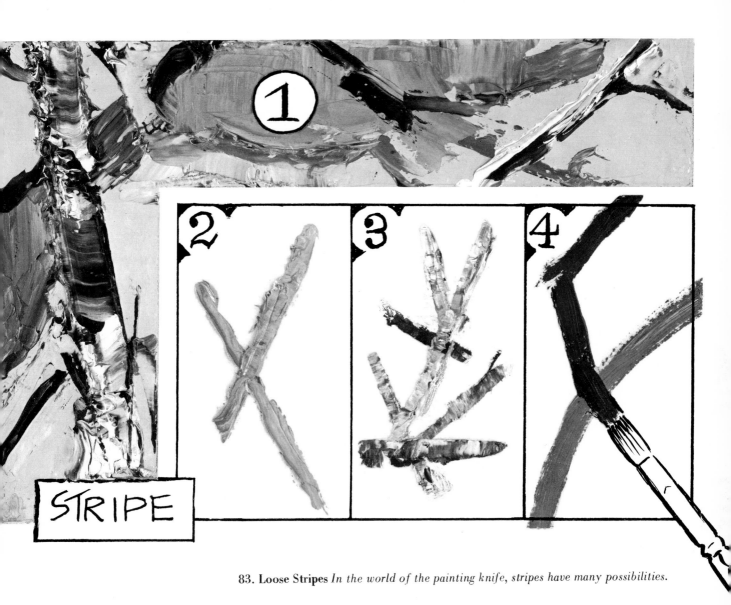

STRIPE

① ② ③ ④

83. **Loose Stripes** *In the world of the painting knife, stripes have many possibilities.*

84. Sparkle *For a fascinating sparkle and crackle, press the heavily loaded knife down on one edge, then lift it up sharply (left). If you do this with less paint, you'll be able to produce little weed-thin lines of the greatest finesse (right).*

these pencil lines around natural objects for years, but I don't seem to find them.

CREATING MASS

Study the copper luster pitcher in Fig. 85. There were no outlines taken into account here. What I attempted to do was to seize, mentally, a whole mass concept of the pitcher, separate this into a few large color and value areas, and put these down in a few large knifestrokes which were intended to create the sense of mass from the *inside*. Instead of outlining, the strokes turn and twist, groping to create a sense of mass, light, shape, all at once. Such an approach is difficult but highly inspiring; in the effort to seize on the soul of an object, one has sudden insights unknown in a more plodding step-by-step method. Here's one of the greatest reasons for painting with a short, broad knife. Would you like to feel as if you were creating this object? It will give you a mighty feeling—try it!

WHEN IS YOUR PAINTING FINISHED?

The copper luster pitcher is in a stage usually associated with the word "finished" in Fig. 86. I'm very suspicious of this word. I don't really want to finish my pictures—in that case, I'd be finished as an artist—there would be nothing more to look at. In this stage, I want to finish it in the sense of stimulating you to finish it in your imagination. To do this, I must keep in my finish the bold simplicity of the start, adding certain technical manipulations which should increase the magic and increase the enjoyment. One technique is to increase control of shape by giving one knife the job of *cutting in* with background tones while an inside knife works outward. In this way, you can feel the forms between your hands as a sculptor would; this is truly drawing in mass. But how to do the small finishing things?

Try to suggest details, textures, highlights, and so on rather than actually trying to delineate them. Do this lightly, with an extremely free wrist, watching to see what your wrist is giving you. You may be surprised by what you get—something far better than anything you thought you could do. The process demands that you stop instantly the moment you've done this beautiful thing.

Now try this. Set up some solid and simple object, some pot or whatever, paint it simply, but with thick pigment. Except for a few hints, don't use any outlines. (Here's a suggestion: make a pencil drawing beforehand, on another piece of paper, to help you grasp and understand the *character* of what you're about to paint.) Slap on the big mass tones, *turning* them to grasp the form. Come back to flip on (lightly) tones and textures which will make your pot, or whatever, leap into reality. When it's strikingly vital—*stop*!

SILHOUETTES

I've dwelt on getting the depth sense of objects with a few broad swipes of the knife, but some objects are so simple in shape that the eye apprehends them as silhouettes, with only a detail or two superimposed. In such cases, that's just the way to paint them. I'm very fond of laying in a full silhouette of a simple-looking object and then savoring the return with a light but loaded knife.

Here's something else for you to try. Select some very simple object, say a white china pitcher with a bit of pattern on it (Fig. 87). Squint your eyes, get the full flood of light, and set your impression down as a silhouette. Return, perhaps with a bit of soft shadow, which will suddenly expand the silhouette into depth, and then tap the pattern on like a butterfly lighting on a flower. You must be the one to decide whether to start with a silhouette or the big mass strokes I was speaking of before. The one which will best snap the paint into the final magical depth reality will be the right one. My picture of the white antique teapot was done according to this last method. In this picture, I used the smallest of my knives. I like to use it with a cross movement, resting my knife hand on the other hand or on a small stick. Used dry, this knife can smooth down bumps and irregularities, or can lay on new tones which fuse with the old work underneath. I strongly recommend that you practice with this or some other mini knife.

To sum up about outlines: they're a matter of individual taste and experiment. I've urged that you learn to see in mass, and draw by inner breadth rather than by outer wire edges. But a certain amount of outlining may help in some cases, provided you retain the sense of mass. Sometimes I use loose, sketchy outlines made with a small, square-ended bristle brush to help locate forms in a composition and to provide gold tones between the colors. Edges in nature have a vibrating color feeling, and tones separated by a gold sensation give the whole picture a painterly, non-photographic effect; also, tones so separated tend to create a sense of depth—one retreats behind the other. I dust off the first faint charcoal hints and turn them into gold, using raw sienna diluted with turpentine. The colors lap over the outlines, but the hint of gold remains.

Fig. 88 shows how such outlines might look if used on the luster pitcher. (For study purposes, I've made these outlines heavier than I'd normally paint them.) Here's another exercise for you: try such outlines on a number of different shapes, trying to keep them loose and suggestive rather than heavy and pedantic. As you work around the outlines, creating a mass, a rounded effect on the inside, and cutting in with background from the outside, the outlines themselves will tend to disappear; the effect will be very similar to the second stage of the luster pitcher (Fig. 86) where only a

85. Creating Mass (Step 1) *This luster pitcher is being painted using the concept of mass rather than outline. The form is created by inside body strokes.*

86. Creating Mass (Step 2) *The big, inner strokes have created the main shape, and the background strokes help by cutting in from the outside. Highlights and final details were very lightly flipped in. What fun!*

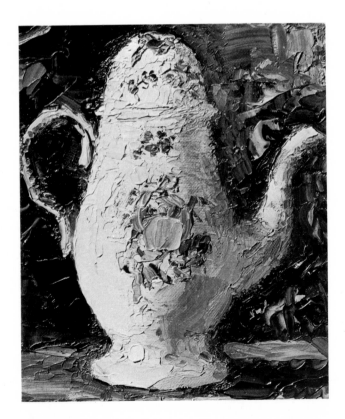

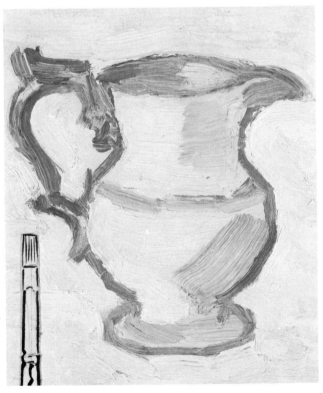

87. Flat to Round *This was done first as a soft white silhouette, with shadows worked in wet-on-wet and fused with a dry Magic knife. The knife also was used to flip in the design.*

88. Using Brush Outlines *Sometimes you'll want to make an occasional outline with a square-tipped brush. Keep such lines loose and sketchy.*

very few charcoal hints were used at first. Experiment with both approaches to outline and choose the one which works the best for you. Using the brush outline is the easiest; but creating a form by the sense of mass alone is the most thrilling—acquire a taste for this and you just may throw brush outlines away!

WHEN SHOULD YOU STOP WORKING?

Now for a vital bit of knife business: how will you know when to stop? There are two stopping points one needs to consider. One is the right time to quit working during an individual painting session. Teaching experience has shown me this should be at the first sign of indecision and fatigue. You should know your own stopping point, and discipline yourself not to continue beyond it—your picture will probably be ruined if you don't. Freshness is important in painting knife work; the impetus of those strokes dies quickly if you start picking at them. I diagram my own session stopping point—at about an hour and three-quarters to two hours—in Fig. 89.

The second stopping point is concerned with how far you should carry the picture before ending your work, irrespective of individual sessions. To find this point, paint many pictures, compare them, find out what you're after. Train yourself to stop working on a picture when it expresses—at least in some degree—what you want it to. Try not to spoil something which has an authentic ring. When it rings for you, stop, even if the picture isn't completely finished.

There are, of course, a great many other painting knife effects, and we'll handle them in the next chapter. In this chapter, I've tried to present the core, the essence of this way of working with oil paint. I'll sum it up in two paradoxical statements.

Be bold! Lift up a lot of pigment, cut loose from fear, put down those big strokes with force.

Be delicate! Waft that paint over as you return with it—let the leafy lightness of your knife touch your picture into impressionistic reality.

You can combine these two elements, the force and the delicacy (this is what I like), or you can select from this great range of effect some particular blend which will best express the thing you have to say—and this is the most important consideration of all.

Here's one more vital point to sleep on. Every minute or so, stop—walk back—look at the work from about ten feet. Does it hang together, carry from a distance? Do the strokes and touches and tones combine to say the thing you want? If not, study how to make them say it.

This is very vital in knifework. Slap the stuff on as roughly as you want, *provided* that when you walk back, it—as my wife Odin and I are fond of saying—"flips over." By this, we mean that the paint must turn into nature itself, or better, into the super nature we're after.

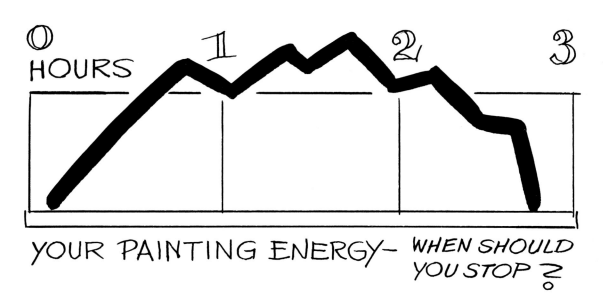

89. When to Stop *This is my personal stopping graph—it tells me not to work for longer than two hours at a time. Make your own graph according to your own needs.*

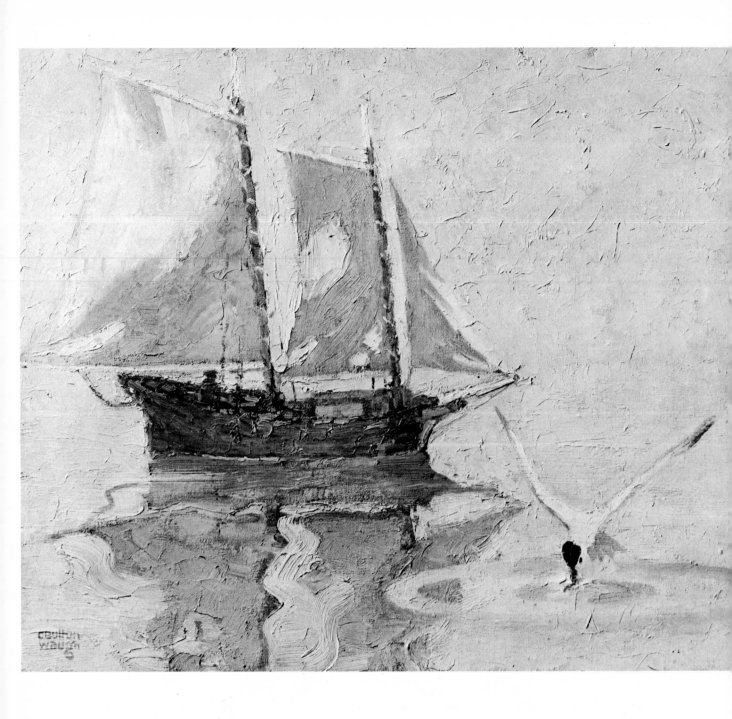

Calm, *24" x 30". Collection Mr. and Mrs. Elia Larocca. This picture is the result of years of sailing in the broad harbor of Provincetown, Mass. The little ship is a "pinky" of earlier days (notice the sharply cocked-up stern), and the total effect is a treasured memory of moments of total calm, where everything paused, stopped. The horizon line is invisible; the sky and the water are one. I've held all the values light in this painting, so the viewer can enter my feeling about the calm, high, salt air and share it with me.*

6
LOOKING
AT
NATURE

We've covered the main painting knife approaches to the rendering of the close, more positive elements of a picture. Let's shift the focus, turn from the sharply controlled elements to the movement into depth and distance, the subtleties of vibration and air, and the richness and splendor of texture. These disparate and manifold elements all lie well within the range of the painting knife. There's much abstract beauty to be revealed, as well as a great many points of contact with nature to be established. Construction of bridges into the mystery of nature, as I see it, is the final end of painting with a knife.

ATMOSPHERE

Behind the production of softer, more distant effects with the painting knife, there exists a simple principle: distance implies, besides lighter values and more muted colors, some shimmer, some vibration in the air. Paint a perfectly flat tone, any tone, and it creates the sense of something close to you; it's a kind of wall paint, too close to allow for luminosity and vibration. It gives the sense of there being hardly any air between the flat object and our eyes. It follows that to create the sense of air (which will give us a sense of distance) some degree of vibration becomes necessary. We need to study, then, how to get this vibratory feeling into knife-work. I'm sure you'll be delighted to find how natural pulsations are to this technique. There are many ways of producing them. I can only give you a few, but I hope that from a bit of exercising with these, you'll go on to produce many more varieties of your own. The first approach to vibration is the actual vibrating of the knife itself.

VIBRATIONS

For the first illustration (Fig. 90), I laid a scraped, light gray tone and charged an Arrowhead knife with a broad glob of darker gray. I readied my wrist as if to produce a rounded stroke, but instead of drawing it right around I set up a very rapid back and forth sawing motion of the wrist, still

keeping up, however, a clinging contact with the surface underneath. The effect produced reminds me very much of the *vibrato* or vibrating quality of tone produced by a back and forth movement of the violinist's fingers on the strings. Interestingly, the violinist's fingers retain their downward pressure even when vibrating sideways; this is just the case with the vibrato of the painting knife, and will perhaps help to give you a key to its production. Hold your wrist very loosely and shake it rapidly back and forth. Try this without the knife and you'll be surprised how fast that wrist can wriggle. Please practice the painting knife vibrato with black, gray, white, and tones in-between.

THE LOST AND THE FOUND

The next illustration (Fig. 91), gives us four rounded agate-type strokes. In these, the tones, which at the beginning of the stroke were sharp and distinct, have been deliberately run or shimmered together with a vibrato of the hand. This should begin to give you a conception of the immense range of painting knife effects—some things sharp and close by, others vibrating and distant; some things "found," that is, in focus, distinct, others "lost," meaning fused, distant, vague. This is what's meant when an artist speaks of "the lost and the found" and it's a very fine and descriptive phrase. In this illustration, the lost places aren't entirely lost; they haven't changed to a sense of air, but the one on the lower right definitely suggests water, or reflections in water. This half-lost, reflection effect is a particular specialty of the painting knife; because it's extremely useful I want to go into it carefully. I call it by the undignified name of the "wibble wobble." (Sorry about this, but I can't think of the effect by any other name!

THE WIBBLE WOBBLE

To practice the wibble wobble, take a knife like the Arrowhead, charge both underedges with different tones or colors, and draw it sharply back and forth with a zigzag motion, meanwhile drawing

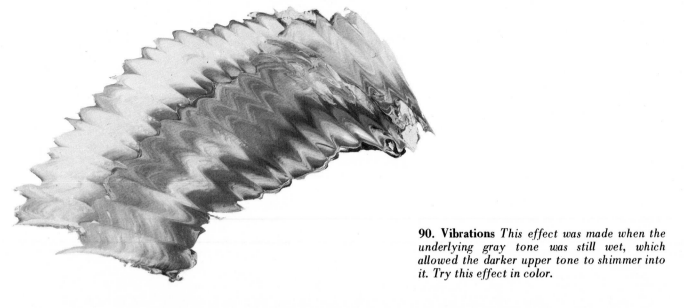

90. Vibrations *This effect was made when the underlying gray tone was still wet, which allowed the darker upper tone to shimmer into it. Try this effect in color.*

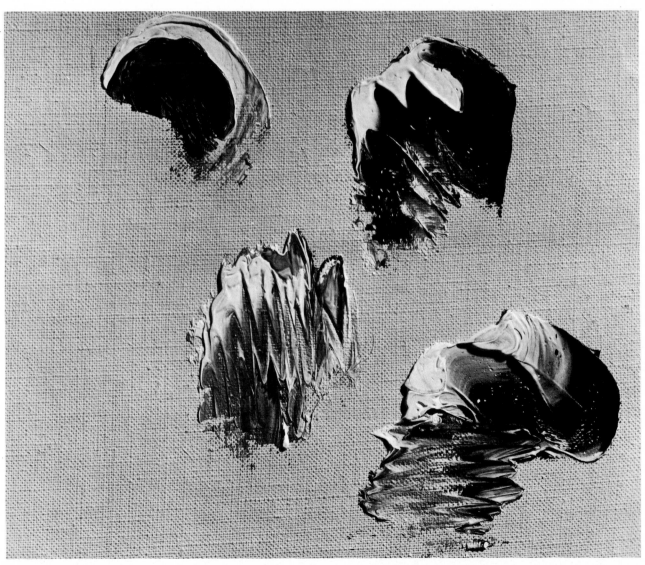

91. Sharp to Soft *These black and white pigments have been twirled together with a Magic knife. Start shimmering like this and you'll see the beginning of the water effect.*

it slowly down (Fig. 92). I should explain that this stroke is larger than the shimmering vibration mentioned before, and that it will work best if you lock your wrist and saw back and forth from elbow or shoulder or both.

Fig. 93 shows how many wibble wobbles can connect, creating the sense of a water mass. When I try for this effect, say on a fluctuating set of reflections, I keep rapidly recharging my knife, seizing on colors which the actual reflections suggest, and run wibble wobbles overlapping or on top of one another. This is tricky; you don't want to lose some beautiful effect which has magically leaped out, but you must work toward the main, over-all effect. Train yourself to recognize when you've reached this, then stop—really stop—choke off that temptation to go on and on, for then the sparkle will suddenly go out of your water and there'll be nothing left but dry mud.

It's possible to get effects of extreme beauty with the wibble wobble. I can't possibly give you an exact formula, but I'm sure that if you'll practice a bit, it will get into your arm as the vibrato gets into a violinist's fingers. Then you'll be set; you'll do it automatically.

Wibble wobbles create water effects because water is always trying to seek the lowest level, trying to lie flat. And since it's almost always moving to some degree, the movement tends to be in flattish lines back and forth. Please notice, however, that this kind of effect is typical of inland water—ponds, lakes, and quiet parts of streams. Sea water ripples are quite different. Here, the wind builds up peaks of water which sink down into troughs and are built up into other peaks. But the lines building waves and ripples always sag, either up or down. There are no straight lines in wave forms.

STILL WATER

There's an important feature of wibble wobble effect I wish you'd check out by taking a walk to look at some flat water where there's a distance element, across a pond, for example. You'll notice that the distance pulls the wibbles much closer to each other when far away and that, as you gradually lower your eyes, they open and become wider in a very exact ratio. This enables you to make your brooks and streams lie flat and go way off, leading into the enchantment of mystery. In Fig. 94 I show a little sketch of my particular brook to emphasize this point, and I hope you'll try to find something like this in nature and work it out through the wibble wobble. Incidentally, don't tilt your wibble wobbles to one side or the other or your brook will drain out of the picture.

Here's a most useful gimmick for making brooks lie flat. With a pencil, make a simple plan as if looking down on your brook from above; its meanderings will show rounded lines as it winds back and forth. Now lift the sketch up, hold it flat, and look at it just below the eye level; the rounded

92. The "Wibble Wobble" *Here, this effect is seen close at hand. Any knife with a straight edge will produce a wibble wobble. Use several colors when you practice. Get the movement into your arm.*

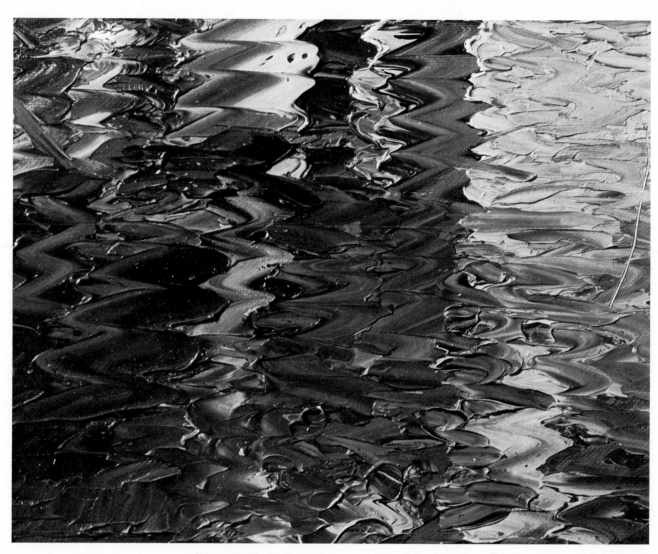

93. Living Water *Here's a kind of magic—all you see is water, yet you can sense a dock above, out of the picture area. Or is it a bank stand of upright trees? The water is suggesting something!*

lines will have become more pointed and these pointed caps will tend to overlap and retreat as in nature, with the brook lying wonderfully flat between them. Get this into your picture.

LEAVES

Being out in nature looking at brooks brings up another very typical painting knife effect which I call "the millions of leaves." As a boy, I was haunted by the mystery of the woods and tried to paint it. But I had no idea how to handle that shimmering effect caused by millions of sharp details blurring into one richness, as the individual loops of a Persian or hooked rug blur together into a sense of opulent depth and pile. I remember, too, inviting a student to come down and join me in painting my brook where it wound through a strip of woods. "But I wouldn't know how to paint those millions of leaves!" said he, and I thought to myself I hadn't solved that problem either.

A little later, I found myself in my upland woodlot, in all the gold of autumn, determined to use a full day, or a whole lot more, to thrash out the solution to the leaf mystery. The millions of leaves, glorious gold, wine-colored, deep rust, lemon, pink, were all there and I went at them furiously, trying to paint them one by one, and failing that, group by group. I had all kinds of paint—but I saw I wasn't making it—something was wrong. I flung myself down on the carpet of leaves, completely baffled. Suddenly, looking sideways, I saw the woods from a new angle. I saw them as a shimmering tapestry, without any individual detail.

I jumped up, flinging on all the wild fall colors with swirls and stabbings of my knife, not guiding individual strokes, thinking only of enriching the color depth which I could see was piling up and which I could see, also had a real, intimate family relationship to that thing in front of me which I was seeing as a fabric, a fantastic textile, rather than a presentation of detail. It was confusion, yes—but as the canvas became covered I said to myself, "I was confused when I saw this, yes, so I'll paint it confused!" The first effect was something like Fig. 95. You'll have to imagine the color.

The millions of leaves were there—but still struggling to burst into reality—and then I saw the slender twisting trunk of a young tree, a deep purplish note against that gold. I flicked it in with a flashing downward stroke of the knife, lightly, over all the gold. *Wow!* I could see the woods coming! There were other hints of trunks, veiled, buried in the gold; I hinted at them, cut a few glittering cerulean sky spots—very few—and a vague hint of an opening. Now all those confused strokes had turned into millions of leaves (see Fig. 96).

THE POWER OF SUGGESTION

If your eyes are given a few credible hints, they seem to take delight in finishing the effect; they're

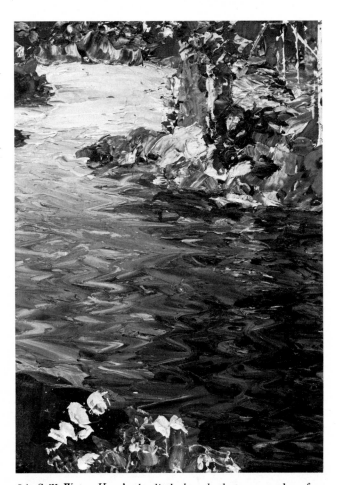

94. Still Water *Here's the little brook that runs only a few hundred feet from my studio. Look closely, and you'll see the wibble wobble in it.*

95. A Confusion of Leaves *Leaves, leaves, leaves—what a confusion they make! How can you organize them, straighten them out? You can't. Paint them confused, the way they are.*

96. Controlled Confusion *A few hints of something beyond the confusion of leaves gives form to your painting.*

in on the creative part of the act, not dull spectators at a performance already completed by the artist. And these suggested pictures, "half finished" though they are, seem always to be the ones which stir people the most—the viewer wants to solve the mystery himself.

Since the experience I've told you about, I've painted billions of leaves and I hope for another good billion before I die. Try for a few million yourself. As to knives, I recommend the Magic knife type, or Long John if you can manipulate it by using the soft, springy end rather than the longer part further down; these leaf shapes are rather shortish, although many spirals and rounds may be worked in. The point is to let your wrist *go*. Let it paint for you! Decide what colors to give your knife, keep feeding these colors to it, and then—step aside—let that hand and knife do the painting. A friend looked at one such picture of mine and said "Coulton, that's confusion—but it's controlled confusion—I mean confusion when close up, reality when you step back."

THE FLICKER

The next effect is along the lines of the last, but in a different time of year. I've just finished the little illustration in Fig. 97 and the date is May 3. It's the time of the "flicker," the time when all the millions of little, adolescent, light yellow-green leaves are decorating the woods with a peculiar shimmer which comes only at this time of year, and then just for a week or so. The feeling is all radiant and young, and what maddens me is that I so rarely can get out there to paint it—some pressing problem is always coming up to grab at me. At least this year I had the fun of doing this illustration for you to suggest that the painting knife is very capable of handling effects of extreme delicacy—indeed, that's one of its greatest areas of performance.

As I did this little sketch, I made a few notes of the process I was using. First, I spread a light gray paint tone over my whole area with the Long John knife, which is so wonderful for this purpose. Then, with a Magic knife, I worked lighter sky tones around, releasing gray silhouettes to suggest distant trees. Still using the Magic knife, I flickered in the darker treetrunks to the left, not trying to guide the knife so much as to let it go on its own. Then came the flickering leaves—vibrating lights, and a few darks—which shimmered all over the sketch. The happiest thing was last, those extremely young little saplings to the left and right of the main treetrunk. These were done with the edge of the Magic knife. This is an effect only made with the straight, sharp edge of a painting knife.

As you read this, it's probably not May 3, but you should be able to find many soft, distant-type effects which will give you a chance to let your knife flicker. Try it in black and white, because it will give you a very strong training in values, and you'll be freer when you come to using color. If you mess it up, scrape the whole thing out—you can use the fine medium gray and start over. I scraped and restarted this sketch twice before I got what I wanted.

LIGHT AND SHADOW

We've been getting farther and farther away from things close at hand, and now we head boldly out in a new direction. Let's start by looking for big important things, letting the diddling unimportant ones go. In this spirit, we'll discuss how to construct the drama of light through the manipulation of shadow.

The little sketch in Fig. 98 demonstrates my point in the most reduced, simplified manner I can manage. I suggest you try it for yourself. I used gray charcoal paper for the ground, tempera white for the sun, and black drawing ink for shadow. It seemed better to do these shadows with a flat-ended lettering brush, rather than with a painting knife. The brush works so quickly and easily one can concentrate on making shadow points. Pinch your brush flat, draw across the square end for a smaller line, and pull it down for a bold, heavy one. Used this way, one can get splendid shadow effects in seconds.

KNOW YOUR LIGHT SOURCE

Now the great, the major, the mighty business in building shadow is to determine the source of the light. Outdoors, it's the sun. *Where is the sun?* We must know this exactly; all outdoor shadow effects, except those from artificial light, are dependent upon it. Since the shadow is on the side away from the light, locate the light and you know exactly where the shadow should be.

In my little sketch, the sun rises in the east; its light floods over a series of receding cliffs. The sharp faces of these cliffs, hidden from the sun, are receiving no light from it; and because the sun is so close to the horizon, there's little general light to fall on them.

Please notice that the lighted parts of these cliffs, actually composed of the untinted gray of the paper, look lighter than the general background tone. Mere optical illusion, a prosaic person may call it—I call it magic. I know it comes from the force of contrast; the sharp black tries to create its opposite on the neutral ground—we'll see how colors do this a little later—but I embrace it happily as magic just the same.

What a marvelous thing! You pick up a little brush, dip it in the most ordinary ink, and wham—there's the big, imposing range of cliffs along the Labrador coast. The vast simplicity of this coastline, where there's nothing but rock, water, and sky, gives me the feel of the naked geological essence of our planet. It was probably this feeling which first attracted me to the painting knife,

97. The Flicker Effect *Frankly, I love this picture—I don't always get as close to nature as this. Painting is full of the unexpected; when something you like happens, you should be grateful.*

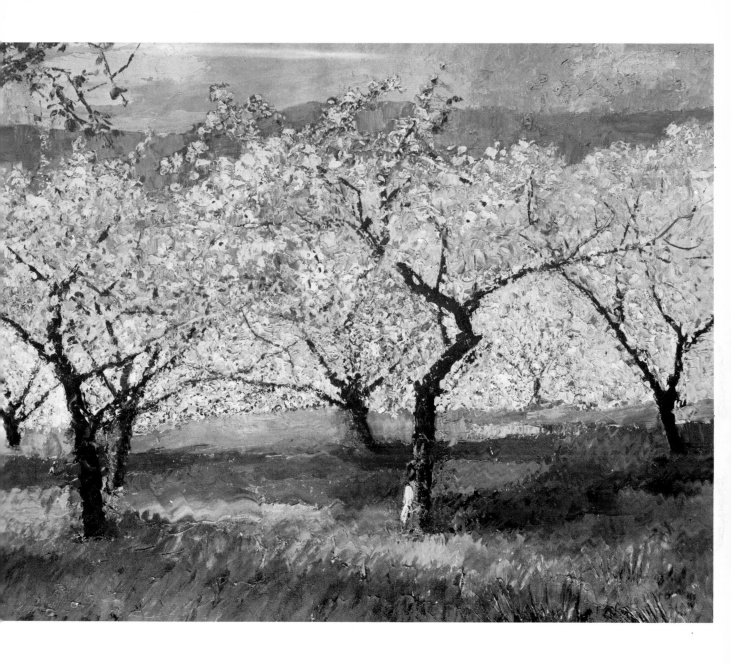

Inside the Orchard, *22" x 28". Courtesy Grand Central Art Galleries, New York. Some painters get esthetically drunk every springtime, and I'm one of them! I gather my stuff together, talk my wife Odin into cancelling portrait appointments, and we drive up to Marlboro, N. Y., where the little hills are patchworked with puffs of powdery bloom. If you come to Marlboro, I'll be the bearded painter with the glazed eye and a patch of cerulean blue on his nose. This picture is pure Marlboro: what I especially liked was the linking of all the blossoms together into one fabric, done with various knives in dot strokes of white, lilac, muted pink, delicate green, and—the secret of painting blossoms— tiny spots of dark.*

98. Shadow Makes Light *This is a great principle, expressed here in a kind of glyph. What makes the sense of light on objects? The manipulation of shadow. Ask Rembrandt.*

which can render first or primal things with such force.

In the next picture (Fig. 99), we see the something-out-of-nothing kind of creation even more clearly. Here the textures or breaks of the cliffs are suggested by nickings with the brush, always heavier toward the right or shadow side. It gives one a God Almighty feeling to have such a huge hunk of rock leap right up out of your hand—some of these cliffs soar a thousand feet up from the water.

Please try to create light through the use of shadow in this way. Get a square-tipped lettering brush, some ink, and any kind of gray paper and try it out. There's a kind of knack to it—you need to set those blacks down with boldness—but this can be acquired and it's great fun to do. Also, it's a fine development toward painting with a knife, because you can use shadow blacks with a knife in much the same way. Above all, it leads you toward simplifying, seeing the "picture." Look for some area of rock, or some object, like a house or barn, flooded with light, which you can bring to life in the same way.

The little painting of the Rocky Mountains in Fig. 100, showing the use of such a shadow, was made from a sketch done on the spot. Driving north from Colorado Springs, I'd noticed that snow had been falling in the high mountains to the west and I suddenly looked out the window and saw this scene. I stopped the car, got out, and fell down on my face. Then I got out my sketchbook. The mountain crests were far away, but so new with snow that what hit me was the simplicity of the distant shadows which turned the peaks into solid forms. In front, some kind of crop was growing, then a gigantic plowed field and the black foothills, and finally these ghostly crests. I'm glad I knew the shadow-notching technique so I could get the great feeling they gave me. This should show the value of locating the light source convincingly, then making a strong statement of shadow on the opposite side.

CAST SHADOWS

We've been dealing with shadows on the sides of objects, but there's another kind of shadow, the cast shadow. I found a funny little granary near my home which gave me just the chance to illustrate the two shadows, the one on the end of the little shed, and the cast shadow from the granary which flattened itself amusingly on the ground (Fig. 101). Watch for examples of such shadows, please, and do some sketches which will show the difference in the two shadow types. Since you now understand the importance of shadow study, and that shadows are opposite the position of the sun, I want you to spend a day checking the positions of the sun—or perhaps merely check four times a day.

Pick out some bulky object, clear from shrubbery, standing more or less by itself—it might be a house, a barn, a big mass of rock. For my illustra-

99. Light Makes It Big *This extension of the principle "shadow makes light" shows how light masses, created through shadow, rear into bigness, bringing us a feeling of eternity.*

100. Rocky Mountains *There are only five tones and textures here, but simplicity brings bigness again. For the Rocky Mountains, I prefer five tones to five hundred.*

tion (Fig. 102), I chose a chunky cliff mass with a tree in front. At the upper left, we see this mass shortly after dawn. The sun is rising in the east, modeling a bold shadow black on the far side of the main object, with a long shadow stretching from the tree. The upper right picture is at noon, with the sun directly overhead and high up. It's an unpainterly light that my father used to refer to as the "noon-day glare." Shadows are few, except for those directly under the trees, which all look like umbrellas with this light effect: light above, dark below. At lower left comes that great time when the sun is sinking in the west; bold shadows reappear on the cliff, but opposite early morning places. The tree is now strongly lit from the left; the whole world begins to glow—it's *the* romantic time; with all that contrast and color, it's the time for pictures to be painted. It's still great at lower right—the glow is still on the cliff, but softer; the tree is disappearing, its long shadow merging with the ground. Distant water glitters in reflection as the sun arches down.

A day with the sun! If you haven't tried it already, try it soon.

SKY AND CLOUDS

How about another day with the sun? Not with shadows this time, but with the sky (see Fig. 103).

Sky study! Start this and you're likely to get hooked, you and your painting knife. I've just come in from looking up from an easy chair on a day of wind, warm sunshine, and cool breeze. Great Wagnerian pileups, fortissimos, pianissimos, driftings; things threatening, things deliciously lovely, all have been passing overhead, and I've been worrying about how to tell you to paint them with a painting knife.

You must take some time to study clouds. Let them drift into you, pile up inside. But on this day with clouds and sky, the first thing is going to be the same as with the shadow day: keep locating and relocating the position of the sun. The sky may look utterly confused with those armies of marching clouds, but back of it all is the one precise point where the sun is located. This location will tell the story of the lighting of every cloud.

Mentally, assume you have an enormous paint rag and some turpentine; wipe all those clouds and drifting wisps off the sky until it's clean as a clean painting knife—and what will be there? A blazing ball on a field of blue, located in one particular spot. Please check four times for the location of this spot (hold your hand up over the sun—it might hurt your eyes). There will be a kind of glow or corona radiating out from the sun and it will lighten the sky around it for a considerable distance. The position of the sun and its surrounding radiance will have a tremendous effect on the lighting of the clouds, as shown in the illustration.

101. Cast Shadows *Shadow in back—cast shadow on ground—this little shed illustrates two important things about light.*

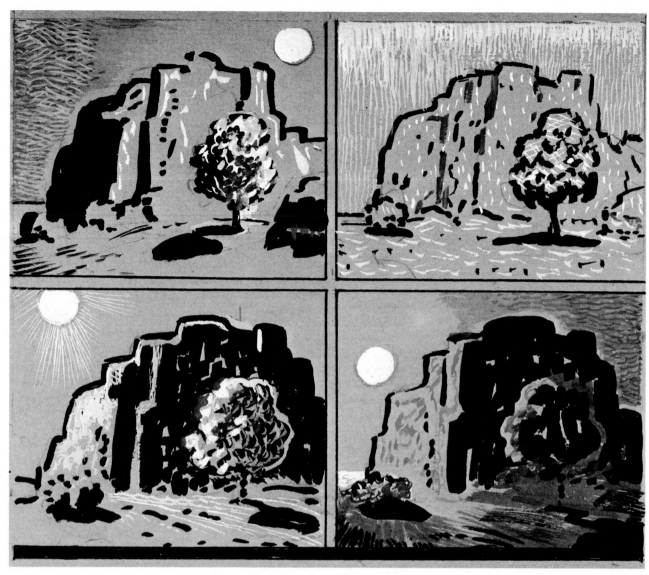

102. Day with the Sun *From dawn to dusk—how the big light moves across our stage. It's a show apparently put on for us artists. We can never study it too deeply.*

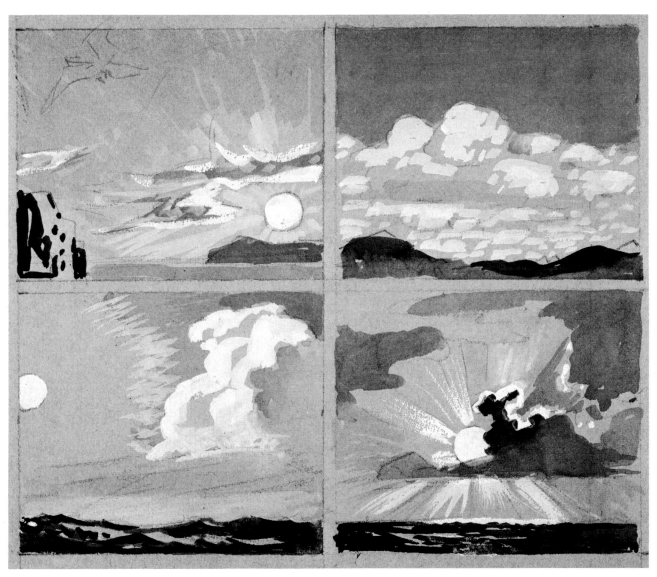

103. Day with the Sky *Four ways the sun lights clouds are shown here. The variations are innumerable—I intend to paint two hundred of them this year. How about you?*

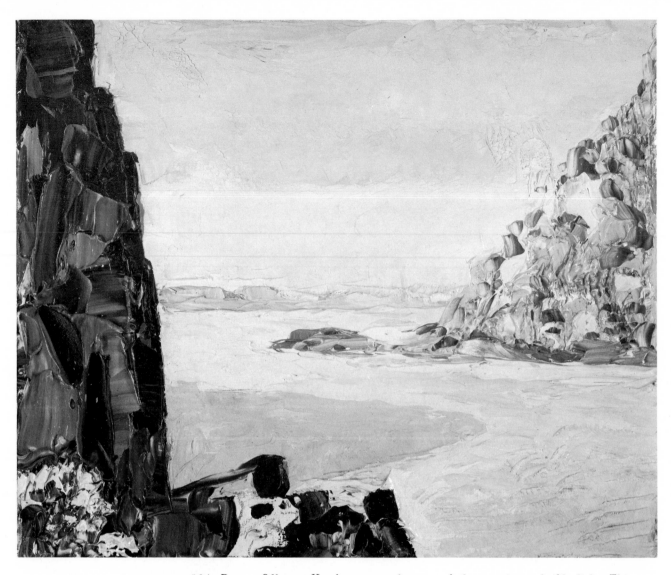

104. Drama Offstage *Here's a case of strong darks creating palpable light. This was sketched from a point on the Old Storm King Road looking north from West Point, New York.*

THE CHANGING SKY

Going out shortly after sunrise, you'll see the ball of radiance close to the eastern horizon (upper left). Wispy clouds march across it, and you'll notice darkish centers and edges brilliantly outlined in fiery gold. At noon (upper right) the sun and its ball of radiance will be so high that it doesn't change the deeper value of the sky far beneath it. In such lighting banks of heavy clouds often lie in overlapping layers; their bottoms, in shadow, closer to each other in perspective as we look at them from underneath. As the sun moves down in late afternoon (lower left), the light may dramatically illuminate the huge cumulus clouds which often pile up at that time of day. At lower right is one of those tremendous sunset effects where the whole western sky seems involved in drama. Don't miss these sky concerts; attend every one you can and get it down in paint as soon thereafter as possible. Please note the color excitement, the darkish, blue-violet clouds playing so wonderfully against the background fire colors and the warm sky, often a delicate greenish gold.

The field of your picture, often to one side of the sun, may take in part of the big, luminous sun halo we've mentioned, giving a sense of off-stage drama. I've illustrated this effect with a little sketch looking down on the Hudson River from a point on Storm King Mountain, which towers on the left side (Fig. 104). Notice how light streams out from behind the rock, situating the sun behind Storm King, whose big shadow lies on the river.

In Fig. 105 we see something else. Here, we're away from the sun halo, on the other side of the sky where there's little change in light from side to side; the change is from lighter at the waterline to darker higher up. The three strips make a good sky exercise.

Mix plenty of medium gray for the top of the upper strip; draw it down with the Long John knife, having charged the side of the blade along its length. Come down from the top with a clinging contact; then mix a lighter tone for working up from the bottom, and a medium tone for fusing the two together by using a little vibration of the knifeblade. When you set in the dark sea and cliff, notice the instant gain of a sense of air in the sky. Here's the magic of contrast again, something you're going to use over and over.

In the middle sketch, soft cloudbanks have been spatted in with Long John's flexible tip. The nearer cloud is darker, an effect one often sees. Below, notice that the concentration on one light section of a distant cloud gives a point of interest, a dramatic feeling. A veil of mist lies in front. Misty veils often come and go across the sky; don't be afraid to use them. They give subtlety and mystery and reduce hard-edged effects.

Please remember that your great model, the sky, is out there waiting to pose and work with you. Wherever you may be living, however unpicturesque your surroundings, the great, tender, luminous sky is waiting for you to study and use it. Be a sky student the rest of your life! I became one when I had time to do only one little 8" x 10" sunset sketch a day—I illustrate one from that period in Fig. 106. I learned from this that it isn't so much the time you have, as what you do with it.

Paint clouds sketchily, impressionistically. Keep the feeling of your skies—except for occasional storm pieces—light and aerial. Avoid harsh darks and lurid, heavy colors. Paint as rapidly as you can from that intoxicating first impression. Use your eyes and keep your Kodachrome travel magazines in a dark drawer and try not to look at them. The delicate sheen, the misting, the breathing of lilac over blue-green, these aren't things a camera can master. Why else are we painters?

Do clouds have shapes? Yes, indeed. You'll find intriguing shapes everywhere to fascinate and interest you; the woods and the skies too, are full of them. Find them, use them, don't enroll in the cotton wool clouds school.

DISTANCE

As we go off into far distance, we must remember how distinctly the values, the textures, and the colors change (Fig. 107). Distant things are lighter, softer, and their edges are blurred or hazy; they're more vibratory, the colors and values tremble slightly. The warm earth colors become muted with the colors of the air, as we'll see shortly. An extreme distance is reached where it's hard to tell which is sky, which is far-off mountain or hill—a most beautiful effect I want you to strive for and attain. This is indeed magic!

We've gone off into the distance as far as we can go; now there's something else I want to take up with you for our final knife exercises: a study of the various textures possible with the knife. We've already looked at some of these, like the wibble wobble, and I want to present some others. These are ways of knifing on paint which can be used in a great many places, in abstract as well as in realistic pictures.

KNIFE TEXTURES

Several useful knife textures combine in the little sketch of a fish house in Fig. 108. Notice the contrast between the very simple sky with its two large tones and the heavily textured quality of the fish house. As noted before, it's the contrast with dark which fills a sky with air, and it's the simplicity of the sky which gives fascination to the rugged old fish house. See if you can find some old building with an ancient, weathered texture and contrast it against a clean, pure sky. You can do this, perhaps, with a closeup of an old, weathered tree-trunk.

Sketch textures like this lightly, loosely, and watch for wonderful things to happen. When they do, stop—save them; don't adjust things out of

105. Away from the Sun *Turn your sky effects over to Long John. He's so floppy and flexible he'll really spread it out. He likes misty veils and close relationships.*

their first vitality. Perhaps this is the most difficult thing to do in painting. But it's very important. Franz Hals didn't fiddle with his marvelous loose brushwork; neither did Manet. When working with thick, loose textures of this kind, try picking up several tones of different values and letting your knife paint with them, almost automatically—but watch it! You must be able to stop the knife when something valid has happened.

To get the sparkle of the sun glinting over Provincetown Harbor in my fish house sketch, I used a wide Magic knife. Here, the knife is not so much moved in some direction as pounced up and down, leaving little sandpaper-like points. You'll find many uses for this texture. If you like to paint on top of such a texture, you can get it by pouncing wet gesso up and down on a panel as a preliminary step before painting.

TEXTURES IN SNOW

Several interesting textures are displayed in the little snow scene with the black brook in Fig. 109. First, notice the contrast between the broad, flat spreading of snow and the detailed feeling of close-up trees and weeds. Too many tones in the snow would have destroyed its effectiveness to act as a backdrop for more detailed textures. When working from nature, watch for blank areas, areas of calm; use them, make them talk. Quiet areas are the secret of the power of old master paintings.

Practice the effect of massed woods as seen in the back of this sketch. A number of tones is used, loosely vibrated together, but they're all light enough to fit into the distant backdrop. Look at nature to locate the various backdrops you'll find, almost like stage drops behind the actors in a play. Here, the backdrop is a mysterious wood, wrapped in shadowed snow; in front of this is the intriguing shape of the sharp, vibrant brook breaking through the ice in a black arrow form. The suggested tangle of trees and branches, and the vibration of the weeds in the lower right provide secondary points of interest.

Try a sketch in which you simplify what you see into a few big tones, as I did in my snow study. To do this, squint your eyes to cut down on extraneous detail, hold a card with a 2" x 3" cut-out section (a view-finder) in front of your nose and move this around until you find a center of interest (here, the black brook), an area of calm (the snowbanks), and a large, winding line to hold the elements together (the way the brook winds around the snowbank to the left, and the movement of turning off in the distance to the right). Remember: get the big areas down as fast as you possibly can!

TEXTURES TO MUSIC

The next illustration (Fig. 110) involves a wild swinging around with a Magic knife, using spring

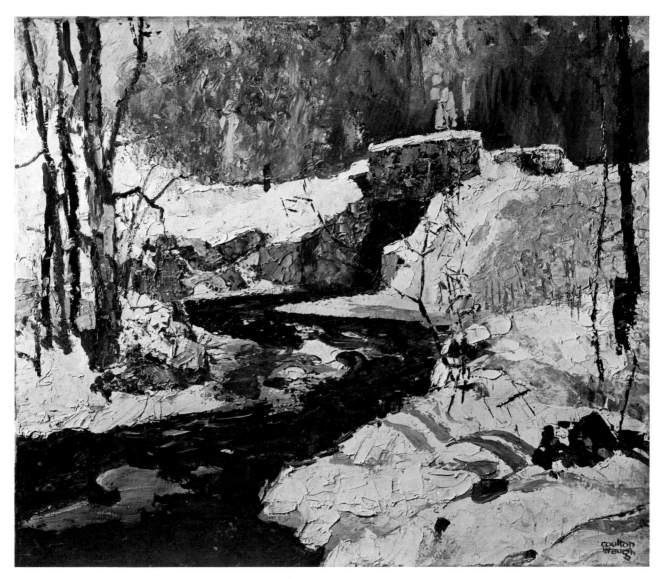

When the Ice Breaks, *25" x 30". Collection Coulton and Odin Waugh. The brook water, which has turned such an ebony black against the whiteness of the snow—and which only shortly before was entirely invisible under the white—has broken into view under the warmth of one of those first pre-spring days. My heart leaps, I feel the whole stirring of the coming summer. My bold black water, carrying its islands of muted slush, weaves arrogantly through the snow. I must let my arm weave arrogantly as I paint it!*

106. Sky Student at Work *(Left) This is a view looking west across my fields at near sunset. The colors were exhilarating, but subtle, too. One shouldn't miss effects like this—please get out there and try it!*

107. Distance *(Above) This is my personal distance workshop. Sky and mountains merge as you look down the Hudson River, which lies only five miles from my studio.*

108. Old Fish House *Many heavy knife textures are featured in this sketch. The distant water sparkles because of raised-up paint. Notice the broad strokes in the sky and the variegated textures in the fish house.*

109. Textures in Snow *Long John and Magic knives cooperated here to demonstrate a treatment of snow. There is both contrast and softness, a sense of near and of far.*

tulips for the subject. How can anyone stay in a dull mood handling a theme like this? I didn't feel trite and literal when I did this, so a trite, literal rendering was out. It's a kind of dancing with the knife—and actually that's the secret of this little painting—it was done to music, a procedure I recommend. It wouldn't be fair for me to try to impose my musical taste on you, but in private, I prefer Beethoven's Appassionata Sonata for wild painting escapades like this.

Use some rhythmical music which will set your wrist free, and at the same time get you going with its beat. In spite of the freedom, you'll find that a curious orderliness is apt to result; the movements of wrist and arm are limited by the very muscles which set them in action, so that a uniformity of rhythm sets in, an interlocking of movement; if you keep your forms swinging together in this way, you'll have a happy time doing it, and a lot of pleasure in looking at the results afterward—and you may also have a very good picture. What makes Van Gogh's paintings so fabulously valuable? This kind of thing, touched with genius, carried to the extreme.

Speaking of Van Gogh, he often used a kind of strapwork or basket weave impasto, with strokes alternating up and across—particularly effective in backgrounds—tending to carry on the heavy weave of his impasto pictures. Here's how weave and basket effects can be made with a painting knife, in different textures according to the size of the knife.

110. Textures to Music *It's spring and the rhythm of spring is in your blood. So you put on the Appassionata Sonata and slam into some spring tulips. Crazy? I don't think so—one has to live.*

WOVEN TEXTURES

You'll be in a good mood if you can slam out big basket weaves of the kind shown in Fig. 111. Use lots of pigment and get into a musical rhythm as I did in that dancing tulip picture.

Our next illustration (Fig. 112) shows, at upper left, a simplified block of a weave texture, so that one can study the actual strokes. By all means, try the basket weave in many variations. To the upper right is one of these textured follow-ups—in this case, a rhythmic texture with baroque, scroll-like forms expressed by straight lines subservient to the general movement.

To the lower left of Fig. 112 is a little texture I love to use; it's done with a Magic knife, which is deliberately loaded with more than one color or tone, then rapidly sawed up and down on its straight edge. Used with pale, distant tones, it can wonderfully suggest the shimmer of distant woods and the textures of grass. Here, I think of it simply as a fascinating and amusing little bauble of paint. The lower right texture is a diagonal crisscrossing of Magic knife-edge work on an original flat area of gray; I put the black lines in one diagonal direction, then crosshatched them with white lines in the other diagonal direction, making a kind of rough tweed.

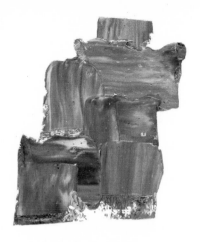

BINDING TEXTURES

Before we leave the textural possibilities of knife-edge work, I must mention the up and down edge vibration which uses very heavy pigment; the knife is so loaded that the pigment sticks right up in the air, catching the light from the side. Used boldly all over a canvas, such strokes may create a unifying texture. There may be baroque line movements underneath, but the edge vibration will bind them together as the thread movement binds a woven textile.

The texture block on the left side of Fig. 113 carries on this binding movement of the up-right line. But in this case it's done with many soft upright strokes or stripes. Such an approach, both useful and artistic, was a feature of the technique of many of the finest impressionist painters—Degas, Mary Cassatt, Cézanne (though his were usually diagonal), and Gauguin. I was thinking of Gauguin when I did this little upright knifestroke block; he liked to enclose areas in arabesques and baroque outlines, and then work to restore the balance by applying all his color areas in upright stripes, creating a beautiful and distinctive style. I've rendered this in a broader manner by using Long John's flexible tip, but it could also be very nicely done with the small, square-tipped bristle brush. Try both of these textural ups and downs to find something that fits in with your own style of painting—which should always be the object of your search.

To the right of Fig. 113 is an edge effect of this type, using straight but systematically crosshatched lines. I did this over an underlying gray tone, to give depth to the woven effect. Its sharp glitter is in violent contrast to the soft strokes to the left; variety of texture is what I'm trying to demonstrate here.

You may wonder what's back of the surrealistic effect of the next illustration (Fig. 114). I wanted to try to paint this fragile, delicate flower with a clumsy painting knife—a challenge, if you will. It wasn't easy. My concept was to paint each petal at a single pass—light, nuance, and all—and to cut around with the background dark to create the fragile edge.

Get a single, translucent flower of some kind and try this for yourself. I confess, I had to scrape out and recreate my tulip four times before I was satisfied. Your knife must be absolutely clean to get the translucent effect. Take a deep breath for each petal, and pray!

But why the crazy black and white textures around the black panel? I was relaxing from the tension of following those petals. Also, I liked the wild contrast of it. This outer texture, incidentally, is one I'd like to have you practice. It was done with a Magic knife, picking up not gray, but chunks of black and white, and putting these down so they made blocks with very little fusion between them. It would be an effective texture for stonework.

111. Woven Textures *What are the wild weaves saying? That it's tremendous fun to sling on very heavy pigment, kept under control by a basic basket pattern.*

112. Baskets and Textures *Four kinds of knife textures for your consideration and practice. I suggest you vary these and create a lot more of your own.*

113. Binding Textures *The block on the left shows soft upright lines using Long John stripes. The block on the right shows a sharp crosshatch with the Magic knife which creates shadow and light.*

TEXTURES IN NATURE

You may wonder why all the emphasis on texture in this chapter entitled "Looking at Nature." Because, first, texture is one of the primary aspects of nature. Walk down a road in fall, and you'll see unusual textures everywhere: old grass against new grass; heavy, withered weeds; big treetrunks with rough surfaces; smaller, more suave and youthful ones; an amazing jumble of twigs against the sky.

Second, I bring the subject of texture before you to suggest that it is precisely within the genius of the painting knife to create texture. We deal with pigment used without medium! It's stiff, it sticks up, it presents a corrugated surface. Such a surface, I believe, fits into the story of modern painting. It restores art to something beyond the purely imitative, beyond the literal. "Le mur, toujours le mur!" cried Gauguin, meaning he wanted his painting to relate to a *surface*, and our painting knife textures will enable us to do just that. By an eerie paradox, this technique allows us to move far away into the suggestion of distance, at the same time retaining the stroke and heavy pigmentation which relates the work to the surface. Full impasto pigment has been widely used only for seventy-five years or so—and then almost always with brushes. I hope you'll feel, as I do, that by exercising and experimenting with knife painting, you'll be moving toward the creation of something vital and beautiful, and also of something new.

As we approach color, I want to emphasize once more the special ability of the light, broad painting knife to execute fluttering effects, and I submit the illustration in Fig. 115 to emphasize the point pictorially. A loose wrist! Let the painting knife (at least sometimes) go on its own! You'll find this most fascinating when you come to echoing colors around a canvas; so these comments are not so much review as anticipation and preparation of things to come.

114. Tulip *Surrealism? Not exactly!*

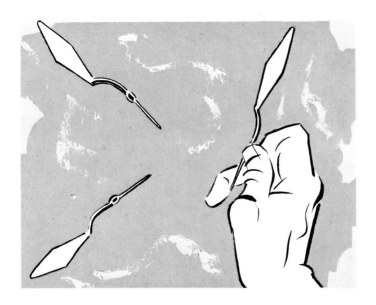

115. A Knife Can Fly *This is the flutter stroke which we've studied before. Please keep it in mind, especially because it can create beautiful webs of color.*

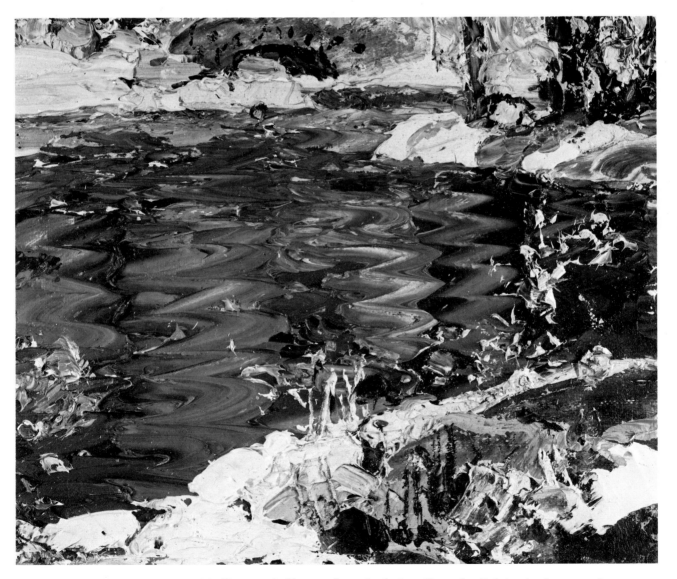

116. Textures in Nature *Several of the effects detailed in the last two chapters are brought together here. You'll recognize softening toward distance, the wibble wobble, and the flutter stroke.*

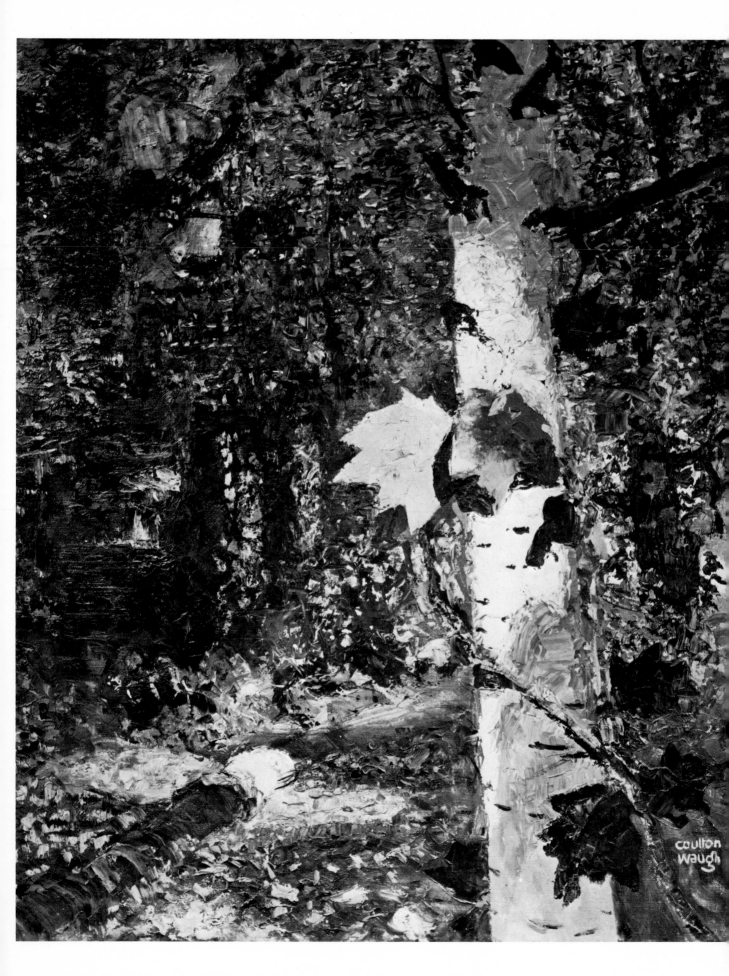

A great many artists, I believe, will agree with me that color is a kind of art absolute. There are other things in art—great things—but to those of us in whose eye the color cones have enlarged and become more sensitive as the years have passed, color has come to be a powerful experience; we begin to see all nature, all objects man made or God made, as color spots—we see the relations, the color chords. And, being painters, we're seized with a passionate determination to put down our own color perception; painting in color gives us a sense of creation parallel to the magnificent richness of nature.

COLOR AND THE PAINTING KNIFE

Color and the painting knife are one! This is my conviction. I want to make beautiful color spots, but my broad, springy little painting knife wants to make them too. (You'll soon find out what a personality a painting knife has.) Making rich color is the natural, absolutely reasonable way for this gleaming implement to work. Because you can get it so clean just by drawing it through a fold of rag, it can give back to you the totality of the color purity and brilliance present in the pigment as squeezed from the tube; by virtue of its shape, it can chop color in little blocks small enough to register in the eye impressionistically; because of its delicacy, it can lay spots of fiery colors, one on top of the other, leaving sizzling color effects such as one expects to find only in the rarest jewelry.

I take keen pleasure in presenting what I know about painting knife color in this chapter. Please take this as an invitation to a color workshop: we'll be sitting around a big table together, off on a voyage of discovery through research—points being accepted only if you can verify them on the palette in front of you. The ground has been laid already.

The Trail, 25" x 30". Courtesy Grand Central Art Galleries, New York. I was happy about this painting when I did it, and I'm happy about it now. It's one of those pictures where the forest gods permitted me to creep up rather close.

You know the tools, you have the basic pigments, plenty of rag, a big clean palette or several small ones. All color systems are go. The color spots, in their variegated glory, are about to burst upon us. Let's get squeezing!

LAYING OUT THE PALETTE

The drawing in Fig. 117 shows how I lay out my basic colors. I suggest you follow this layout. You'll notice this is a compact group of only a few pigments. There are very good reasons for this. First, in working outdoors, a whole raft of tubes will snarl you up; a few are a great deal easier to handle. Furthermore, working with only a few colors, you'll soon get to know them exceedingly well; each has its little foibles and follies, the conditions under which it can be gay or sober, frivolous or profound. You'll need to know which colors will mix with which to produce still other colors. And you'll be delighted, I'm sure, to discover the huge range of effects possible with this restricted group. You may have a pet system of your own for colors and palette setting—if you're passionate about your system, use it. But if you play with my system, for a while at least, you'll be getting the most from this particular book.

WARM AND COOL COLORS

You'll notice that my palette is roughly divided between a warm side and a cool side. Warm colors are those with some main relation to the sun's rays. They're aggressive, they come forward, they're related to sun colors and to the general warmer local color of earth itself. Mix a little raw sienna with cadmium yellow medium and you'll get a beautiful, glowing rich gold—plowed earth under hot, late afternoon sunlight. Now, if you clean your knife and mix some cerulean blue with quite a bit of white, you'll get the opposite, the luminous, cool color of the air. Between these two, one warm, the other cool, we get the symbolic feeling of our delicious little planet, so graciously balanced, so livable, so different from the hideous blacks and

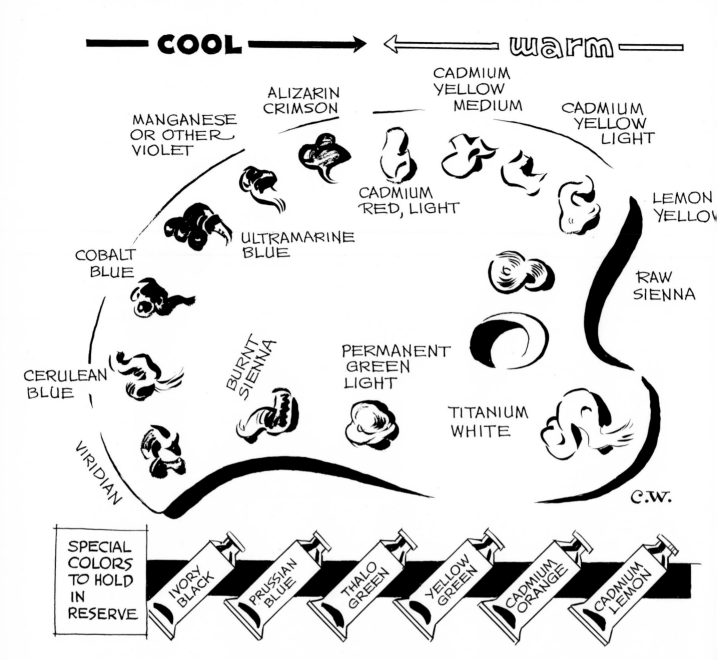

COOL ⟶ ⟵ **warm**

MANGANESE OR OTHER VIOLET

ALIZARIN CRIMSON

CADMIUM YELLOW MEDIUM

CADMIUM YELLOW LIGHT

CADMIUM RED, LIGHT

LEMON YELLOW

ULTRAMARINE BLUE

COBALT BLUE

RAW SIENNA

CERULEAN BLUE

BURNT SIENNA

PERMANENT GREEN LIGHT

TITANIUM WHITE

VIRIDIAN

C.W.

SPECIAL COLORS TO HOLD IN RESERVE

IVORY BLACK

PRUSSIAN BLUE

THALO GREEN

YELLOW GREEN

CADMIUM ORANGE

CADMIUM LEMON

117. Palette Layout *This is my basic palette, with a few extra colors. Have some extra paper palettes to give you more mixing room.*

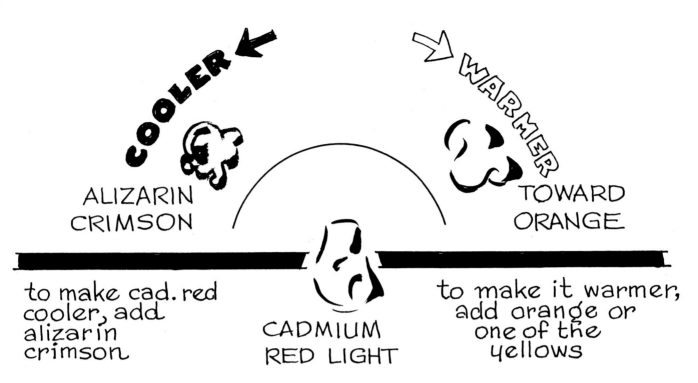

COOLER

WARMER

ALIZARIN
CRIMSON

TOWARD
ORANGE

to make cad. red
cooler, add
alizarin
crimson

CADMIUM
RED LIGHT

to make it warmer,
add orange or
one of the
yellows

118. Warm and Cool Colors *Check all your colors to see which are warm, which cool.*
This illustration shows how to tip them one way or the other.

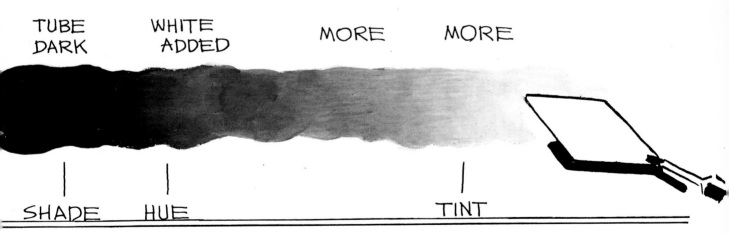

TUBE
DARK

WHITE
ADDED

MORE

MORE

SHADE HUE

TINT

ULTRAMARINE BLUE

119. Values *A trace of white lifts the tube darks to their brightest color point (hue).*
Above this point, white dulls the color.

(continued on page 145)

Key to Color Textures of the Fall *The circled numbers indicate color chords: (1) warm oranges, yellows, and yellow-reds contrast with (2) the cooler greens of the fields, (3) the muted violets and faint yellows in the distance, and (4) the darker reds, blues, and browns in the foreground. The circled C's indicate complementaries: (upper right) blue-violets contrast with faint yellows; (upper center) violets and yellows vibrate together; (right center) yellow-orange contrasts with blue; (lower center) a vibrating contrast of red and green. Knife and texture strokes are shown by the pen lines.*

Color Textures of the Fall, *25" x 25". Courtesy Grand Central Art Galleries, New York. There are three basic factors at work here (see key opposite): the broad color areas which relate boldly with one another (circled numbers); the echoing and vibrating of the colors; and the many pairs of complementaries—red and green, blue-violet and red-orange, muted yellow-green and muted blue-violet (circled C's). Also apparent are the various knifestrokes illustrated throughout this book, as well as the flutters, textures, and jeweled color effects (pen lines).*

Apple, *8" x 10". Collection Coulton Waugh. Here's the color plate of the final step of the apple demonstration reproduced in black and white on pp. 166-171. Now you can see the rich, crisp color of the apple set off by the green shadows of the soft, white napkin.*

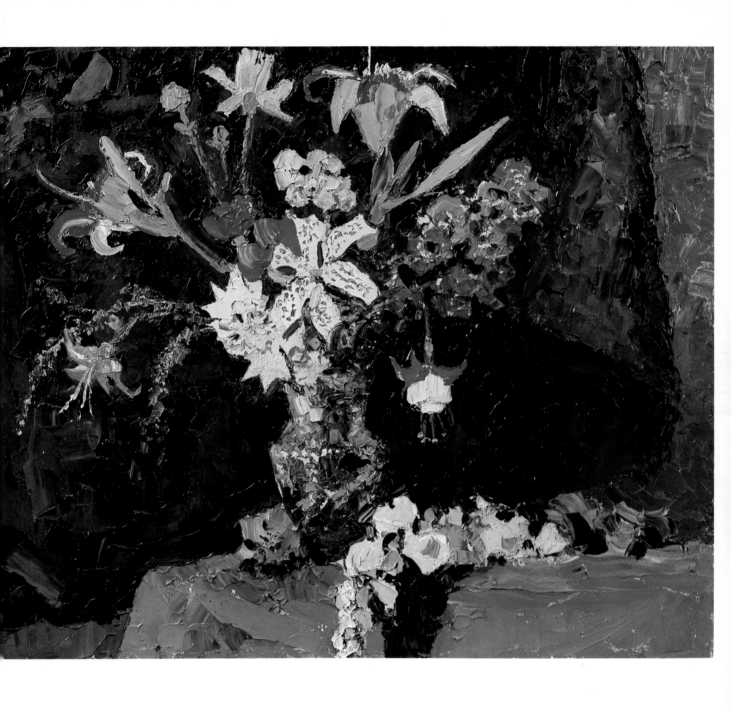

From a Formal Garden, *24" x 26". Courtesy Grand Central Art Galleries, New York. Final step of the demonstration reproduced in black and white on pp. 200-205.*

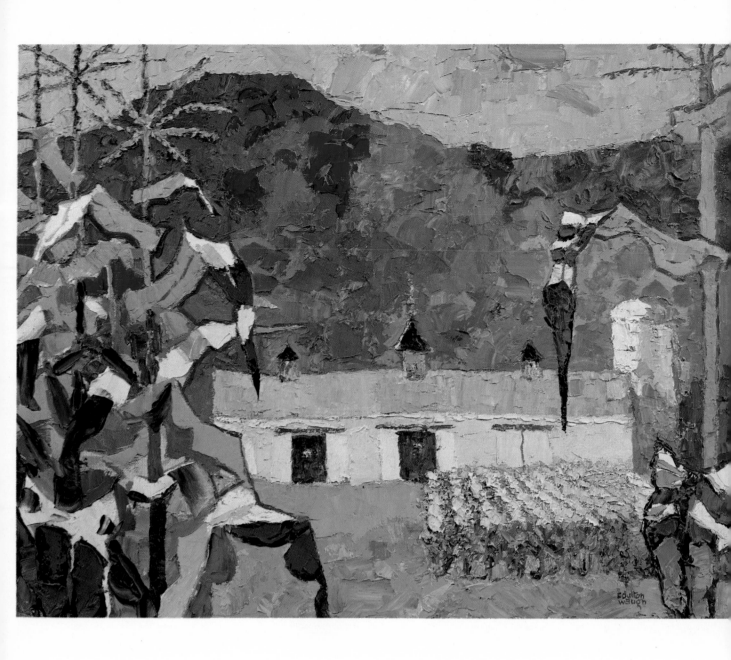

Mountain Farm, *22" x 28". Courtesy Grand Central Art Galleries, New York. Corn is the most splendid of all plants. The straight lines (so naturally done with the straight edge of the painting knife) contrast with the rounded, scalloped stripe effect of the other parts of the leaf (done with curved strokes, wrist work) and the striking sun color (Magic knife work in high yellow-green) contrasts with the almost black shadow notes and crackle patches from the almost white sky.*

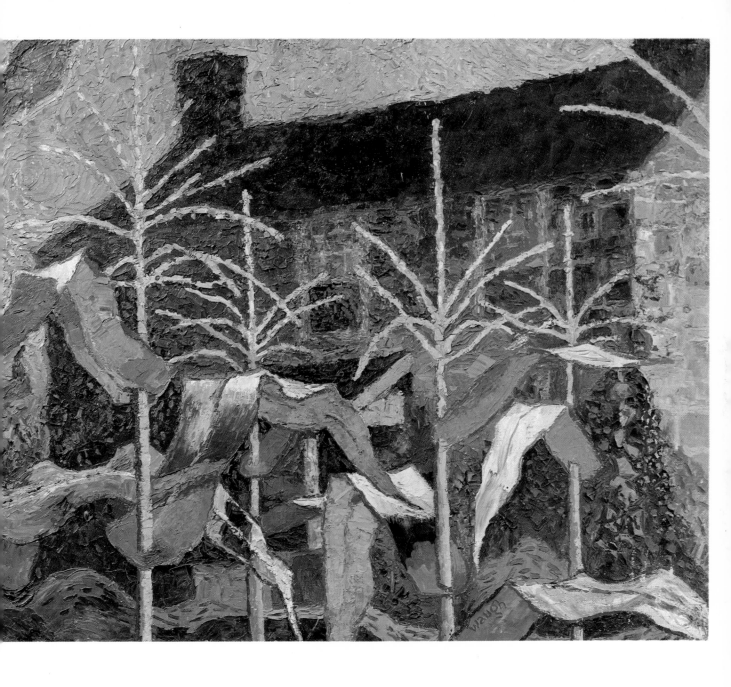

The Young Corn, *25" x 30". Collection Odin Waugh. How beautiful is anything which is young—especially if it's your child, or, in this case, the first young corn I ever raised! I got into the corn rhythm which moves from the corn into the sky, dancing and swirling in little pointillist strokes, whirling down into the old stone house, which seems itself to be growing out of the soft, undulating earth. Weave, repetition, beat, this is the texture that holds a picture together—but the beat, the rhythm, is more than the texture of the picture, it's the life of the young corn, the picture itself.*

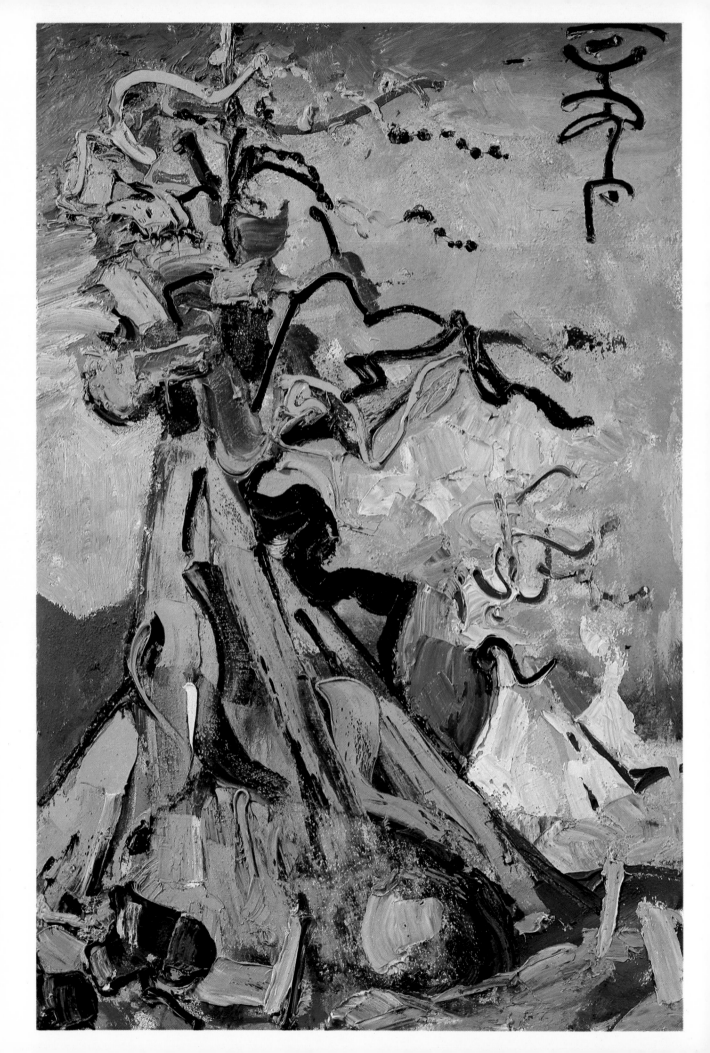

The Brave Shook *(Left), 20" x 30". Collection Odin Waugh. Final step of the demonstration reproduced in black and white on pp. 229-233.*

Surf, Sun, and Wind *(Above), 18" x 24". Collection Coulton and Odin Waugh. Final step of the acrylic demonstration reproduced in black and white on pp. 211-215.*

My Love for the Sloop, *25" x 30". Collection Coulton and Odin Waugh. Final step of the demonstration reproduced in black and white on pp. 188-192.*

John Sailing, *25" x 30". Collection Coulton Waugh. Final step of the demonstration reproduced in black and white on pp. 223-228.*

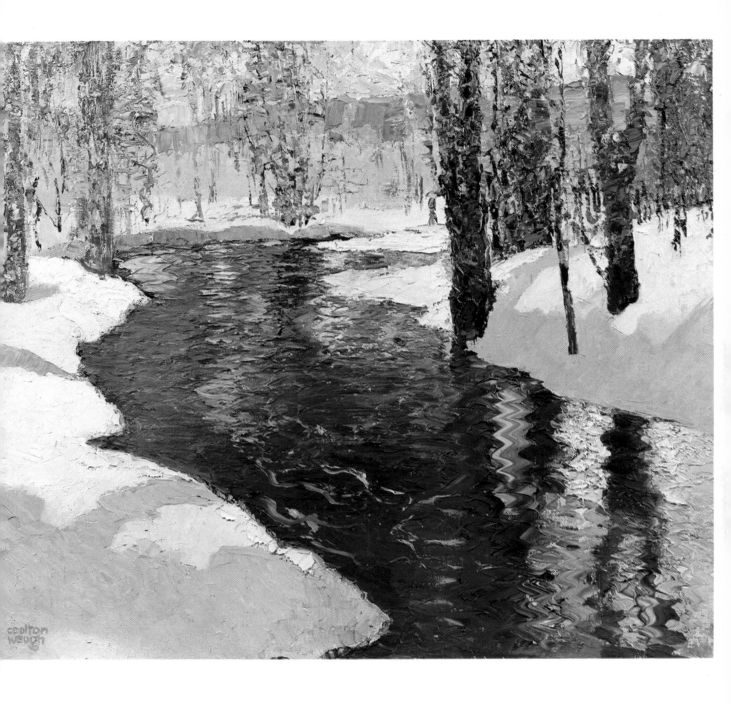

Ira's Brook (Left), 25" x 30". Collection Mr. and Mrs. Ira Newman. Final step of the demonstration reproduced in black and white on pp. 216-222.

Moment in March (Above), 25" x 30". Collection New Paltz Savings Bank. The late March sunlight has suddenly loosened the snow covering my little brook. The water has broken through and is flooding away and beyond, a ribbon of dark colors gleaming and shimmering like old beaten silver or armor plate. The new and warmer sunlight, so exciting and promising at this time of year, sifts in and out of woods and fields, lightly touching the snow which fell the day before yesterday. The first redwing blackbird of the season sings far away. It's a single moment of the year, unique; a transition, time in movement, like the movement of the brook itself.

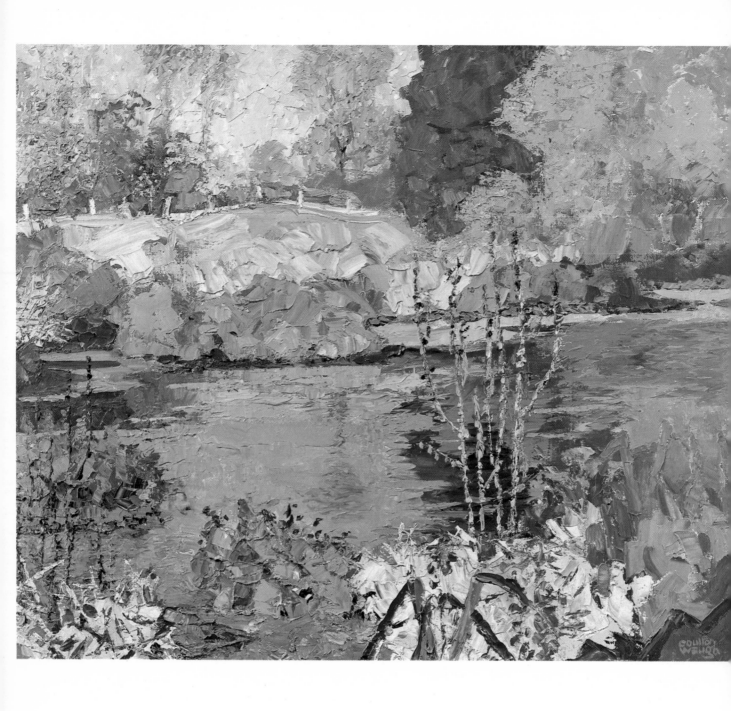

October Pond, *25" x 30". Collection Coulton and Odin Waugh. Final step of the demonstration reproduced in black and white on pp. 206 -210.*

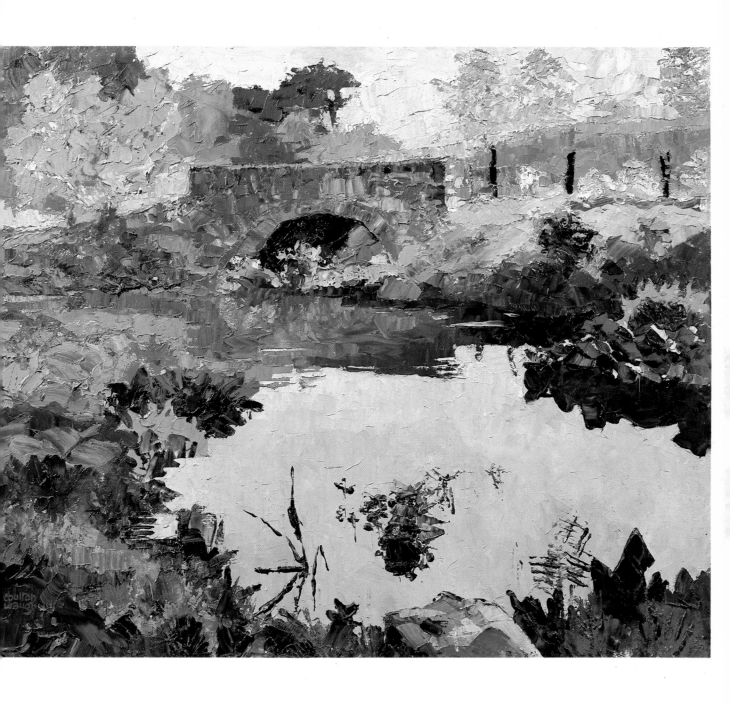

Last Light—The Stone Bridge, *25" x 30". Collection Cooperstown Art Association. Purchase Prize, 1963. Here's the painting I told you about in such great length in the Introduction to this book, the scene my painting knife and I tackled with such confidence one memorable September afternoon.*

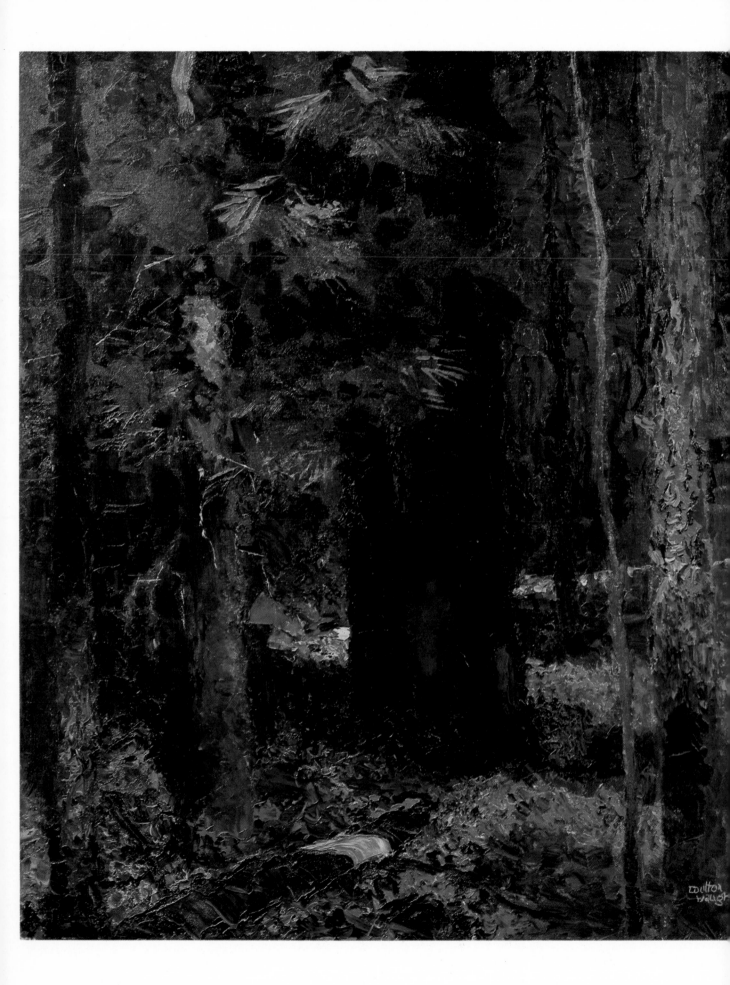

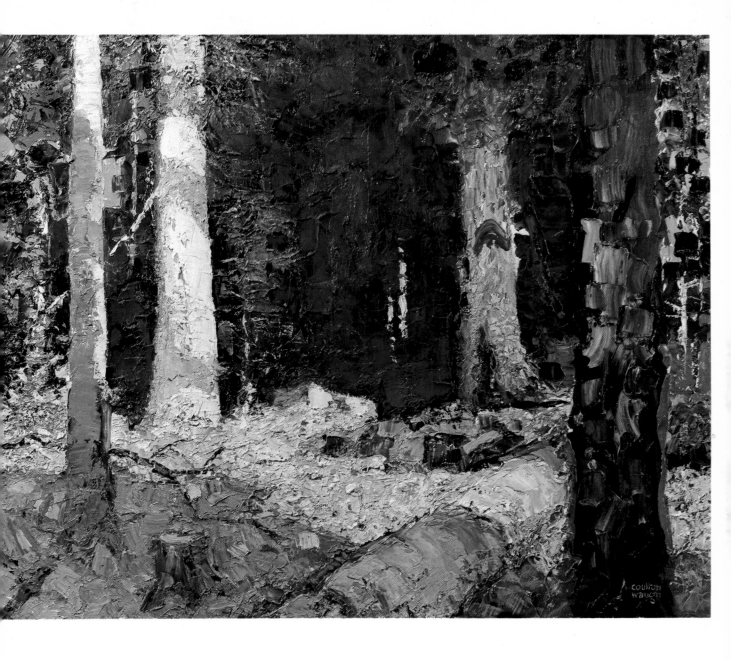

Evening, the Woods *(Left), 25" x 30". Collection Coulton Waugh. These dark hemlock woods are on the property of a lifelong friend, Dr. Henry Cooper of Cooperstown, New York. Henry and I roamed these woods together as boys— they're filled with memories as well as with trees. Years later, my wife Odin and I used to sit on the patio of a little cottage Henry had loaned us and watch the drama of late evening crinkling in and out between the trees and through the undergrowth—at first with a great blaze and excitement, then retreating spark by spark. As the dark filters between the trees, it doesn't frighten you. Instead, there's a feeling of infinite comfort, a sense of home. Long ago, Henry and I might have made a small fire, exchanged a few stories, rolled up in our blankets on the springy forest floor, and gone to sleep smelling the fragrant hemlocks as they arched their protective green fingers above us.*

Pathway of Light *(Above), 25" x 30". Courtesy Grand Central Art Galleries, New York. Final step of the demonstration reproduced in black and white on pp. 193-199.*

(continued from page 127)

grays of the unlivable moonscape. I think it's very useful to become accustomed to thinking of colors in terms of warm and cool—it's a distinction which all artists will understand.

Some colors, you'll notice, are quite close to the center between warm and cool. Take some cadmium red light and mix in a bit of alizarin crimson; you're tipping it to the cool side. Add cadmium yellow instead, and it becomes a very strong, warm orange. Experiment with permanent green light, tipping it toward the cooler viridian on one side, adding lemon yellow to warm it up on the other (see Fig. 118).

There's another distinction you're bound to notice as you study the colors laid out in front of you. Some colors as they come from the tube are very much lighter than others. Lemon yellow is up toward white; ultramarine blue looks almost black. It's so black that you naturally ask how it can be called a blue.

PIGMENT VALUES

This will bring up a vital point in our color study. We must understand that there are certain tube colors—the blues, alizarin crimson, viridian green—which must be lifted with white to acquire color brilliance. Let's run a test with, say, ultramarine blue (you can try this afterwards with other initially dark tube colors). As suggested in Fig. 117, mix in a little clean white, grinding it into the dark color thoroughly, and lay this alongside the first note; then keep adding more and more white until you've almost lost the blue note.

Several things will be obvious. There will be a point, roughly where I've indicated in Fig. 119, where the full burn, or brilliance, of the color will be at its peak. You may be surprised to find how closely this climax follows the introduction of the white. I call this the *hue point*, and this will be what I mean by the word *hue*, in the following discussion.

HUE

Hue means the greatest intensity of a color, like red or green. Please notice how quickly the sense of color becomes dulled after the hue point has been reached. I don't mean that the duller or softer

The Gold Woods, *22" x 28". Courtesy Gwenyth Waugh Clymer. "I crouched beside some hidden stream, I cocked an inner eye, And in my bright and golden dream, I saw the fall go by." These lines were forming in my mind as I started flinging a wild barrage of strokes—little ones, big ones, twisted, round, and straight—all kinds of yellows and golds—flinging them against a bare canvas without the slightest hint of drawing or design. I was carrying out my personal method of painting the millions of leaves which I've discussed on p. 101. After I'd covered the canvas with leaves, I slashed a tree in pure Prussian blue down one side. And there was my fall forest. Try a gold woods like this!*

colors are not beautiful, artistic, usable—you'll find that I assign them a most honored place in my color pantheon. But I think it essential to understand the difference between strong hues and muted colors—in this case, a color muted with white. Strong hues tend to engage your attention, come toward you; when muted, they tend to retreat into space. Here's a most wonderful tool for control of spatial relationships in your pictures. A great many amateurs will put the most violent, screaming blue they can find into their skies, bringing it right down to the horizon; then they wonder why their sky doesn't retreat! The cool blues, of course, retreat more than the warmer colors, but any hue at its brightest point will establish a close relationship with your eye, pulling itself forward.

Now go on around your ring of tube colors, experimenting with each one to establish its hue point. You'll learn a lot from this. Notice, in the first blocks of color you put down fresh from the tube, what variation there is in these darks, which at first seemed quite alike. I'll come back to this point later.

BLACK

I mentioned before that my working palette excluded black and promised to explain why. That time has come (Fig. 120). I don't mean that black isn't a noble and beautiful color. Renoir once blazed out at some of his impressionist friends, "What's this about black being a no-color? Why, black is the king of colors!" and he went on to quote (if I'm correct) Titian, when he said, "The most beautiful of colors is black."

I agree with this—I've loved black many a year. Yet we must remember that when Renoir used black he used it in its pure form, as a touch or two, a *soupçon*, a note of contrast and excitement—such as a black velvet ribbon around the neck of a delightful Parisienne, who's otherwise glimmeringly iridescent. Yes! I approve most heartily of black used in this way. And I say keep a tube of ivory black in an honored spot in your studio—preferably under a glass bell jar. After you've used black for those delightful touches, kiss your black tube and put it away again.

Black, squeezed out on your palette to be used with all the other colors, is dangerous rather than delightful. You see something dark in nature, and without thinking (or feeling) you reach for a touch of black to darken your paint. It darkens it all right! Your flesh shadows go dirty (flesh is not dirt, but luminescence), your sky turns into colorless rain, your sparkling brook turns into mud.

I must explain here that I know there are occasions when a tonal palette based on the blacks and grays will produce powerful and poetic pictures. You have to have a certain set of mind, a certain brooding temperament, to accomplish this. I'm sure that many very interesting things could be produced by these brooders, using the short, wide

I KNOW THAT BLACK IS A NOBLE AND VALUABLE COLOR, BUT—

120. Why Not Black? *Watch out for this gentleman. He can be very handsome—but!*

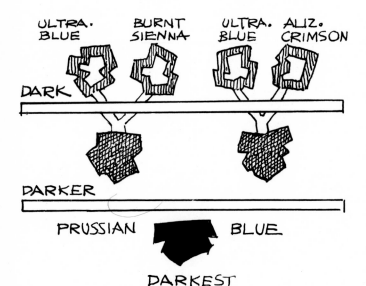

121. Dark Colors *Mix the pairs of colors on the top. Notice how each pair goes down, almost to black. Then check these mixtures against Prussian blue.*

painting knife. But I simply don't have this brooding temperament. Anyway, how can you make sparkling color jewels in black and white? They would look like bits of dirty art gum.

TONES WITHOUT BLACK

You've just completed an experiment which shows that a variety of profound and powerful darks, as well as a variety of delicate and ethereal upper tones can be produced from color tube pigments, without using black or any species of gray, only various admixtures of white. Study Fig. 121 for some other very dark tones which have the glow of color in them. Experiment to find more. And that brings up another set of deep tones, which have so much mystery that I call them the "Magic" colors.

THE "MAGIC" COLORS

I discovered the Magic colors for myself while painting in a little sailing dinghy I had built for the purpose of studying water—her name is the Claude Monet (Fig. 122). The Monet and I were at anchor off Cooperstown, New York. Facing east in late afternoon, the shadowed hill opposite sent a deep reflection onto Otsego Lake, cut with flat sparks of light. What color was that reflection? A deep gray? No—it was a color—but so deep a color, how could I pinpoint it? I realized it was a mixture, a fusion of colors, which were actually there while hardly seeming to be so. A very deep greenish tone, perhaps, ameliorated with some sort of low, pinkish red. I picked up viridian green, lifting it to the right value with white, and mixed in some alizarin crimson. I lifted the mystery right out of the water and put it onto my canvas.

There are many more Magic colors: I suggest you look for them. Mix the deep tones you studied before, the tones of the tube colors, but combine them in various ways, heightening them more or less with white. Look for that moment when something rich happens, something you can't name.

PAINTING KNIFE JEWELRY

Some artists like to mix colors on the actual picture, putting on, say, a brilliant tone first, then softening or muting it with darker touches until they have the balance they want. This system works very well in many cases, and I do a lot of it. One place I use it is in deep woods, with lemon yellow sunlight flickering in and out. I'll lay a lemon yellow ground first, and then ask my painting knife to flash a lot of deeper woodland detail over it—one gets some brilliant effects this way. Most of the time, however, I like to mix color notes beforehand on the palette. The painting knife lays such a strong, clean note of color, if you get this exactly right, wonderful things will hap-

pen. You can hold the color up on the knifeblade and check it against nature—later on I'll suggest a fast way for arriving at color truth through these trial color spots. Mixing a note in this way, you'll need to grind the colors well together with rotating swirls of the knife, as suggested in Chapter 4. But, as also noted there, one should become familiar with the many charming effects possible when two or more colors swirl together in agate-like shapes before final fusion. You may well do this as a deliberate effect, especially important when we come to using the complementaries, to produce what I like to call "painting knife jewelry" (Fig. 123).

However you may talk about the final effect, you need to know a lot about the actual working pigment to be able to produce it. I want to range over these working pigments so that we can examine them closely, learn something of their special qualities—a vital kind of information to put away in the computer of your mind, to guide you, to free you from doubt and indecision in the hot moment when you turn that painting knife loose. Let's take up these colors by families, beginning with the wonderful blues.

COBALT BLUE

In my sketch of the blue family in Fig. 124, you see that I've assigned the central position to cobalt blue. This is not because cobalt is more dominating or fiery than the others, but because it's a middle blue, a true blue, neither purplish like ultramarine nor inclined toward the green like cerulean. Cobalt is a gentle color, sweet and feminine by nature. It lacks covering power, and so doesn't work as well with the block strokes of the painting knife as some of the other blues do. For this reason, I worked quite a while without cobalt, getting its special color quality by mixing ultramarine blue and cerulean. But I've come to feel that cobalt, especially when used in high sky tints, is too purely beautiful a pigment to be without. Surely Boudin—whom someone (was it Renoir or Cézanne?) once referred to as the king of skies—must have used it to get those transparent tints which seem to arch over us very high up, very far away. If you let a lightened cobalt tinkle over your picture, lightly touching the other colors, something wonderful will come into it—the stuff we breathe, the air. This is a great secret. Use it!

ULTRAMARINE BLUE

Quite different from delicate cobalt is sturdy, full-throated ultramarine blue. Of a distinct violet note, it's one of the most passionate dark-tone tube colors; you can use it with full intensity for a black and it will cover and keep glowing. It's a real blue, even if a substitute for black. The empty tubes of this color which I've thrown away would reach around the earth!

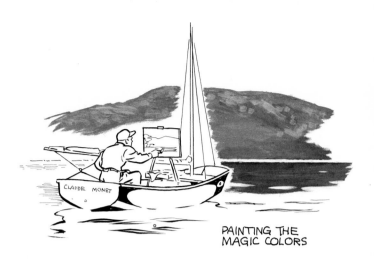

PAINTING THE MAGIC COLORS

122. The "Magic" Colors *There was magic in the moment, as well as in the colors.*

123. Painting Knife Jewelry *Watch your paint as you mix it—you may see something beautiful!*

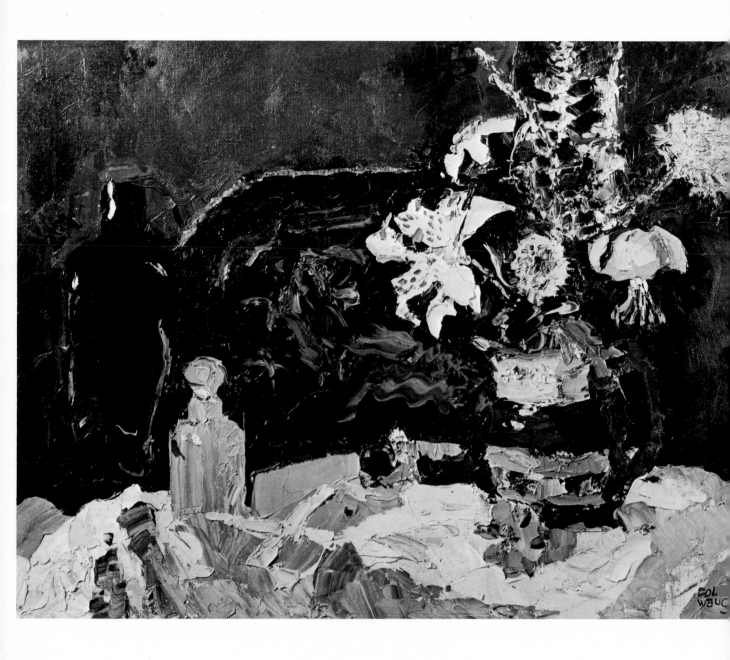

Cooperstown Still Life, *20" x 24". Collection Coulton and Odin Waugh. These objects were created with mass rather than with outline. Having set the objects up in a dramatic lighting, I was seized with the beauty of their color relationships, the way they were waving their colors toward each other over a swimming darkness of air. Here, I slammed ultramarine blue darkness around a yellow flower, cutting the petals to a razor edge with a Magic knife. I saw the big bottle as an ivory black silhouette, finished in a few seconds with one big slide of muted gold just inside the edges and a few fast flicks of light—one, two, three, four. Fortunately, my time ran out, and I didn't have time to ruin it.*

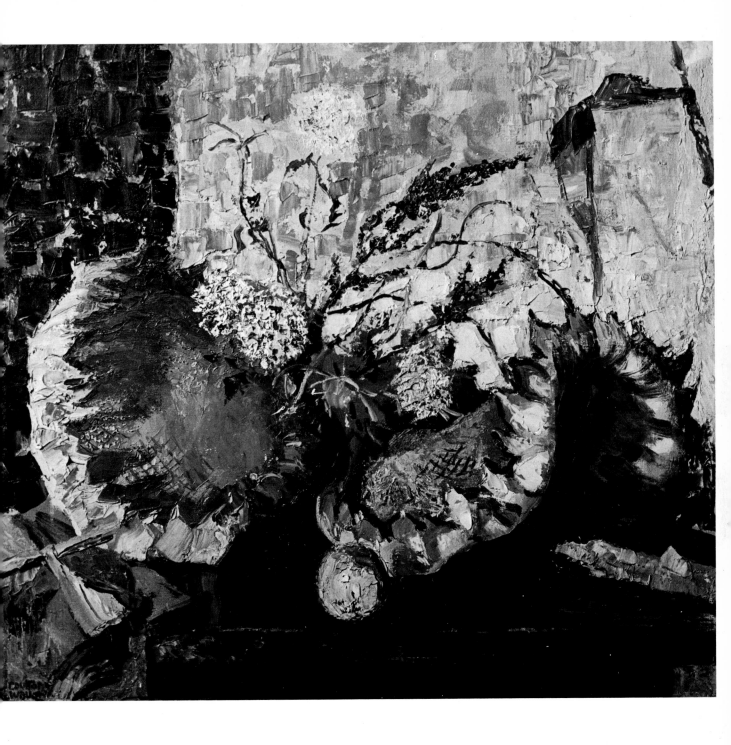

The Sunflower Heads, *30" x 36". Collection Coulton and Odin Waugh. These are the heads of huge sunflowers grown on our farm and bristling with seeds. Besides their size, there's a great rhythm and vitality about them, a message as to what may burst so surprisingly out of the dark soil. I combined them with corn leaves and wild flowers to make a kind of magic picture, a prayer to the gods to make my fields fertile again next year—didn't the cave painters expect to catch more animals by ornamenting their cave walls with pictures of them? This painting is a parade of textures: look at the bristling seed part of the right-hand head, the intricate crowns of Queen Anne's lace done with short, heavily pigmented strokes going first criss, then cross. But the feature texture in this painting is the free use of block strokes.*

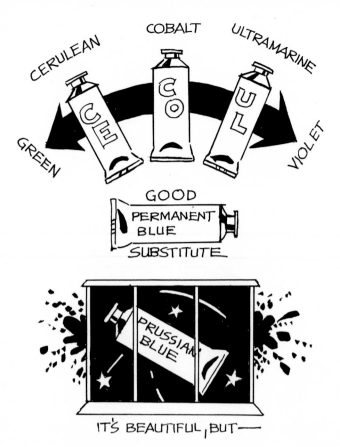

124. The Blue Family *They're a beautiful group, those blues. Notice how they tip toward green on one side, toward violet on the other.*

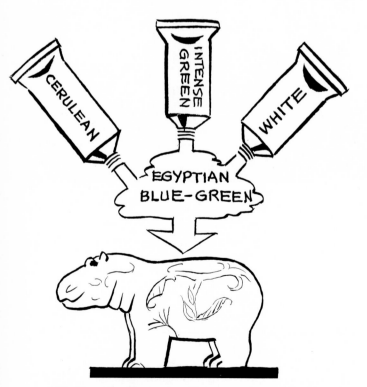

125. Egyptian Turquoise *Turquoise against gold was the royal Egyptian color chord. Even this hippopotamus rates a coat of glorious faience blue.*

PERMANENT BLUE

For quite awhile I used permanent blue as a substitute for both cobalt and ultramarine, and you can use it this way if you wish to add violet to it to make an ultramarine, or add cerulean to tip it toward cobalt. It's an inexpensive, good, hardworking color. If I had to choose one blue for all purposes, it would probably be this.

CERULEAN BLUE

Cerulean blue! This is my color, a kind of childish toy which has delighted me all my life. I first came across it studying Eastern and Near-Eastern pottery and textiles many years ago in The Brooklyn Museum. Flanked with lapis-lazuli and gold leaf, this is what gives the living joyous quality to Egyptian carvings, jewelry, artifacts—objects which might have been only pompously impressive without it. I strongly advise the student of moving color to follow the turquoise thread which weaves in and out of Near-Eastern art in The Metropolitan, Brooklyn, and other museums. As you look at this regal color, think, "Why, I have this same thing back at home—cerulean blue—in my paintbox!

MAKING EGYPTIAN TURQUOISE

Maybe I shouldn't do this, but I'm going to give you the deepest color secret I know. Pure cerulean, by itself, is not *quite* as splendid as the Egyptian turquoise. But you can easily make it so (Fig. 125). Lift the cerulean up with a bit of white—not enough to lose the fire—and then add a trace of that special kind of viridian called phthalocyanine or intense green. Maybe I should have saved this one recipe for my old age. I have certain still lifes with backgrounds of this color which I love so much that I often just walk around the studio, carrying them.

PRUSSIAN BLUE

Prussian blue. Ah, Prussian! This is another color which, like black, I don't include on my basic list, yet it's one which I think artists should use, at times, for certain to-be-specified purposes. But when we speak of Prussian, it should be in lowered tones, pulling down the curtains, for Prussian is dangerous. I don't mean poisonous (though it is toxic), but difficult, temperamental, jealous. Prussian is the outdoor black *par excellence*, intensely blue-black, yet scintilliant with a curious inner light. When you're out some fall day among the fiery yellows of the sugar maples, when you're looking toward the light and it comes stabbing through that high, hot gold, look at the dark of the trunks and you'll think "Prussian." Then use Prussian just as it comes from the tube (Fig. 126). Yet, as I warned, you must watch yourself. Prus-

sian spreads, *stains*. It's very difficult to clean from the knife; it leaves traces everywhere, gets into other colors and kills them—it wants all the show for itself; it thinks it's God. Contain it, keep it separate from the other colors, and you'll be all right. A good substitute for Prussian blue, with more permanent qualities, is phthalocyanine blue, which works far better than it sounds.

VIRIDIAN GREEN

Coming to the green family, we find only two representatives on my palette, viridian and permanent green light. Viridian is one of the most remarkable of the colors. It's not true green, not a green hue, being inclined to the blue side of green. It's a sour, acid kind of color. Beginners are forever using it to express foliage, even foliage in sunlight, something violently against the nature of viridian to express. There are two lights which come down through the summer sky (Fig. 127): one is sunlight, strong, but very definitely on the yellow side, turning the foliage and grass which it strikes to a higher, yellower green than in other places; the other is the light in shadow—places from which the sun is blocked—with light coming down from the blue part of the sky, turning the outdoor shadows toward blue.

When such shadows fall on grass we get a deepened, bluish green; this is where viridian comes in. Too sour to use full strength, it can be ameliorated with a trace of violet or burnt sienna, and then will prove very effective in carrying a charge of light. Another dramatic use of this color is to add it—as a trace only—to a large amount of white; this will produce a sky tone of remarkable luminosity, corresponding to that part of the sky quite close to the horizon, which higher up will turn toward cerulean, then to cobalt, and, finally, at the zenith, to ultramarine. It's a very common error to try to push ultramarine down to the horizon, where it just won't go.

Try this sequence of sky green and blues on your palette and check it with nature. It might prove exceedingly useful to you.

PERMANENT GREEN LIGHT

Moving over from beautiful, but sour and tricky, viridian to dependable, easy-going permanent green light is a pleasure. This is a bland green, toward the yellower side, for which we may find many uses. Please try this: mix this color with quite a bit of white and notice when a fresh, delightful spring green results—not harsh or sour, but pleasant, youthful, one of the most beautiful and usable notes on the palette. Permanent green light with a bit of white and a trace of cadmium yellow light or lemon yellow will give the true feeling of sunlight on grass—the particular thing for which viridian is so often used and which it's far too sour to suggest. Permanent green light with

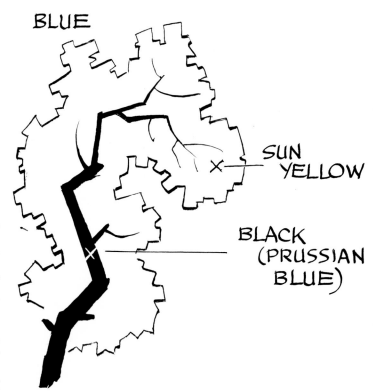

126. Blue-Black and Gold *What pigment can give the intense dark of the treetrunks needed to set off the fiery yellows of fall leaves? Prussian blue!*

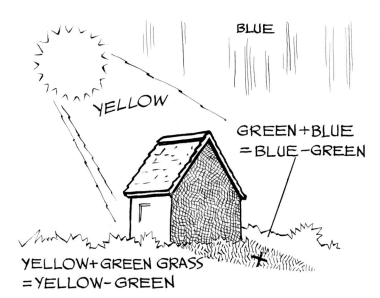

127. The Two Lights *For outdoor painting, understanding these two lights is crucial. Study this little diagram and check it out on a sunny day.*

just a bit of viridian will give a true middle green—like the green of a billiard table.

THE VIOLETS

With the violet family we're sailing in tricky waters. During my studies of Eastern and Near-Eastern art years ago, I became enamored of the magentas and purples—you'll remember that Tyrian purple, an extract of the murex shell (Fig. 128), became the color of royalty—kings were "born to the purple." Purples and magentas are natural colors, colors of the spectrum, colors of many flowers; yet the true purples don't seem to be made in truly dependable oil pigments. Mauve is a beautiful, fiery purple, but it's nonpermanent, and so is rarely used. Cobalt violet is an intense pinkish or reddish purple, very interesting and usable—but, alas, the colormakers' listings tell us it's poisonous. There are quite a number of purple and violet pigments which are safe to use and which are permanent. The trouble is, these lack that Tyrian fire. I use the one I like the best in this category—manganese violet. It's splendid as a deep note, one of the reasons I use it. Its intensity fades out rapidly when mixed with white. I have it on my palette, and I keep a tube of cobalt violet for special use. If you try this, be careful not to cut your fingers while using it. Another valuable special color is Thio violet. If tipped somewhat toward the pink, it has a flower-like freshness and brilliance.

ALIZARIN CRIMSON

With the reds, we're on much firmer ground. Alizarin crimson, coolest of the reds, is a regal color, which does everything you ask of it and then some. Without white, it makes a powerful dark note of pinkish reddish black; it gives brilliant pink when lifted with white and the most delicate, baby ribbon-like tones when boosted still higher. Transparent by nature, it has a high glaze potential and can be used to top other colors very successfully. Thin a little out with turpentine to see how it acts as a transparent glaze, and contrast this with the color as lifted very far up with white. One can find special uses for each effect.

CADMIUM RED

Cadmium red is another magnificent color. Warning: if you want warm, glowing scarlet, flower scarlet, Gauguin scarlet, use cadmium red *light*, not straight cadmium red. Cadmium red alone simply hasn't got the final wham. For true red, feed a trace of alizarin crimson to cadmium red light. Please do this right now. I'll sit back and enjoy the thought of the fun you're having.

CADMIUM ORANGE

About the oranges: cadmium orange is a perfectly beautiful color, but it's so easy to get this through cadmium red light and a touch of cadmium yellow that I leave it off my palette in the interest of a more simplified arrangement.

YELLOWS

You may feel that the groupings of three yellows on my palette is redundant, especially after what I've just said. A way to simplify the group would be to cut out cadmium yellow light, or rely on this yellow alone. Both arrangements, with a bit of tipping, would work very well. My use of the three yellows is because I'm a painter of sunlight and I find very special values in each of these. Mix cadmium yellow medium, for example, with raw sienna and you'll get a true gold, the gold-leaf color of old picture frames.

Try an experiment to establish the peculiar value of this color. Lay two flat tones of any ordinary colors side by side, say a blue and a green just coming together without any blending or fusion. Do you see how banal, cheap, ordinary, such an edge is? Look at nature and you'll find that there's always something exciting happening at the edges of things. In my view, dead edges are not *painting*. Now take a bit of that gold-leaf color I was talking about and run it lightly along the edge between the colors—suddenly this experiment will turn into *painting*. Perhaps it's a trick, but it's a beautiful, magic trick. It tends to separate forms, give them bulk, solidity, so you feel the air behind them. Don't overplay this—just a hint of a deep gold is often enough.

THE BROWNS

Of the family of browns, I feel that only two are necessary—raw sienna and burnt sienna (Fig. 129). Earthy raw sienna, full of body and force, is a color of infinite possibility. Its richness obviates, for me, the necessity of including yellow ochre, a thinner, more flaccid color, which is mainly useful for fleshtones. Even here, the two siennas are ample; burnt sienna lightened with plenty of white makes a magnificent fleshtone, perhaps mixed to vibrate with the more golden or ivory feeling of raw sienna and white. These flesh colors live. If yellow ochre were running in my veins, I'd be a sick man.

SPECIAL COLORS

I've spoken of special colors which I think it's wise to have in reserve, putting them on the palette when special conditions arise which call for them (Fig. 130). I've mentioned ivory black, Prussian blue, and cobalt violet among these, and I'd like to add three colors which are of great value in the

128. Royal Color *This is* murex brandaris, *a shell from which the ancient Mediterranean dyers obtained their royal purple.*

129. The Good Earths *Some of the earth colors are a lot like real dirt, but not these—they glow with real color.*

130. The Special Colors *I advise you to try all these intense colors—they go to extremes which you may find very useful.*

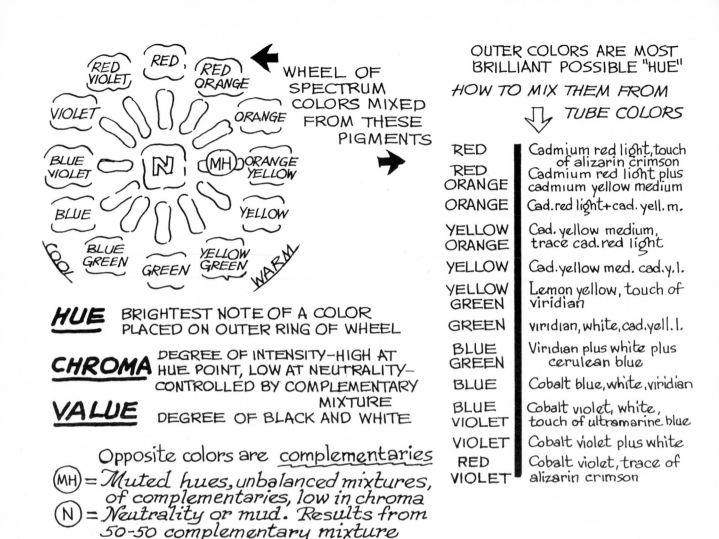

WHEEL OF SPECTRUM COLORS MIXED FROM THESE PIGMENTS

OUTER COLORS ARE MOST BRILLIANT POSSIBLE "HUE"

HOW TO MIX THEM FROM TUBE COLORS

RED	Cadmium red light, touch of alizarin crimson
RED ORANGE	Cadmium red light plus cadmium yellow medium
ORANGE	Cad. red light + cad. yell. m.
YELLOW ORANGE	Cad. yellow medium, trace cad. red light
YELLOW	Cad. yellow med. cad. y. l.
YELLOW GREEN	Lemon yellow, touch of viridian
GREEN	viridian, white, cad. yell. l.
BLUE GREEN	Viridian plus white plus cerulean blue
BLUE	Cobalt blue, white, viridian
BLUE VIOLET	Cobalt violet, white, touch of ultramarine blue
VIOLET	Cobalt violet plus white
RED VIOLET	Cobalt violet, trace of alizarin crimson

HUE BRIGHTEST NOTE OF A COLOR PLACED ON OUTER RING OF WHEEL

CHROMA DEGREE OF INTENSITY—HIGH AT HUE POINT, LOW AT NEUTRALITY—CONTROLLED BY COMPLEMENTARY MIXTURE

VALUE DEGREE OF BLACK AND WHITE

Opposite colors are **complementaries**

(MH) = *Muted hues, unbalanced mixtures, of complementaries, low in chroma*

(N) = *Neutrality or mud. Results from 50-50 complementary mixture*

131. Wheel of Spectrum Colors *Memorize the names of the spectrum colors (right) and learn how to mix them (left).*

blazing season of fall when the outdoor painter needs the most passionate fortissimos pigments have to offer. Phthalo yellow green is one of these, landing on the grass right from the sun; cadmium orange is another—great when there's hardly time to mix orange from other colors; and cadmium lemon is still another, an expensive cousin of plain lemon yellow, which can render the brilliance of fall leaves with the sun striking through them better than any pigment I know.

THE UMBERS

As to the umbers—shall we talk of something else? I see no reason for spending beautiful green money for mud. You may object, "But aren't the umbers very useful in producing deep, rug-type colors?" We're just at the point where we'll be looking at another way of producing such deep colors—richer, more brilliant ones. This system will also show you how to make mud in a deliberate, voluntary way, from the colors already laid out. Mud color is necessary, sometimes. But the mud devil is always there, waiting for us painters, ready to pull us down when we're off our guard. We should understand the nasty stuff, so we won't fall into the swamp.

THE SPECTRUM COLORS

Let's forget about mud. I'm going to invite you to join me in an exploration of mud's opposite, light, rendered with glorious virility through the understanding and use of the spectrum colors. Up to this point, we've been speaking of, and examining, the pigments of the color tubes. I've mentioned many special ways in which they work. But I haven't brought up the great, major use we can make of them. Have you a clean palette and a freshly cleaned painting knife? In the experiments which follow, please see that the piles from which you pick your colors are perfectly clean and fresh, as if just from the tube. The slightest taint of other colors will spoil everything.

We're going to mix some colors at their hue points. And we're going to call these colors by new names, the names you'll find in the black and white color wheel shown in Fig. 131. These are the scientific names derived from the rays of light we see in the spectrum; the names for which a definite wave-length of light has been established. You'll see that the color wheel is *not* the same as the group of pigments on my palette which have names given by paint manufacturers. At the same time, since we artists work with pigments and not with color rays, we have to use the pigment colors to approximate light ray colors.

COMPLEMENTARY COLORS

The listing to the right of the black and white color wheel shows what tube colors (referred to by their usual names) you'll need to mix approximations to the spectrum colors, the true colors of light, whose names are on the wheel. As a start, mix two spectrum colors from the pigment scale: red hue and green hue. Study the table to see how these are made.

All ready? Please mix red hue, according to the recipe given. Then mix green hue (every trace of the red must be wiped off your knife). Now comes a big moment. Pick up a good slab of red hue and spread it down flat with a strong stroke. Now pick up a small amount of your green hue. We don't want a strong stroke here—we want a stroke of the most extreme lightness. Keep your knife parallel to this red color; let it come down lightly, lightly; touch it to the red; draw it across a short way; then, suddenly, lift it (Fig. 132).

If you've done this properly, if what you've produced is what it should be, you'll be at the core and center of this book. You'll be painting in a special way, painting with fire, and doing this not only by virtue of the clean pigment but by virtue of its application with a flexible painting knife. You'll find, I believe, that producing such effects is one of the greatest arguments for painting with a knife. Let's consider what you've done.

If you've done it properly, the green and the red won't have merged or fused together. Painted wet-on-wet, the green touch will lie there intact, perfectly clear, its edges sharply defined. And the character of the green and red will have changed. Now they're not the earthbound pigments they were—they're pulsations of light, almost seeming to breathe, to move. Notice the high, increased brilliance of the green, the extra fire of the red (Fig. 133). What's made this remarkable, exciting effect?

For the expalnation, let's refer to the black and white color wheel in Fig. 131. From this, you'll see that red hue and green hue are complementaries; they're the colors farthest removed from each other on the color wheel: red is the color with the least green; green has the least red. They're opposites; that's why fire jumps between them.

Remember that an electric battery has two poles: a negative and a positive. Connect these with a wire and what do you get? A spark. Consider the opposites of male and female. What happens between them? More sparks. This is the value of the color wheel. It will show you which colors are complementary to each other, without mixing or fusion, the spark will slash every time.

I feel sure you'll want to try associating some more complementaries, and I hope you have great enjoyment in doing so. I hope you'll try some of the lesser known ones: blue-green and red-orange (how beautiful it sounds) and a lovely, unusual relationship, yellow-green and red-violet. Because of violet's extreme sensitivity to other colors, this will be the most difficult pair to lay one over the other, wet-on-wet. But if you can do this without spoiling the colors, you'll have mastered this particular technique.

RED HUE GREEN HUE

try this — see
what happens!

132. The Jewel Effect of Complementary Colors *Handle complementary colors in the right way and you'll be able to make something fabulous- color will be working for you.*

painting
with fire

133. Paint or Fire? *Associate the complementaries and your paintings will flame like fire!*

adapted from an old Persian
manuscript

BLUE-
GREEN

RED-
ORANGE

blue-green and red-orange
are complementaries

134. Color Complementaries in History *Look at Persian illuminated manuscripts in any museum and you'll see how far back the brilliant use of complementary colors goes.*

Try more than just one dot of color over another; experiment with free overlying shapes. You'll see that what we're really doing is creating a kind of painting knife jewelry. Why are jewels so valuable? Because of the abstract value of the brilliant colors they possess, often in complementary relationship. Expect, then, to create rare and beautiful color jewels on your palette, and it's a short step to the same kind of color excitement in your pictures. Study the color plate on p. 129, together with the key drawing on the opposite page which shows the various uses to which the color complementary system may be put.

You may wonder what the word "complementary" means. It helps to consider the word "complete." Consider that a wheel of colored light rays and a wheel of colored pigments work differently. On the light ray wheel, all the colors added together make white, while on the pigment wheel, all the colors added together made mud, a dark neutral color. As a result, when light ray colors overlap or are added to each other, they become lighter; this system is therefore called "additive." But the pigment wheel colors, when mixed, darken each other, subtracting from the light which each had before. This system is called "subtractive." When we associate the complementaries without mixing them together, the colors, as it were, jump into the air and tend to vibrate together in an additive way. As in the additive system, they tend to become lighter and brighter by such association; they're trying to add up to white; they're trying to complete the additive color grouping. Each complementary brings what the other hasn't got; they complement each other by the mutual necessity of being in each other's company; for it's only then that each realizes its potential to the full.

It isn't possible for me, at this point, or any point, to write about or illustrate all the really wonderful possibilities of working with painting knife complementaries (Fig. 134). It's a kind of impressionism, of course. If you recognize how the small color sparks given off by our flexible knives relate to Monet and the other impressionists' techniques, you'll realize that the radiant richness of the complementaries carries on a long tradition of gorgeous color constructed in this way.

Originally, this use of complementaries came from the East and Near-East, from Persia, where the illuminated manuscripts almost burned their vellum pages with the fire of the complementary relationships. The warmth of such color contrasts inflamed Byzantine mosaics and Coptic textiles, then moved to Venice, where, like some other Eastern contributions, it helped to light the wondrous artistic fire of the Renaissance. I trace the complementaries very clearly through the Italian masters, from Giotto, through the Venetians where contrasted complementaries helped to build the splendor of the canvases of Titian, Tintoretto, and Giorgioni; through the Van Eycks and such marvelous colorists as Van der Weyden,

Vermeer, and Hans Memling.

Alas! I must admit the complementary thread became obscured as bitumen and the craze for browns took over and all but buried the brilliant old masters who struggled bravely below it. But no bitumen could kill the spirit of color; it will last as long as the sun sends down its full spectrum light rays for artists to take apart and glory in. There came the day when Constable took a brown violin out in a green field and made an audience agree that grass was really not brown like the violin. Then came Boudin with his discovery of luminous air, Cézanne with his gorgeously colored modulations, and Gauguin, who, of all the rest, most powerfully and artfully associated rich complementaries.

With all this background, is it any wonder that a painter like me, stumbling over his father's discarded small, broad, flexible painting knife, should experiment with it and discover that it could play the wildest and most wonderful tricks with complementaries, picking them up together on opposite sides of the knife, letting them flash together as the knife flickered itself almost loose from his hand?

As I've tried to point out, painting with the complementaries is not new; what *is* new is that by the nature of the painting knife, it's possible to extract more fire from complementary pigment. Certainly one can paint complementary pictures with brushes. But, as I've mentioned before, a brush leaves a little set of grooves; these cast lines of delicate shadows, which lower the fire of the color. With the knife, we stand at a peak of freshness and brilliance. I don't think pure brilliance, just by itself, is so wonderful. But two brilliant complementaries, unequally associated, *are* wonderful indeed!

Before we leave the subject of the jeweled complementaries, there's one more point I want to leave with you. Complementaries don't seem to like to be associated in equal amounts. Red hue and green hue, if laid side by side in equal areas, scream with horror—they make us very unhappy. Try it, it's something to remember. Then cut down the green area, let the red dominate—or the other way around. Instantly, all is peace and joy (Fig. 135).

There's a great deal more the little painting knife can do besides whamming in bold complementaries. One of the reasons I was originally attracted to it was because I'd spent my boyhood in the woods and simply had to find some way of expressing the mystery I'd found there. The woods talk. I couldn't get the feeling of all those crackling twigs and leafy forms, the elusive glinting of light, the loftiness, the rich sense of the tapestried forest floor. It was impossible to get these maddeningly difficult things with brushes—for me at least. Suddenly, when I found that knife, the woods I wanted appeared. It's the flicker which does it. The knife moves through a forest interior, not specify-

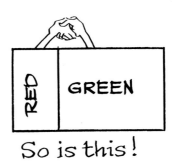

135. Let One Color Dominate *Complementary colors arrest the attention—they'll clash if given equal weight, so keep them unbalanced.*

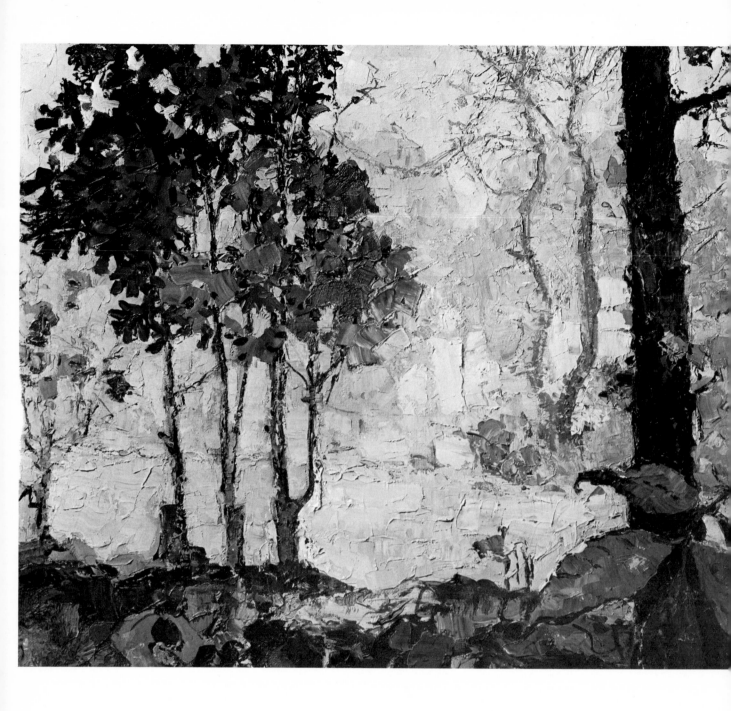

The Color of Fall, *25" x 30". Collection Mr. and Mrs. Raymond Ruge. "He came to unlock the gates of light" wrote Ruskin about Claude Monet, and I was thinking of these words as I started work on this painting. It was such a gaily colored afternoon, with sun streaming from the left, across the meadow, lifting the light up to a big note of high lemon yellow. Beyond, the large silhouettes of woodland trees were turning into a bluish violet haze.*

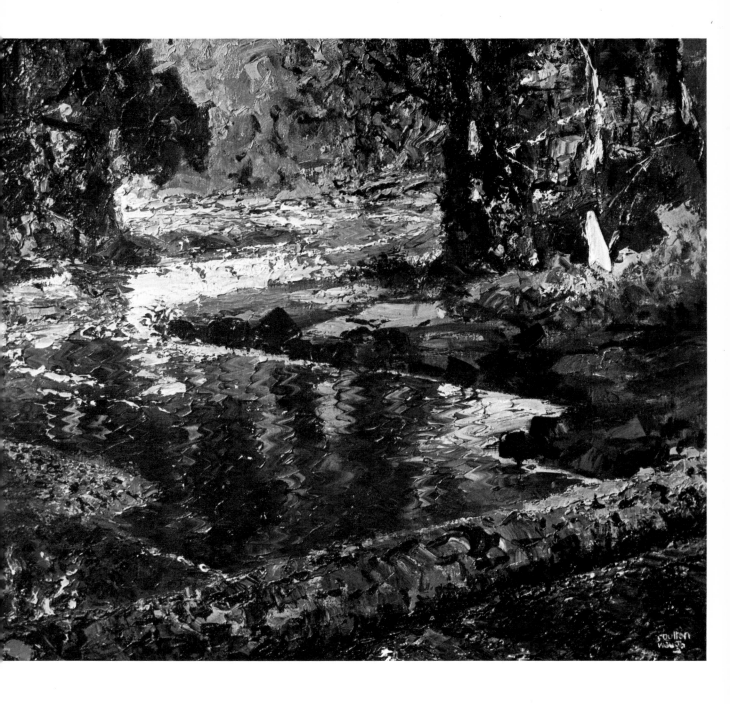

Red Creek, *25" x 30". Collection Coulton and Odin Waugh. This isn't my brook, but one much farther north, belonging to my old friend Dr. Henry Cooper. Henry's brook is wider than mine, and moves with a more deliberate rhythm. I rejoice in Red Creek, Henry's brook, not only because I splashed in it as a boy, but because its water displays such divine wibble wobbles. There's a lot of color in Henry's brook, too. It runs through a gorge, a real ravine, and one side is usually bathed in light yellow-green, while the other is shrouded in mysterious darks. There are big, flat table-like rocks lining this brook and wonderfully rotten logs—we used to dig into them, years ago, to catch various little hiding creatures. Now I prize their patches of elegant green moss as a delicious natural color note.*

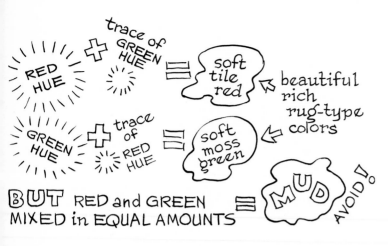

136. Muted Hues *Here's a rare color secret: mix colors in unequal amounts and they make exquisite, rug-like colors; mix them 50-50 and you get mud.*

ing or making outlines, but adding up feelings, expressing them by suggestion. In nature, details are confused, they blur. Hold the knife very lightly, perhaps charged with several colors, and your details will blur too.

There's one important matter, on the color side, which we must take up at this point. What happens when the complementaries, instead of being merely associated side by side or laid on top of each other, are deliberately mixed together?

MIXING COMPLEMENTARIES

Let's try it (Fig. 136). Take a gob of your red hue, mix in a very small amount of green hue, grinding the two together to get a flat tint. The brilliance has gone right down from the two hue points, but you'll find something very beautiful lying on your palette. It's a red, but a much softer red than red hue; it's a kind of tile red, gentle, quiet, friendly. Now try it the other way around, mixing a trace of red hue into green hue. Here we have another very attractive muted color; we could call it moss green. It has a shadowy charm and coolness, it belongs alongside a gleaming brook. It also belongs alongside that muted tile red; notice that though these two colors are softened complementaries, they're still complementaries, still colors which belong together. Even in their quiet way, their relationship is evocative of life and beauty.

We can carry this process a step farther and get two darker muted colors which still retain their red and green individualities. It's in this lowered range that I give you my answer to the question asked before—how can one get the soft, deep, rug-type colors without using black? Here they are, rich and quiet but still glowing—that is, as long as the mixture between the original notes of red and green is a one-sided one, more red than green, or more green than red.

BEWARE OF MUD

But what happens when the mixture becomes exactly equal, when we introduce as much green as there was red into the mixture? Try it. Make the mix 50-50. What have you got? Ugh! Shudder! Mud!

In each of the two original colors there was a degree of light. (Remember that color is part of the scale of the light rays.) When green began to reduce the color red, a lot of red's light was lost, and green's too. Each time these colors were mixed, more light was lost. They were still rich and beautiful when mixed in unequal amounts, because some of the light was left; but with a 50-50 mix, each opposite cancelled the other out. The result was that all the light had winked out; what was left on the palette was only a hunk of dirt.

This hideous denouement should teach a lesson to all of us. It means that if an artist fiddles and tinkers with his picture too much, adding layer

after layer, scrubbing after scrubbing, the light is bound to wink out of it; suddenly it will flop down on its stretchers, dead. The moral is this: use those rich, lowered complementaries, but watch out for that 50-50 dead point—*learn when to stop!*

USING MUTED HUES

Another thing about these muted hues: try some of them as background to the sparkling color jewelry. As you go back to nature to test these ideas, you'll see combinations of jewels and muted tones everywhere. You'll see that bright hues and flashing colors advance; muted hues retreat. This will give you a control over the ability to make color spots seem near or far away.

By now, you've just about absorbed my whole color system. Taking darks further down than the muted hues has been mentioned before, as we investigated the great range of darks possible from undiluted tube pigments. It's been shown that very high ethereal tints may be obtained with additions of white to the tube pigments, resulting, not in gray, but in very delicate actual color, producing the effect of that huge upside-down bowl of air which is the sky. The echoing of such sky colors in and out through your picture is what will give it unity, and this unity will be richer and more moving because you've expressed everything through color. You can see now that it's possible to range all the way up and down the scale of values, transposing or translating them into the colors which they really are. Working in this way, the totality of your picture will give you that sense of parallel richness to nature which was the purpose of assembling this color system.

CHECKING COLOR AGAINST NATURE

A final item gives us a fast method of matching our color spots with those of nature, using three tools: (1) the color wheel of hues, (2) the range of values in black and white, and (3) the range of chroma (brightness or dullness). Here are the three steps, also covered in Fig. 137.

(1) Fix on some color spot and decide on its general color name in terms of the color wheel. You might think, "This patch is blue hue tipped toward blue-violet." Mix some of this hue color (for further details on how to mix hues, see p. 155).

(2) Now decide on the value, according to the value or acromatic scale in Fig. 138. Is it low dark? High dark? Etc. Adjust your blue spot accordingly, using low tube colors (not black or gray) to darken, white to lighten.

(3) Now hold a smear of the mix on your painting knife next to the actual spot in nature (Fig. 139). Have you picked the right color name? Is the value about right? If not, adjust your color mix. Now for

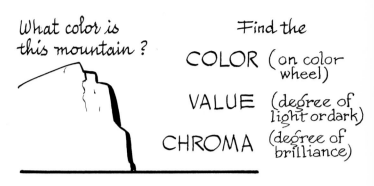

137. Matching Colors Against Nature *This system works if you practice it carefully and faithfully.*

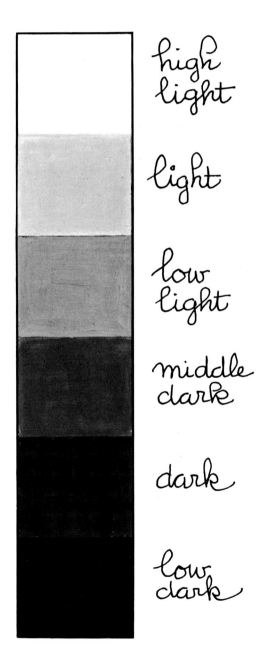

138. Scale of Values *Get used to the names of the values on this scale—it will help you in matching color notes.*

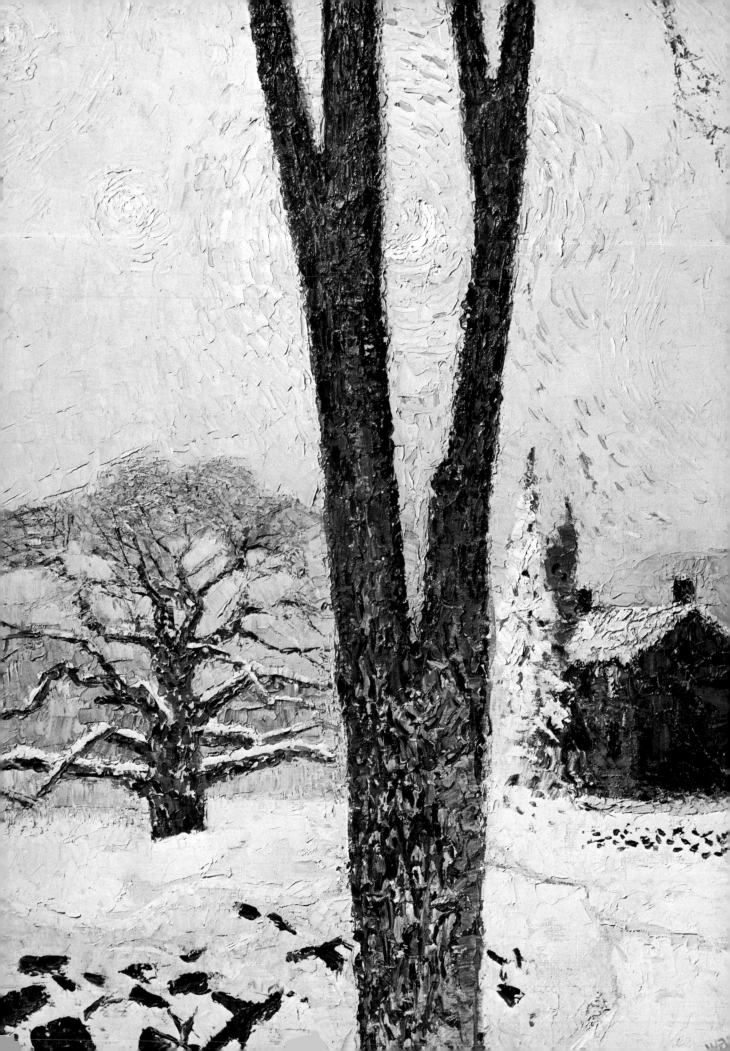

the important consideration of chroma (degree of brightness or dullness; for further details, see p. 155). Your paint mix is bound to be bright, because you haven't dulled it yet. Let nature guide you here. If the blue is a curtain, the chroma you mixed might be okay; but if the blue is a mountain across the Hudson River, your mix would undoubtedly be far too bright. If so, touch in a bit of the complementary, such as orange or burnt sienna. Just a bit of adjustment in this way and you'll poke that blue right across the river.

After a bit of practice with the hues, you can switch to thinking of the actual pigment colors in Step I. For example, estimating a spot in nature as blue-green, you'll think of it at once as cerulean blue, perhaps with a trace of viridian.

This color system is curiously appropriate to the subject of this book, the painting knife. This, no doubt, became apparent as you experimented with the production of sparkling painting knife jewelry. But our remarkable little tool has many more color production potentials hidden up it's metal handle. You've seen the great variety of stroke it can produce; now we must wed all the strokes and all the colors together.

We must then take this combination to nature, to see what it can do for us in rendering the near and the far, the glowing and the subdued, the poetic and the flamboyant. And I hope that through all the demonstrations which follow you'll find something which will further your art understanding as well as your delight in the work itself.

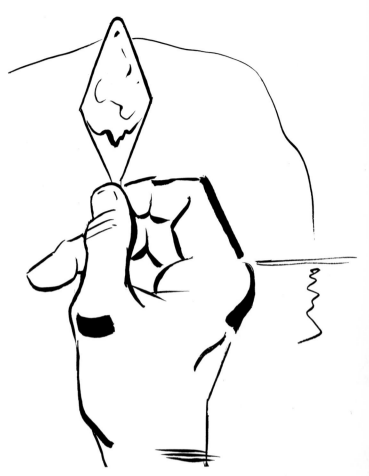

139. Keep at It! *If your color mix doesn't match nature, don't give up. Adjust it until you get the results you want.*

The Moon Tree *(Left), 24" x 30". Collection Coulton and Odin Waugh. We country people know two aspects of a winter's night: we can huddle inside the little spaces of our homes, warm, hibernating, or we can step outside into the cold, the hugeness. Empty space was coming all the way down from the Crab Nebula this winter's night, but the sky was magnificently illuminated by a horned moon, trapped (as I saw it) between the dark arms of an elm as tall as antiquity.*

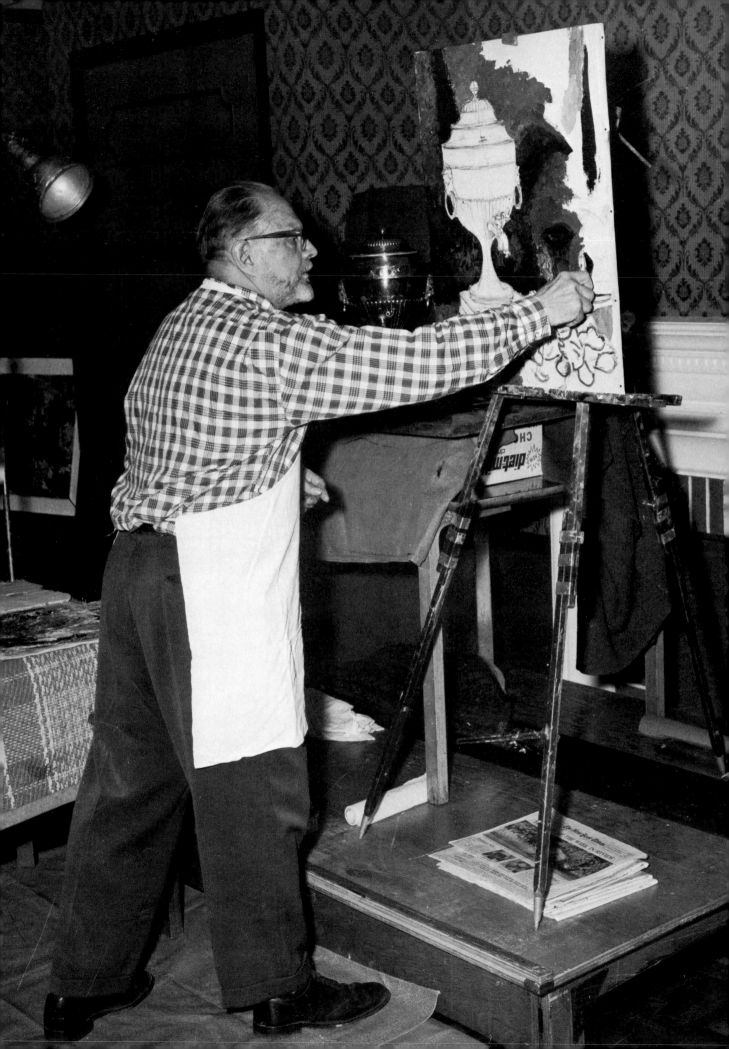

DEMONSTRATIONS

The Artist at Work *Here I am working on one of the demonstrations coming up. My apron isn't usually this clean, to say nothing of the floor—I'm in my Sunday best because I knew you'd be looking over my shoulder as I worked!*

1
AN APPLE

Now we go into real painting. These are demonstration exercises, not theoretical explanations—I want you to take that knife and slap on pigment with gusto, with intense enjoyment. Please remember the methods we'll be putting together: the exciting new use of the painting knife, the creation of rich, enamel-like, vibrating textures, the use of brilliant light and exciting, gay color.

Color is the very first thing for you to think about. Visit your best supermarket and shop for an apple—*the* apple—the one in which you find color at its highest sparkle. You can see the apple I used for this demonstration in color on p. 130. (Remember: fluorescent light kills the red colors. Check your apple under daylight or incandescent light.)

Don't feel you have to match my apple in doing your own apple painting. You may find one you like better, perhaps with a dramatic sploosh of yellow or green across the red. Okay. But don't buy it at all, or paint it at all, unless some rocket of enthusiasm has gone off in your mind. I want you to see this not as an apple but as beauty itself. Once you see this way, you're off—you'll do a real painting.

At home, arrange your apple a little lower than eye level using a rumpled white napkin as a background. It's a small subject; you can easily get it onto an 8" x 10" canvas board, with a margin of about 1" all around. Have incandescent light pouring from the upper left to give you a dramatic cast shadow. You'll need a full range of colors, a Magic knife (others, too, if you like), a bit of charcoal, some clean rag, and hand-cleaning gel.

Ready? Go!

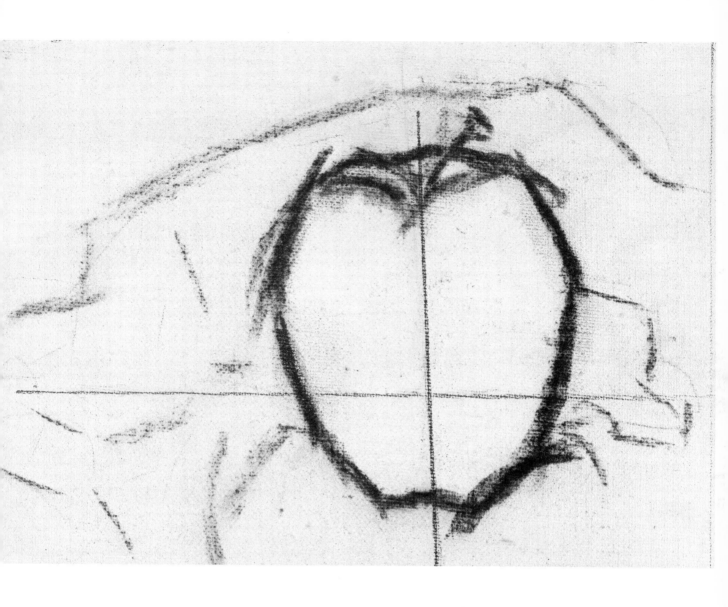

Apple (Step 1) First, I study this composition with an apple through a view-finder to establish an arrangement I like; now, I sketch it in lightly with charcoal on canvas. I draw the horizontal line of the table and the long, upright axis through the apple, observing the slight tilt to the left. This axis line is extremely useful in dividing the apple in half, enabling you to compare and balance both sides. As I work, I dig more energetically into the contour of the apple with my stick of charcoal to define not its outline, but its mass.

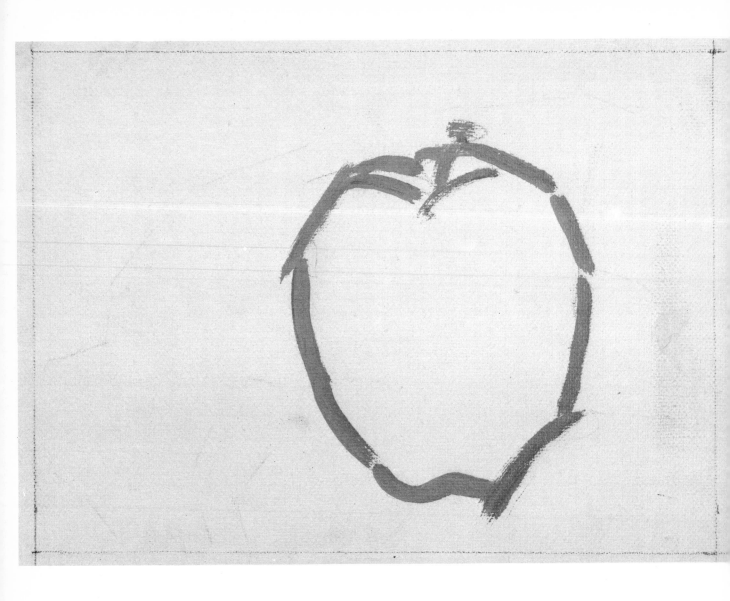

Apple (Step 2) The heavy black charcoal line is flicked off with a clean rag, leaving a wide, quite light outline. This outline is gone over with a paintbrush charged with raw sienna diluted with turpentine, to provide a deep gold working ground on which the edges of the apple and the color of the background can be brought together. This eliminates unfortunate white gaps of canvas at the edges of the apple and provides plenty of room for me to manipulate the paint from both inside the edge and outside the edge of the form.

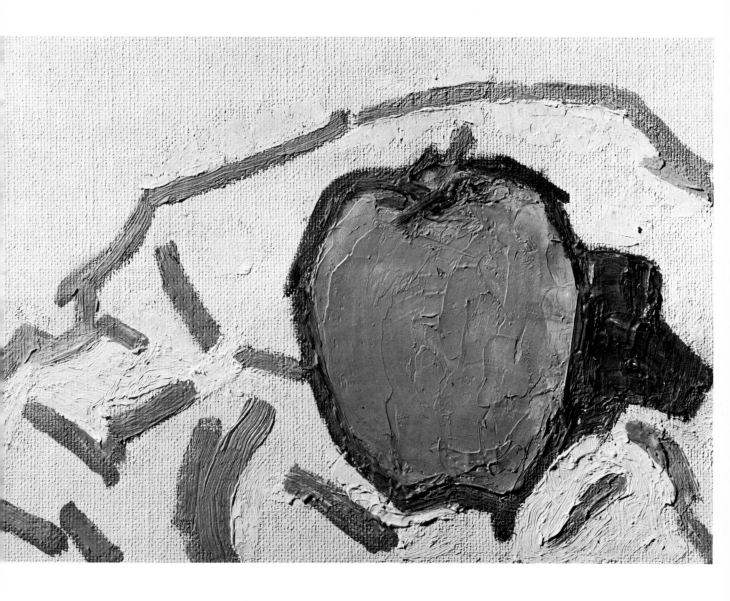

Apple (Step 3) I go over the background with the same gold outline of diluted raw sienna that I used for the apple, defining the rhythm of the folds of the napkin which move up and around the apple. If you look at something through squinted eyes, you'll be able to see the main color note, rather than details. I do this and find the main color note of the apple to be cadmium red light. I slap on the paint, moving the knife to follow the roundness of the apple. I cover the entire apple—shadows and all—in this way.

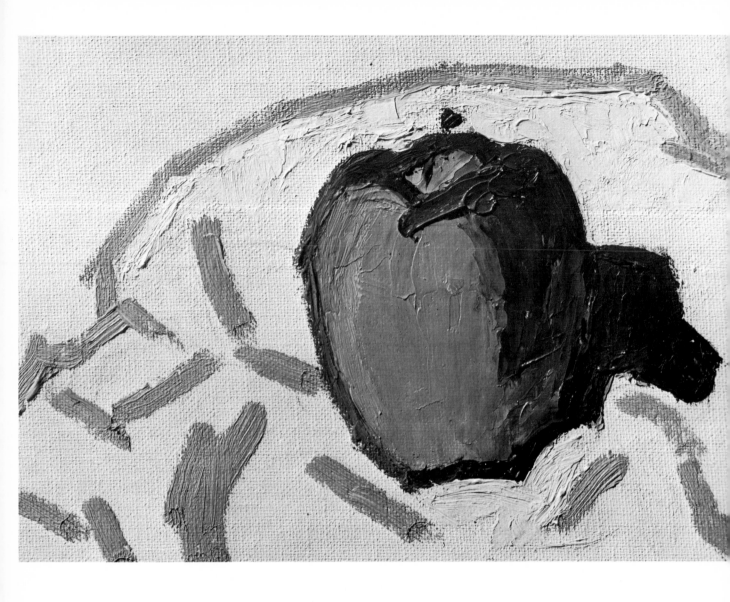

Apple (Step 4) The next step is changing a flat, one-color object into a modulated, three-dimensional one. To make the cadmium red light color of the apple recede, I use alizarin crimson, a cooler red, to turn the edges of the apple, and in the main shadow. I use a cooler red for the turning tone rather than a complementary color because I don't want to lose any of the exciting redness of the apple. The two reds (warm and advancing, cool and receding) are vibrated into one another with the knife, shaping the apple into a round mass.

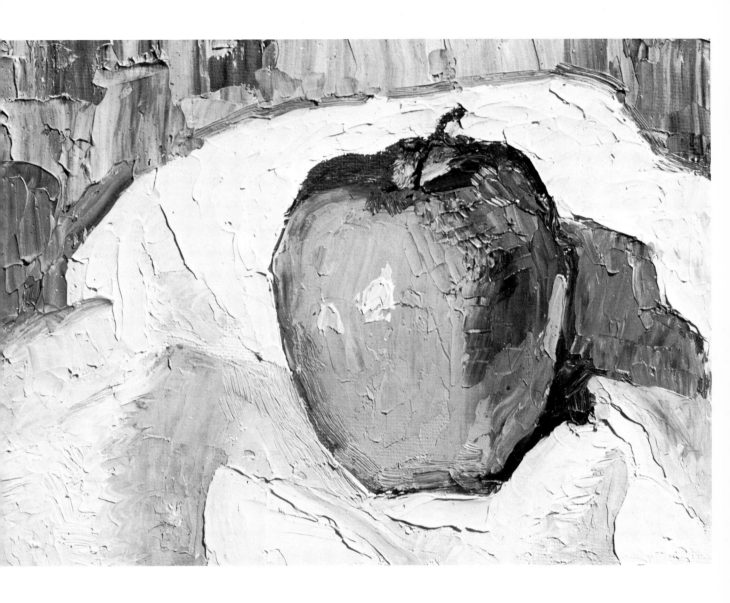

Apple (Step 5) The background is painted in with soft lines to contrast with the crispness of the apple. The napkin is done in white with shadows of green tone. The tone behind the napkin is cerulean blue with a trace of white mixed with raw sienna. I purposely leave the colors somewhat separate, using a rich, up-and-down texture to preserve the impasto quality of the picture. And, finally, the last touches are applied to the apple: a green glow at the top and light pink highlights cut into the surface with quick, sharp flicks of the knife. (See this final step in color on p. 130.)

2
STILL
LIFE

Now that we know all about apples, let's bite into something different. Let's start constructing complete pictures, taking up, in this and the next three demonstrations, important elements particularly relevant to the use of the knife. The first of these demonstrations shows how to deal with more complex shapes, how to construct detail through painterly manipulation, and how to begin to suggest the magical relationships of light and shadow. Let's concentrate on all three of these aspects at once.

First, look for some fairly simple object, yet one with enough variety of shape to make you sweat a little. Make it one that has a big over-all tone, yet with a bit of decoration and detail too. Arrange a posing stand, say with boxes on a table, which will raise your arrangement up to the level of your shoulder (this study should be done standing up, using your easel). Now for the fun. Put a mirror face up on the stand. Arrange some rich fabric for a background. Do you have a large seashell? Some other interesting small objects? Put a couple of them on the mirror, too, toward the front right. Now arrange an incandescent light coming from the upper left. The two objects give you shape, the rich background provides texture, and the reflections in the mirror add mystery. I found a perky little china dog for my main object, a spiny murex shell for the smaller one, a bit of rich brocade for the background. Now look at Step 1 of the demonstration which follows to see how it adds up.

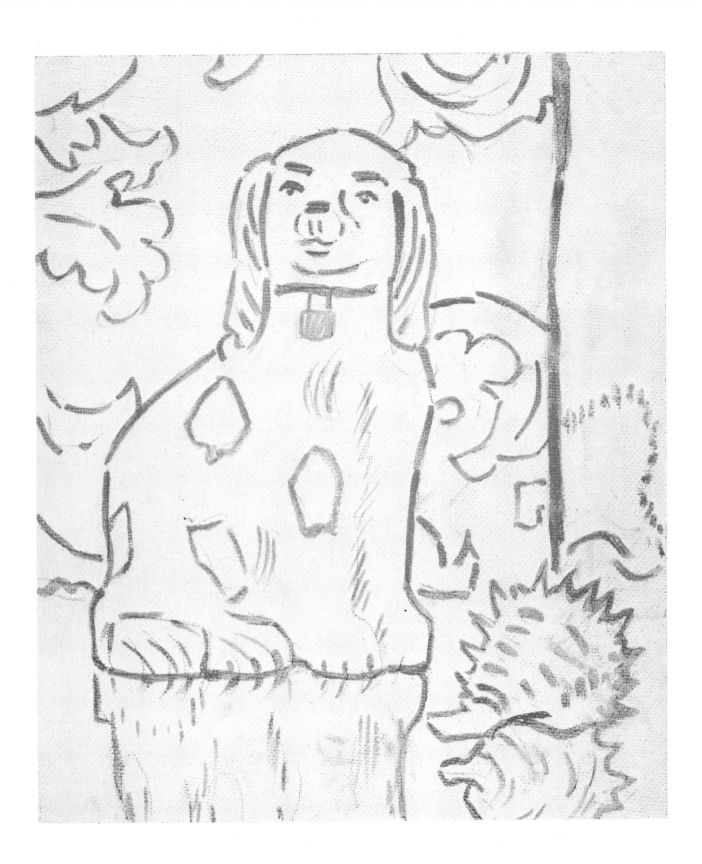

Still Life with Dog and Shell (Step 1) Notice how I placed my dog a bit off center, allowing for a calm area to the right. The shell, making a triangle with the dog, is more toward us and dropped down. The darker brocade pattern displays the dog's light color effectively. The line of shadow it leaves against the lighter background to the right gives a strongly constructive upright line. Arrange your objects with such vitally important design considerations. Sketch outlines lightly in charcoal, dust off, then go over them lightly with raw sienna diluted with turpentine.

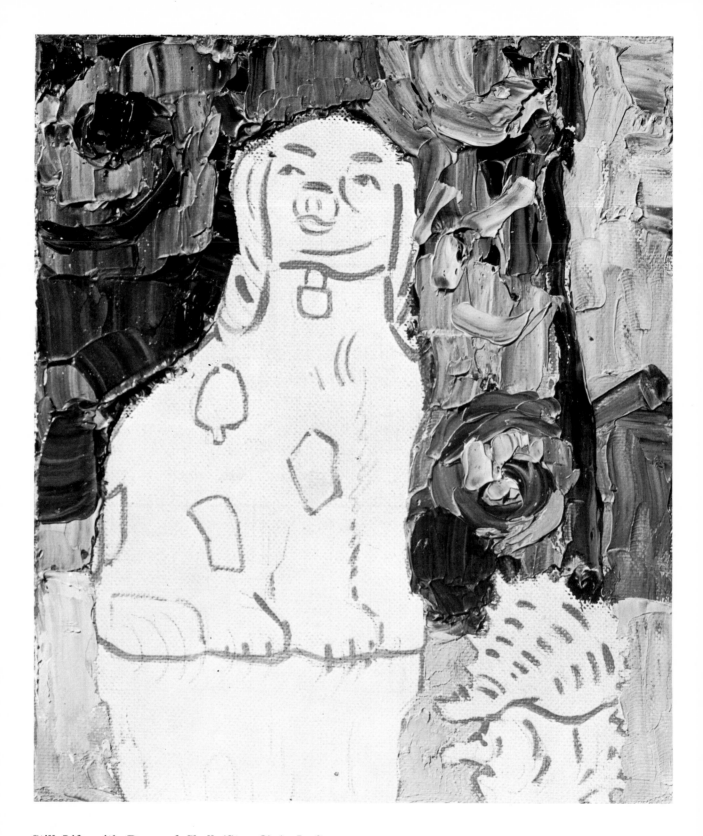

Still Life with Dog and Shell (Step 2) As I often
do, I work the darker area first, enclosing the main
point of interest and constructing it by contrast.
Here, the darker area is the rich brocade. There
are several deep, muted colors in it: I mix them on
the palette and using a Magic knife, start to apply
them with a heavy final knife texture.

Still Life with Dog and Shell (Step 3) Now I study the dog's over-all tone of old china—a soft, creamy white—and I butter this on all over him, searching for the true silhouette, disregarding details for the time being. I suggest you proceed in the same way. Note the dog's main shadow tone carefully (its color is a little more bluish than the warm white body); its value is quite light to preserve the final light china feeling of the body. I knife this on and then, cleaning my thumb (I rarely have a clean thumb!), I vibrate light and shadow softly together. At this point, I consider the shell, and get its main tones down (forgetting those prickles). The drawing of the shell depends on the position of its long axis line tilted up from the glass. Get this right, and you can compare the two sides.

Still Life with Dog and Shell (Step 4) Now it all happens! With my best energy, I tackle that head—its details really give me a workout. I see the little muzzle sticking out and get its shape. Then, taking a Magic knife, I mix a sharply darker tone and start snicking in the eyes and the dark details. It's difficult but very exhilarating. In places, I use a mini knife, resting my right hand on my left for control. Several times I fail, scrape out the face, start again—I'm a stubborn man. Suddenly, I've got it. After that, the ears, the spots on the body, and other details are delightfully easy; so, too, the soft, mysterious reflections and spikes on the shell. I hope you'll share in that final exhilaration, too.

3
WILD
FLOWERS

With this next demonstration, we move into a somewhat different area of knife painting, less detailed, more free and liquid. I want to show you how, by flipping your knife around a bit, you can use impressionistic suggestiveness to draw close to the mysterious beauties of nature. In this area of painting knife work, wild flowers have always been a particular inspiration to me. They're so modest, so individually self-effacing, yet so capable of grouping together to suggest a mass effect of intricacy, beauty, and nature. Let's work with them. I've foraged outdoors and picked wildflowers, an armload of them, and arranged a group in a small, simple, white pitcher.

In this demonstration I'd like to introduce you to the Rembrandt lighting effect. The cagey old painter used to let a shaft of light come down from some upper window, allowing for shadow in the unlighted parts of his painting. I try for this dramatic feeling by deliberately blocking out some of the upper light with a piece of cardboard or a panel. In my demonstration, the light comes from the upper left. Set up your flowers, move a piece of cardboard around in front of your lamp, and watch for the point of drama—then *stop!* We're going to paint just that.

The Wonderful Weeds (Step 1) The big design consideration here is the total mass of the flowers: I plan to have mine filling up more than half of the upper part and spilling down into the lower. The pitcher goes to the lower left. Light, coming from the upper left, makes an arabesque movement on the pitcher which is picked up by the delightful, sparky shapes of the long weeds, some falling against a dark ground above left, others dropping down to the lower right. Consider these rhythmic movements as you arrange your flowers. A soft cloth over my stand accentuates these movements.

The Wonderful Weeds (Step 2) In this Rembrandt lighting, I see a deep velvety background of ultramarine blue mixed with burnt sienna. I apply this first down around the wildflower group and the pitcher, already getting some of the wildflower effect by leaving areas of canvas bare. In this case, I apply a white silhouette over the entire pitcher. Consistent with the loose effect of the flowers, I'm treating the pitcher and base loosely—I'm trying for a heavy paint texture throughout the picture, which I'll get with loose vibrations of a Magic knife, using plenty of pigment.

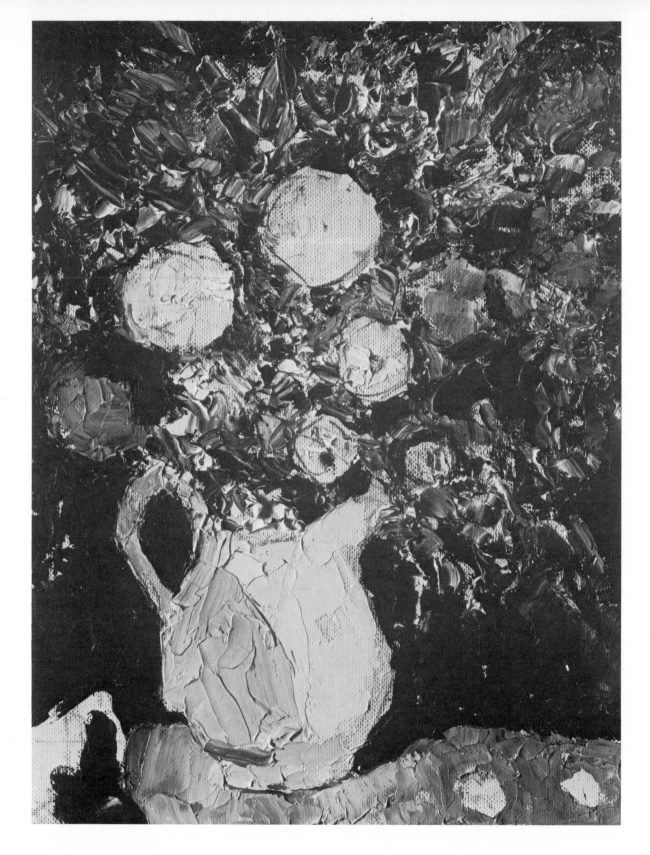

The Wonderful Weeds (Step 3) Now I begin work on the flowers themselves. As you try this, I suggest you squint your eyes to blur detail. Look for the vibrating, effect of the total mass—this is what I'm after at this stage. I pick up a number of light, muted colors, all together, without exact arrangement, covering the underside of a Magic knife. I slap these colors on rapidly with a quivering wrist, pouncing them up and down, watching the general effect, adding a touch of some special color when needed. I don't let myself stop to investigate the particular shape of any particular flower, although I decide which flowers are shrouded in shadow and which tend to stand out. I add a shadow falling across the left side of the pitcher.

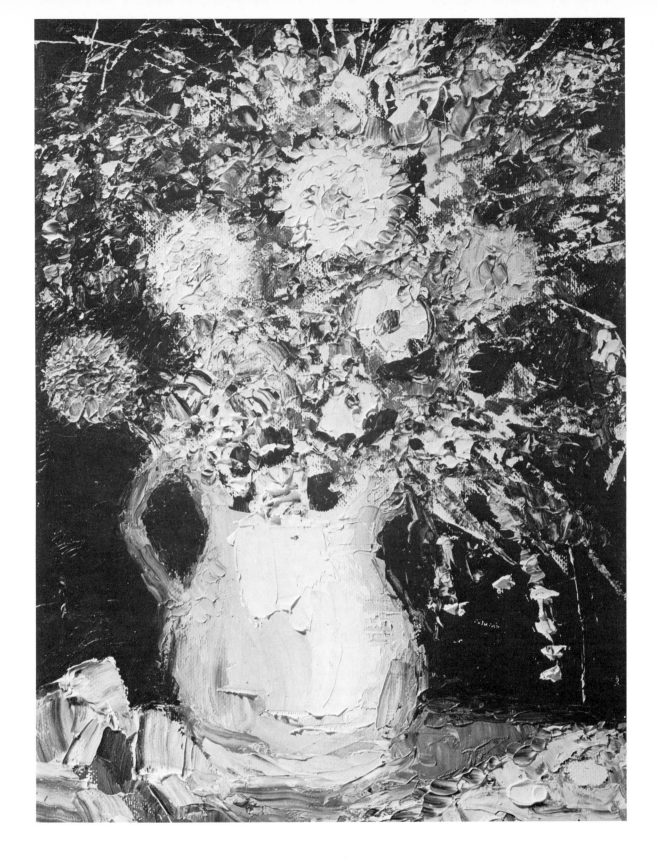

The Wonderful Weeds (Step 4) Now we must finish those flowers. Wait! I don't mean tighten them up; their loose, wild character is better expressed by loose, wild painting. But we can emphasize one or two to make focal points; we can introduce a few notes of dark; above all we can get—with the point of a Magic knife and heavily loaded dabs—the sharp, staccato dots on the graceful little weed sprays falling down from the upper right and lower left. We can see, too, that the bottom of the picture has sufficient interest. I have fun using heavy pigment, which makes agate-like transitions. Now our wildflowers are finished. I hope you enjoyed it as much as I did!

4
SHINE
AND
GLITTER

In this demonstration, I want to introduce you to a certain ability of the painting knife, one which I can't, perhaps, analyze and take apart as I have the others. This is something that comes out of the living tissues of the mind under the spur of strong inspiration. If I can't tell you how the mind works, I can tell you how the knife works—and maybe that's enough. To try this effect, search your house for something really glittery, something which throws off sparks of light.

Silver? That's the best. In my case, I'm using a family silver tea urn. Brass and copper objects are good, but they have a lowered glitter, so try to fish up something in silver. Set it up in a Rembrandt lighting. How are we going to paint it? With silver paint? No, that wouldn't work at all. There's a curious process here, which, if you master it, will enable you to paint far more than silver tea urns. You'll be able to paint sunlight sparkling on the sea or on the surface of a glittery running brook, as well as light sparkling on the jewels so proudly displayed by the portrait painter's model. Learn the secret of the silver urn, and you'll have a very special area of painting at your command.

The Shine and the Glitter (Step 1) You may think I've drawn my urn too much to one side. If this were in color, you'd see that it's balanced by the white cloth and especially by the little bottle standing on it, which is a true, fiery, Persian or Egyptian turquoise blue (you know already how I feel about this color). In drawing the urn, I first set up an up-and-down axis line. Then I mark divisions of shape on it and compare the outlines of shapes on both sides.

The Shine and the Glitter (Step 2) We start as before, with a sploosh of heavy dark buttered around the object. This sets up a value relationship right away that we can check our other lights and darks against; it also begins to bring the main object into being. Yet all we have now is a white urn. It may be hard to visualize what will happen, but there are times when faith is the only ticket.

The Shine and the Glitter (Step 3) Now we're going to do something that may seem ridiculous. We're going to look at all the dark places on the urn, forgetting about the sparks entirely. Check the color and depth of these dark notes and paint the entire urn with them; it will almost disappear into the background. There will be very little silver effect; the whole thing will be just dark mud. A friend of mine saw me do this at a demonstration and told me afterward, "When I saw you muddying your whole picture into nothing, I said to myself, 'Coulton has got himself into a corner; he'll never get out of it!'" Can we get out of it? Well, we can certainly try.

The Shine and the Glitter (Step 4) So, in place of silver, we have this dreadful, muddy-looking thing. But wait. I pick up my little Magic knife. I clean it thoroughly, then I squeeze out fresh piles of white and lemon yellow. I pick up a good load of both these colors. Wham! I slap on a whole set of white strokes, dots, and other suggestive shapes, which, seen together, create a startling sense of silver over the dark ground. In places, I lay in a simple silhouette of the bottle to the right in brilliant turquoise and the apple to the left in my most delicious cadmium red.

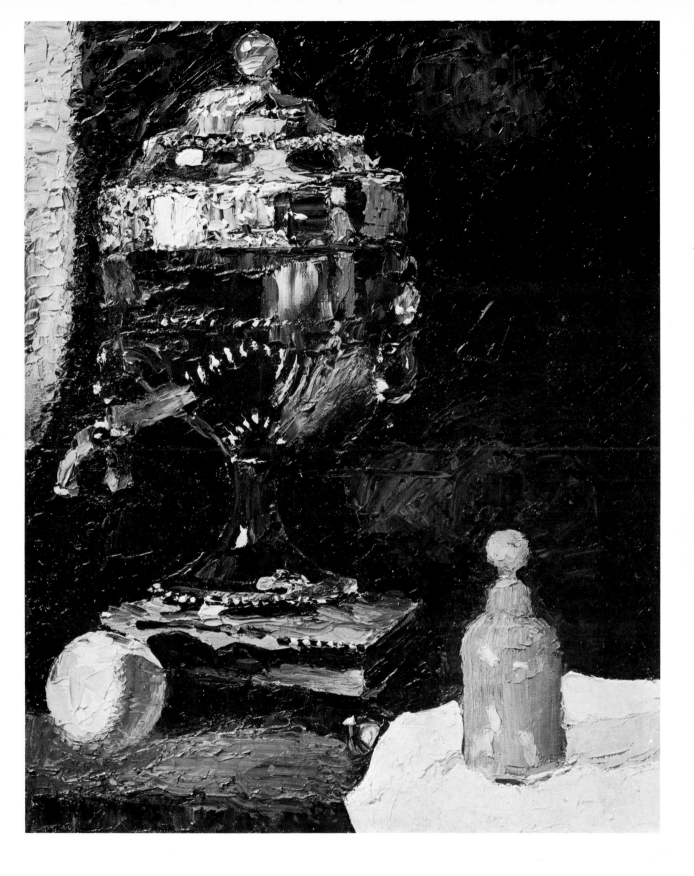

The Shine and the Glitter (Step 5) This apparently magic effect is actually based on the ability of the painting knife to lay fusing strokes wet-on-wet. So we have the sharp glitter of silver. Now I dot and flick pure white, using the point and edge of a Magic knife. This is carried down across the body and over the silver base. The apple and a shadow to the right have been finished; the background tone has been extended to the edges, and the final touches have been added to the bottle and drapes.

5
BOATS
ON
THE
RIVER

I love the sea and boats. To understand this love, you must know that I'm an old ocean sailing man cast up on the shores of the Hudson River. I plunged into the maritime history of the Hudson and soon learned all about Hudson River sloops, those tall craft which had carried the river traffic before the days of paddle-wheel steamers. Yes, I knew the sloops intimately, through pictures, through models; yet it was hard to believe, one day in 1969, that I was looking at an actual Hudson River sloop, a real one, complete in every way, actually sailing up my particular river, the Hudson! It turned out she'd been especially built to publi-cize the need of cleaning up pollution on the river—in fact, her name is the Clearwater. A kind friend, seeing my ecstacy—and my agony—at being on land at such a time—took me out in his motor boat and we spent a wonderful morning chasing the sloop around. My wife Odin and I made sketch-es of the light on her sails and her lovely feminine hull. If you like boats, follow along with my pic-ture in the demonstration which follows. If you don't like boats, leave the sloop out—no, that wouldn't make sense. Put the sloop in, but say to yourself, "I'm studying how to paint mountains and light on a majestic river."

My Love for the Sloop (Step 1) I'm happy we have the color plate to check with in the color section of this book, because the general group of colors, or color chord, has a lot to do with the design of this picture and was a primary consideration. I saw the warm light gold of the sails in the afternoon sunlight against the mountains in light and bluish green shadow; a high yellow-green sky with a patchwork of gold-edged, violet clouds; a band of ruffled blue under the boat and a band of light gold under that, with the darker notes of the two boats and the wharf section in front. The purpose of the outlines is to delineate these color areas, to keep them separate. Make a different arrangement if you want, but follow along with the patchwork color idea. Make your sketch in charcoal, dust it off, and go over the outlines with raw sienna diluted with turpentine.

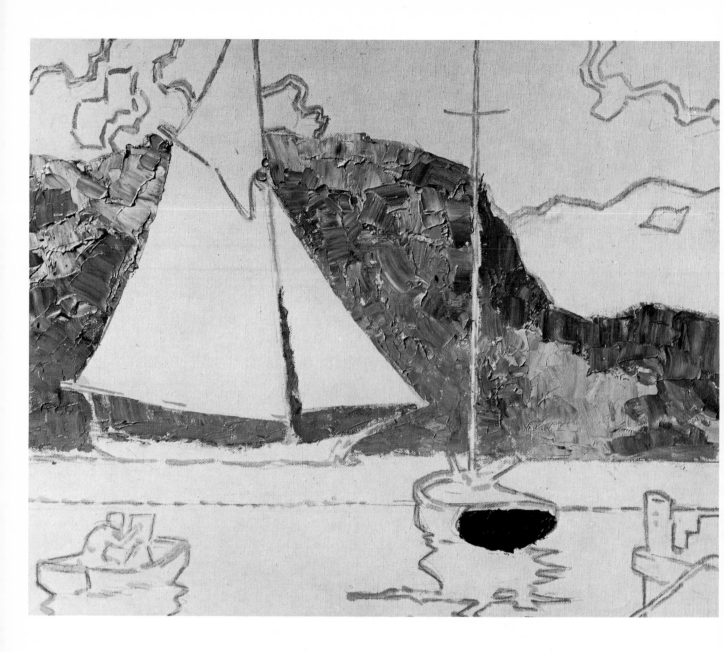

My Love for the Sloop (Step 2) I start right in with the mountain colors behind the sails. The mountain at the top is illuminated with light—a kind of distant yellow-green (light yellow-green plus a trace of violet, its complement). The main mass, in shadow, is deeper and cooler in color. For this, use a bit of cerulean blue and viridian, muted slightly with burnt sienna. Put this on with a vibration suggesting distant, rounded tree forms. An occasional touch of lilac and light ultramarine blue will also help to push the mountains away. Soft, gold outlines help to separate mountains from sail and sky. Several dark notes in the foreground begin to establish a sense of depth.

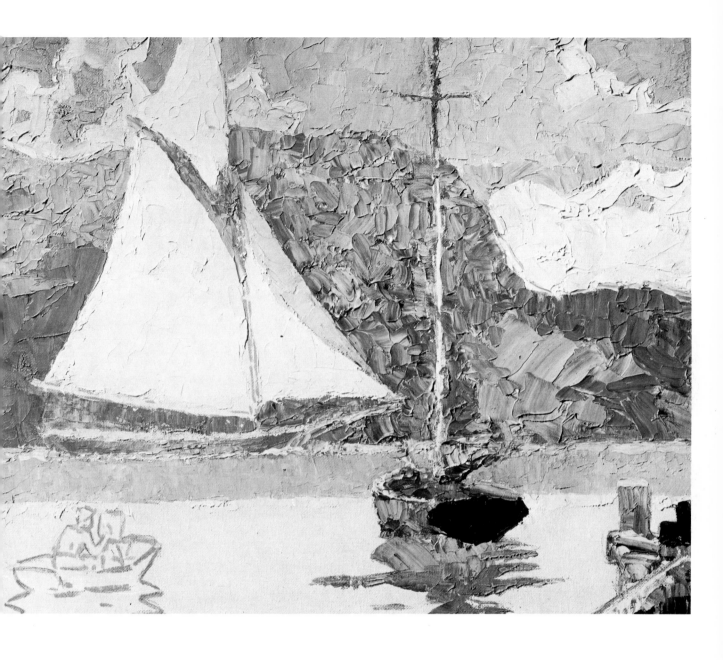

My Love for the Sloop (Step 3) Now for the warm, enticing sky. See it as a play of complementaries: red-violet clouds against a soft, high, yellow-green sky (this should be slightly muted). Between these colors comes the sensation of red-gold often seen around a violet cloud. Use strong rhythmic strokes to make these colors. Next comes the beautiful blue (light cerulean, a touch of viridian) under the boat, representing water ruffled by wind. Then the calmer water below, reflecting, in a pale way, the light yellow sky. I'm using a Long John and a Magic knife to paint the broad color areas characteristic of this picture. I use quiet strokes which fit in with the majestic feeling of sloop and mountain.

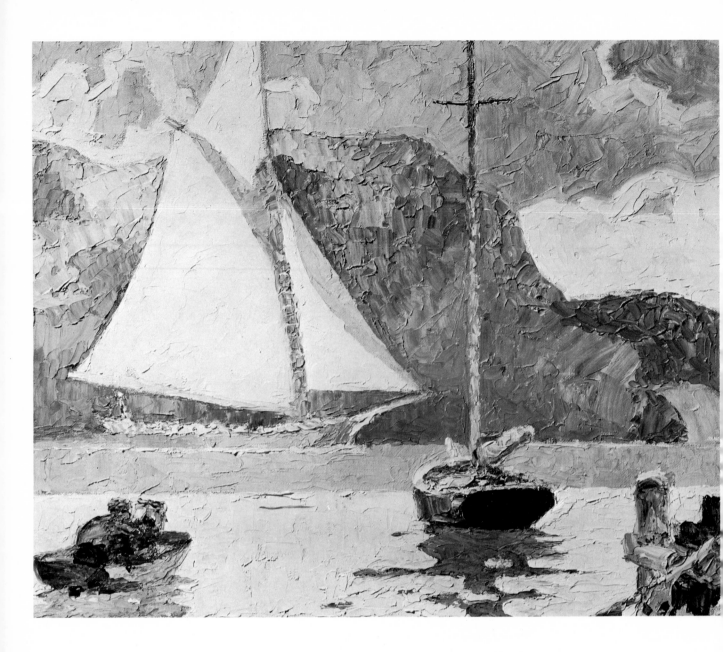

My Love for the Sloop (Step 4) Now for the high part of the picture: the sail color of white warmed with touches of raw sienna and cadmium yellow light. It's the lightest, most brilliant note in the picture, but it shouldn't be too yellow. The green of the hull and the blurred notes of white and golden brown on the deckhouses follow, as well as the two smaller boats and the dock—dark notes lit by warm, bold sunlight. I did the upright mast of the anchored boat with a small knife using a cross-stroke, but you can use a brush if necessary. The picture is nearly finished by this time, but I move slowly now. I'm not trying to pile on all kinds of little details: indeed, I often take details *out* at this stage. What I'm occupied with is the picture's poetry. Above all, I want the lofty majesty of the sloop. (See this final step in color on p. 136.)

6
WOODS

Woods seem to speak. Certainly they speak to me. I'm never more conscious of nature, never closer to nature, than when prowling through the woods. They have so many diverse beauties: the packed-down, softly sculptured forest floor with all its textures and colors, the variegated, muted colors and bark patterns of the treetrunks. Above all, I love to find those dark, mysterious background areas where one can hardly see—one must feel—the forest events which are going on. As a boy and as a young man, I longed to paint the woods, but never found out how to satisfy this longing until I discovered the use of my little Magic painting knife.

In this demonstration, I'm going to show you some of the main things I know about painting woodland. How will you use them? I suggest you make some notes from this demonstration, carry them and your painting equipment into some woodland (after all, what's a car for?), and go to work. If you can't actually get to the woods, why not paint a picture based on the material supplied here—perhaps rearranging it to suit yourself? This experience should help you when you're finally alone with woodland nature.

The picture analyzed here is the result of a walk into a patch of deep woods. Suddenly I saw a scene which electrified me—I unhitched my painting equipment instantly and got to work as fast as my hand would fly. The results are shown in the demonstration that follows.

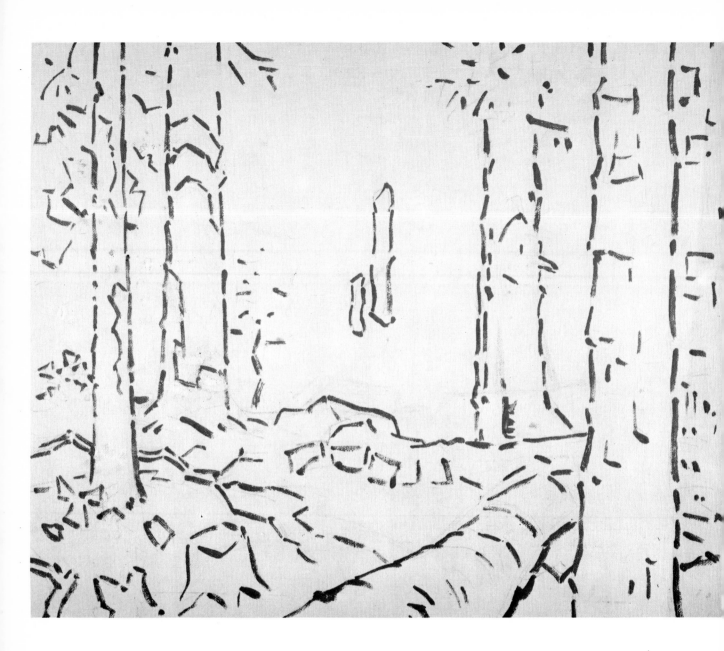

Pathway of Light (Step 1) I'm looking at the dark woods, yes—but also at a brilliant light blazing a pathway through it. The first step is quickly to capture the elements in sketchy line (first charcoal, then gold) and suggest the structure of this pathway. The light sifts down from high on the right, beyond a shadowy, foreground tree. It falls orange-gold on the forest floor, lifts over a fallen treetrunk, and rises to smash against a strong, upright hemlock, which turns it toward the right. Then the light is picked up by a down-pointing stone and disappears into dark forest mystery. Only a light slit in the dark hints at its continuation far way.

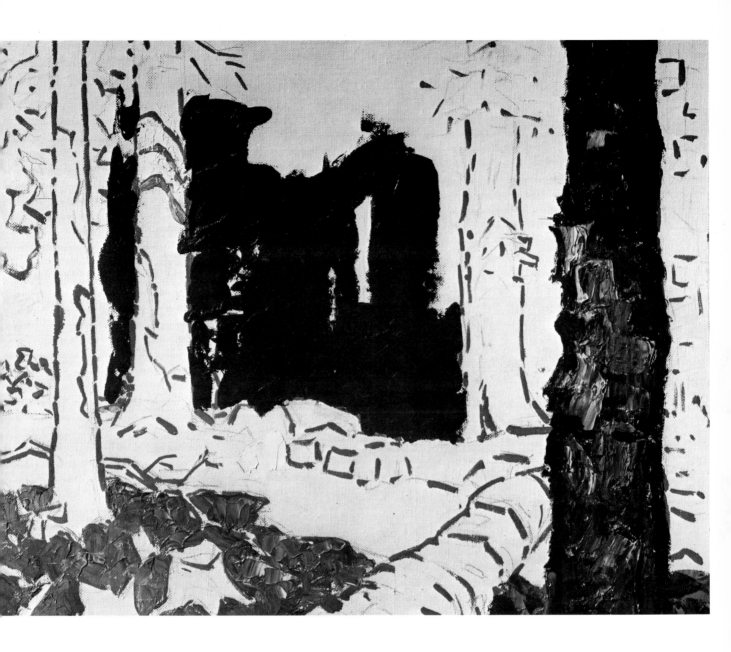

Pathway of Light (Step 2) My first thought here is
to isolate and define the path of light by beginning
to contain it within dark areas. The first area is the
dramatic pool of dark in the center. Always look
for such dark areas; the forest gods reside in them.
Use the Magic colors, perhaps alizarin and viridian,
with a touch of ultramarine; vibrate them softly
rather than harshly, using a Magic knife or a large
brush. In this step, I paint the closeup tree to the
right, getting its final, rich dark textures in heavy
strokes and block forms. I can see the pathway of
light beginning to appear.

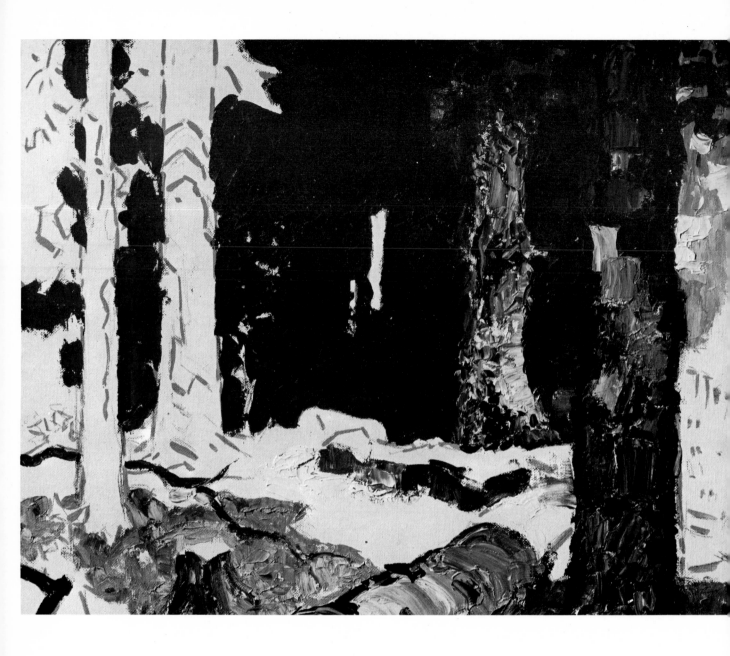

Pathway of Light (Step 3) More darks go on here in a richness of dark leaves suggested by knife-strokes and blocks of pigment against sunstruck areas both to the right and left. The ground shadow over the lower left helps a great deal to contain the light pathway.

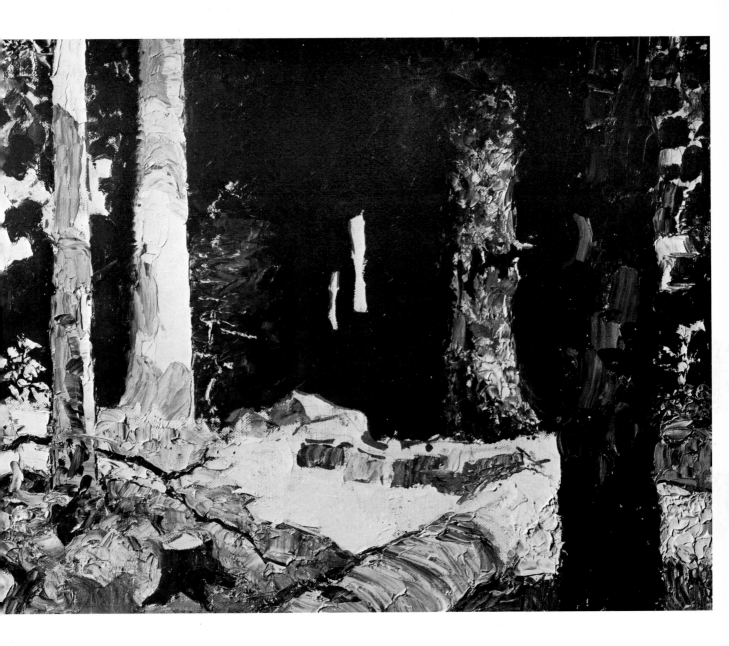

Pathway of Light (Step 4) I begin to develop the textures on ground, log, and treetrunk with the knife, using many colors. I add hemlock sprays at the top of the tall tree. Wait, there's something wrong, I believe I've offended the forest gods somehow; I hear them muttering somewhere. I've lost the power of the brilliantly illuminated tree to the left by cluttering up this strong center of interest with unimportant fronds; I bring the dark up instead. Now I have my pathway of light, and the sense of hugeness—solemnity, too. There's nothing worse than painting it pretty. However, I do plan to introduce some light, fun elements, especially the witty sparkling of sunlight on dead twigs, done with the edge of a Magic knife. It's like flashing glitters on the dark body of the urn in Demonstration 4; snap around with your knife this way, and you'll bring the woods to life.

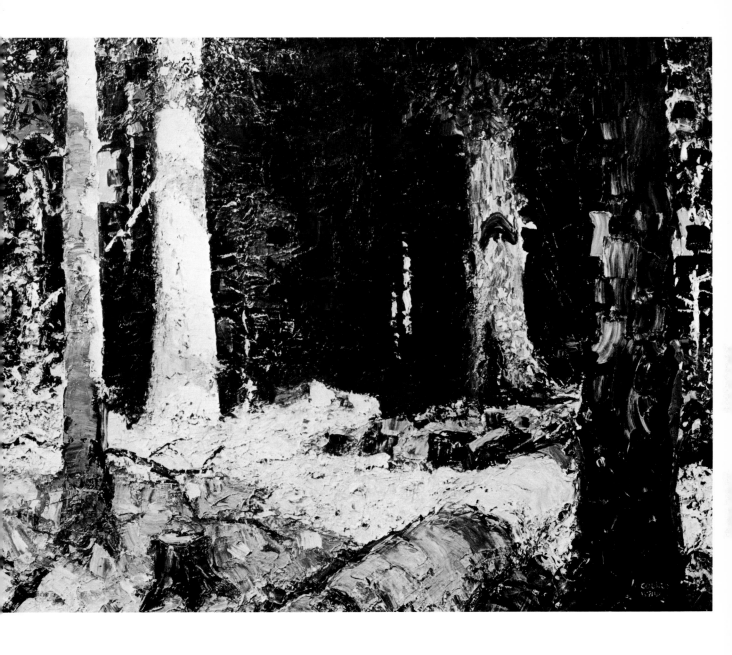

Actual Size Detail

Pathway of Light (Step 5) Here, in the final picture, rich background details are added; the vibration of the forest floor in shadow is an example. You'll find there are many colors in such a woodland carpet: deep golds of raw sienna, red gold of burnt sienna, flashes of pink and soft green-blue (of course muted and deepened in shadow). I add a few restrained hemlock fronds in places where they'll not harm the strength of the design. To do these, load the knife edge with plenty of light gray-green and vibrate it around from a center to get the feeling of soft fingers reaching down. I end my woodland picture with regret, tipping my knife in respect to the gods of the forest. Both of us, you and I, must visit them again. (See this final step in color on p. 142, and detail opposite.)

7
THE PERSONALITIES OF FLOWERS

Back from a country road near Cooperstown, New York, lies the most fascinating formal garden I've ever seen—and I once spent a winter on the edge of the Alhambra gardens in Spain!

Few artists with primary interest in form, color, and light can resist painting flowers. Considering them merely pretty, I used to fight the temptation to paint flowers, but gave up the struggle years ago. The natural wildness of my nature led me first to wildflower painting. We've already had a demonstration of painting these, treating them as a shimmering mass of colors and textures, a woven, interlocked, vibrating whole.

But the flowers from this Cooperstown garden are different. The owner of the garden, Mrs. Henry Cooper, has an eye for big arrangements, blocks of colors; but she seems also to have a special sympathy for the individual flower. She nurses these little personalities so that her garden suggests a collection of gorgeous floral opera stars, with prima donnas hanging on every bush. Walking through this garden one day, the desire seized me to try to display a group of these tiny coloraturas as individuals, studying them one by one, and, by way of challenge, doing their portraits with my bluntest painting knife. Mrs. Cooper kindly opened her cutting garden to the snipping of my shears and I retreated to my studio nearby and got to work!

From a Formal Garden (Step 1) Although I am determined to present these flowers as individuals, my bouquet as a whole has to be structured to fit meaningfully into the picture format. I think my earlier, cold attitude toward flower painting had to do with the way so many flower artists plunk their blooming bunches directly in the picture's center, pinning the eye down so strongly that the one thing it wants to do is get out. In my first thumbnail layout I fell into this same trap; but I squirmed out in my second (see opposite page). I'd tacked a deep blue backdrop behind the flowers, but it fell

in such a strong rhythmic fold that I moved my flowers to the left to take advantage of its winding design, providing an area of deep shadowed calm to work against the excitable tinkling of the flower colors. Now I can study each individual flower and draw it quite slowly—although with the necessary zap that such highly developed individuals seem to require. Wherever possible, I use a straight line in the charcoal outlines, dusting these out and replacing them with quick-drying, turpentine-diluted gold (raw sienna), and drawing these gold lines with a narrow little square-tipped bristle brush.

From a Formal Garden (Step 2) Now I begin the display of these little personalities in terms of oil paint. Where do we start? I'm a believer in displaying hierarchies within pictures; points of intensity or interest arranged in a sequence, so that the eye can consider each within its own natural setting. Studying my flowers this way, I find the point of greatest intensity is the double white flower to the left of the central lily. I think of this center intensity as the Renata Tebaldi of my picture, since this great singer is my favorite; the next in intensity is the fuchsia hanging all by itself to the right—let us designate this the Maria Callas of the group. The area occupied roughly by these two becomes an area of spotlight, and so I spread my dark blue background first in this area of greatest intensity. I'm using a Magic knife to do this, finding the straight edge of its blade superior to other knives for the purpose. I'm working to preserve the zap I mentioned in Step 1; the crisp snap of the aristocratic little petals is best expressed through a series of sharp, straight, decisive edges.

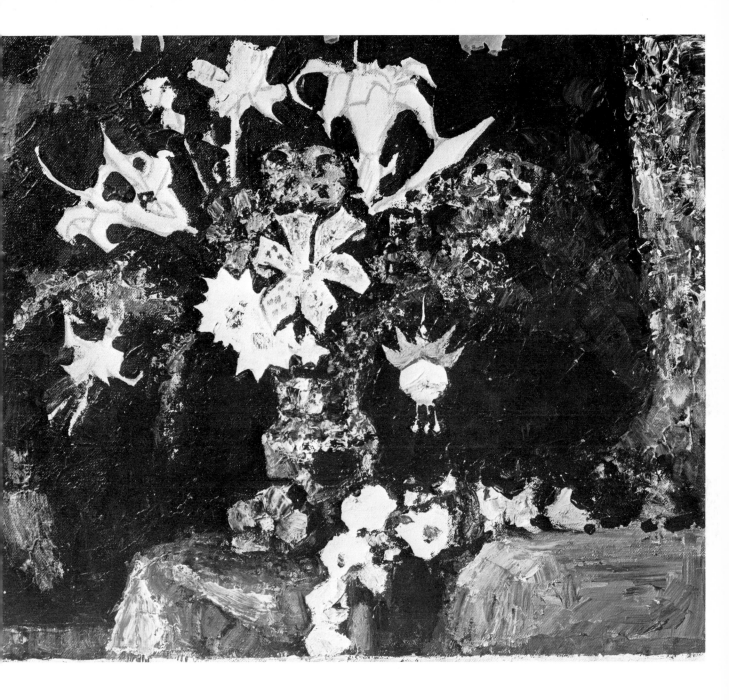

From a Formal Garden (Step 3) It would have been possible, of course, to first carry through the small climax area designated by the last step, following with the rest of the picture afterwards. "I advance my picture all at the same time" said Cézanne, and I believe this to be sound principle, since all parts of a painting react with one another. Consequently, I begin this step by nicking the black around the rest of the flowers and getting the big dramatics of shadow and light established in the back and the foreground. Now I come to the actual painting of the flowers; I've finished the ones in that first inner area, leaving the outer ones

for the final Step 4. The procedure for painting these flowers is as follows: (1) put in the dark background around each petal, trying to get character through the use of many straight edges laid with the Magic knife; (2) lay the general color of each petal, in thick paint, between the edges, also trying to preserve sharpness and character; (3) cut around with the dark ground tone, where necessary, to gain even greater crispness; (4) add delicate little interior details, shadows, spots, stamens, or whatever—but with extreme lightness and delicacy so that the all-over sharpness and fragility of the flower remains intact.

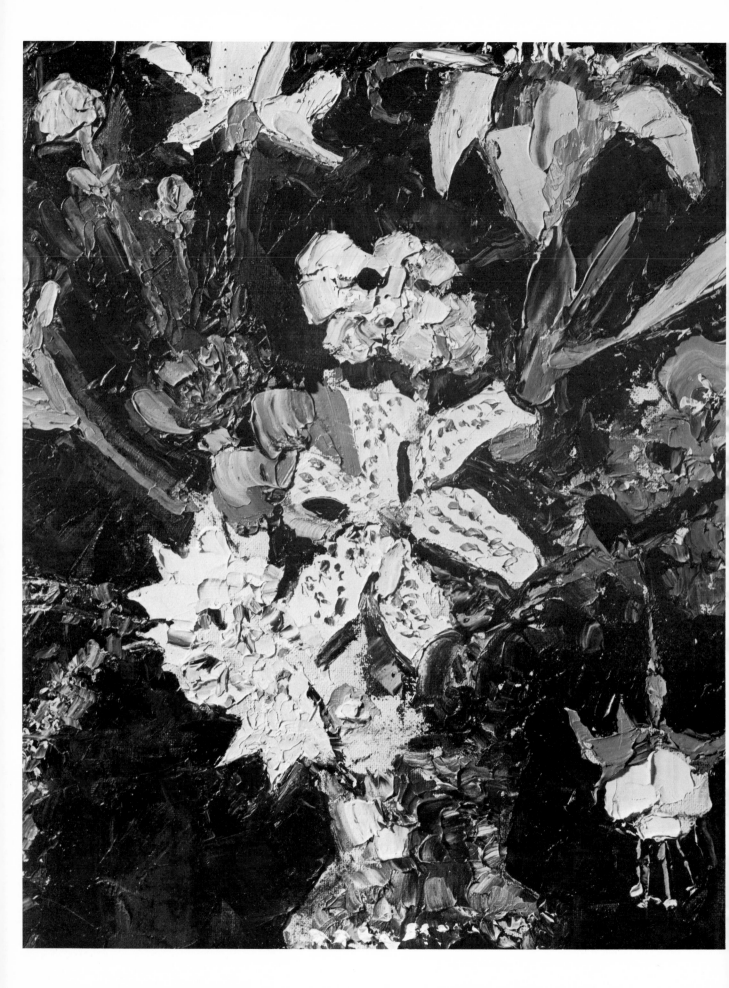

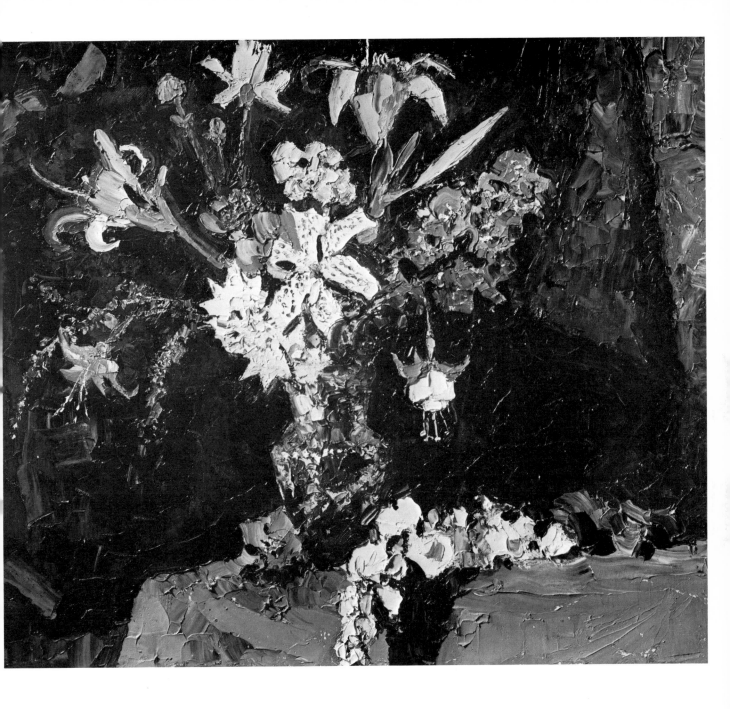

Actual Size Detail

From a Formal Garden (Step 4) The outer flowers are much deeper here than in the previous step; this is because they've now been painted in full color whereas before they were silhouettes of a light canvas tone. This means the concentration of interest on the central group of flowers has been greatly increased. Many other details throughout the picture have been elaborated toward the same end: deepening in parts of the background, greater delicacy in floral elements behind, an emphasis on "the lost and the found." (See this final step in color on p. 131, and detail opposite.)

8
A POND

Walking in autumn-color country on an October day, did you ever find yourself looking at a patch of blue so blazing it seemed borrowed from the brightest blue of the best stained-glass window of Chartres Cathedral? We're beside a pond, a simple little pond; the time is three or four o'clock, and the afternoon colors are beginning to fire up. All that dark blue from the dark blue zenith of the sky is concentrated by the little pond's surface; the rich weeds and water bushes (now turned to heavy gold) grow freely around this little water sheet. The brilliant blue of the water is almost intolerable by complementary contrast with the weeds and bushes. Here I am, this October 15, with a clean 25" x 30" canvas and full painting equipment. I bang it down—seconds later, I'm ready to go—time is very precious. Ordinarily, I'd consider the composition, get gold lines down. No time for that! I put down actual paint at once, preceded by only the briefest charcoal placement suggestions.

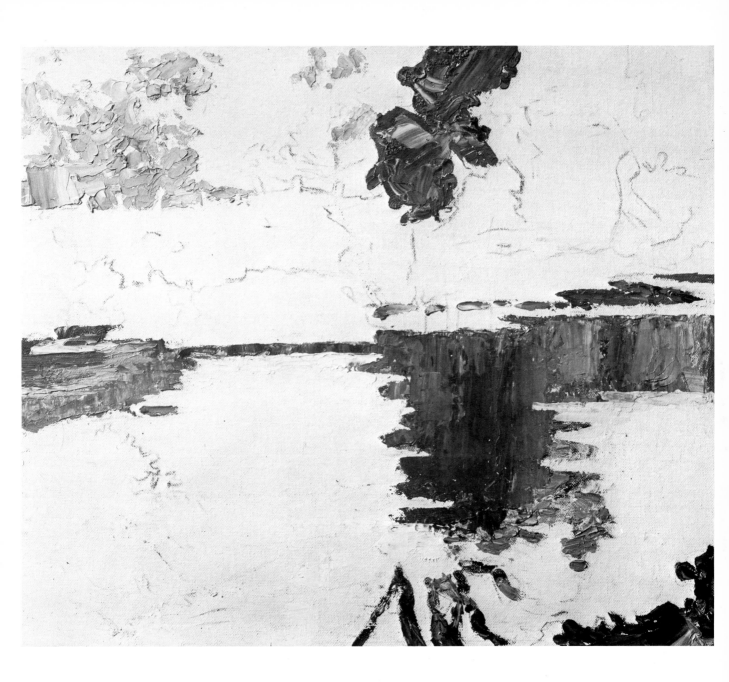

October Pond (Step 1) The inner design core of this painting is made by placing the further edge of the pond well up—about two-thirds—giving plenty of room for the big display of blue below. Cutting right down across this, two-thirds to the right, is a heavy, dark fall tree and its reflection. I put in the shadow under the pond's edge and the big downward forms at once, as fast as my hand can move, using the Magic knife and full rich pigment.

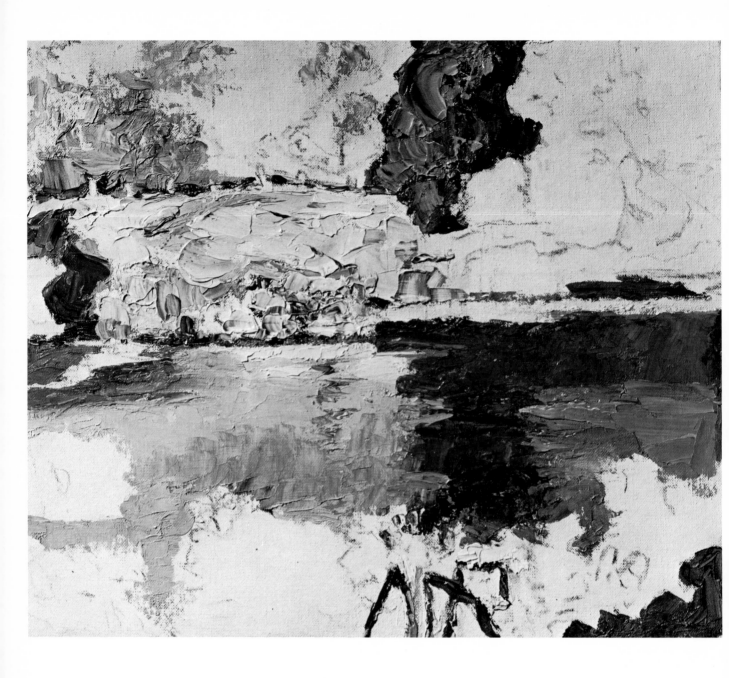

October Pond (Step 2) Now it's time to trap that
great water note of blue against pinkish orange. I
stop for a second or so to carefully clean my knife
or any possible trace of orange or brown—an
absolutely necessary precaution in this kind of
painting. Sorry about the drab gray in our repro-
duction trying to represent the fire blue I'm af-
ter—check the color print in the book's color sec-
tion. This blue starts with ultramarine, but it in-
cludes cobalt and cerulean, dragged across. The
hot, gold bushes, cadmium yellow and raw sienna,
are painted with the fullest possible Magic knife
impasto, and in the bank above it the gold is
lightened with pink—terrific!

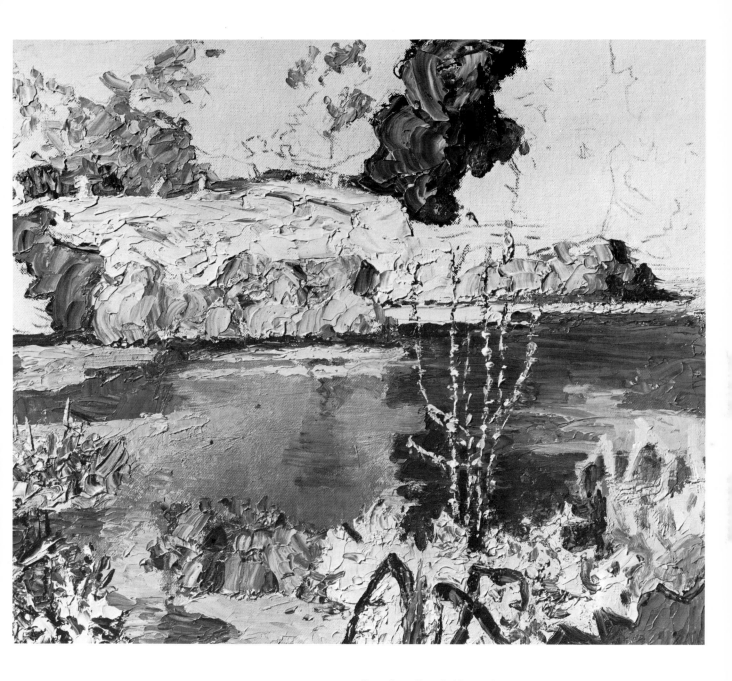

October Pond (Step 3) I have my main color contrast and now come down to the areas at the bottom. From the first, I've noticed five extremely rich color areas, like five beautiful rugs, and I now work at them with tender loving care. There's one in the water, of hot, darker greens; below this is a patch, generally shell pink with darker weed forms; then a somber, very deep gold chunk; a very light pinkish white area, decorated with sharp darks which echo the main darks above them; and a fiery, red-orange group of plants jumping against the blue in back of them. Now—something I've been longing to do from the beginning—I put in the tall, light gold spikes of weeds cutting upward across the tree shadow with the edge of a Magic knife. They play a major compositional role, joining upper and lower picture areas with their skeins of lively gold.

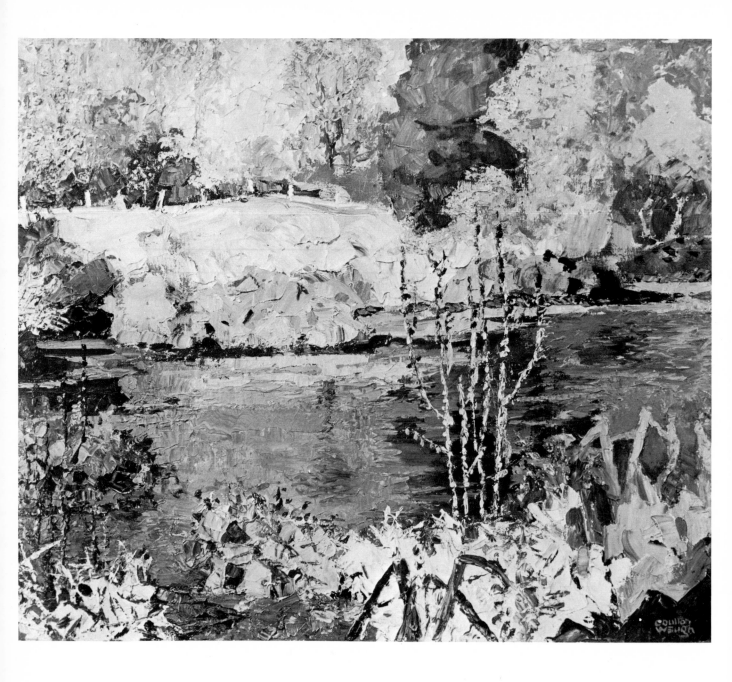

October Pond (Step 4) I've mentioned before Renoir's delight at "giving oneself over to the pure joy of painting." This is what I'm doing at this stage as I lay in the light, tender blue of the sky, encrusted with flickers of pink. My painting knife is a rich set of fall colors, and I ask it to please let go and give me the shimmer and flicker of fall beyond the little posts indicating the road. The wrist, the wrist! It can turn and flicker a painting knife as lightly as the fall flickers a golden leaf. Check the many other textures in this picture, each related in suggestiveness to some aspect of the motif, yet all tied together in a common color chord of gold and fiery blue. Now my picture is finished; I am tired and happy. Far away, down the road, the bell is ringing for supper. (See this final step in color on p. 140.)

9
AN ACRYLIC MARINE

This picture began as an experiment in manipulating the acrylic medium with a painting knife as well as to find out how well such knifework would blend with acrylic washes. I'd already discovered that water was the acrylic secret: work without it, and the medium goes on strike, quits; give these thirsty paints water, and they sing with gratitude.

As I started, I was thinking of the flowing acrylic water wash and was swinging my largest brush back and forth when suddenly I had the theme of my new picture: it was to be the sea swinging back and forth as my big brush was swinging. For isn't this swinging the essence of sea water in action? It's always lifting up, swaying to a peak one way, crashing over, sucking back, swaying to a peak again. I made a couple of little thumbnail sketches (below) to fix this movement and said to myself, "I'll let the big brush, filled with acrylic wash, swing away and see what relation my painting knife technique has to it."

Surf, Sun, and Wind (Step 1) This step is very appropriate for painting water; I call it a "rhythm sketch." It's not made of hard, definite lines—swaying water makes very few of these. Such a sketch is best made by swinging a big brush loaded with light pearl gray in loose sequences of arm movement, trying not so much to trap squirming details in your big net, but instead to trap the interlocking, long, flat, swinging rhythms of the everlasting sea. I used two square-ended bristle brushes to make this sketch, one 1" across, the other ¾". To get a free, grainy, airy quality, don't load the brush with too wet a wash or it will cover all the grains of the canvas as well as the spaces in between. Make sure it's dry enough to touch the grains and skip some of the spaces. Acrylics are particularly adaptable to this drybrush technique. Read Wendon Blake's useful books *Acrylic Watercolor Painting* and *Complete Guide to Acrylic Painting*, and you'll be able to pick up many pointers about drybrush, and all the other kinds of acrylic brushwork, too.

Surf, Sun, and Wind (Step 2) This step establishes a tone pattern, or a color chord. The few big important value patches are also important color patches. The real key to the painting will be here. Using loose acrylic color and value washes, I set this key. The dark sky lifts to the right in a long movement; the very large area of sunlit foam, including the wave, is simplified a little from the first step to make it a ghostly white mass; the shadow from an unseen cliff rests in a beautiful, slightly muted blue on the water movement and on the rough, tumbled-rock dark below; these are separated, in the middle, by jumping white foam which brings the big white note all the way down to the bottom. This pattern pleases me—now, not to lose it!

Surf, Sun, and Wind (Step 3) Here, I grab my Magic knife, and before the surprised acrylics know what's happening, I seize the tops from several newly-squeezed piles and start whamming in the turnover of the wave. Then the lifting up from both sides; in front, the big rounded white pileups of foam. Hey! This is good—this is the kind of thing I'm after in painting knife work. The sky and the water under the wave are also done with the knife. It will work if you act fast enough, but you have to keep squeezing out paint with a heavy hand. As an experimental change of pace, the bottom of this picture is underpainted in bold slaps of half-wet acrylic, done with a 1" wide brush— there's something very handsome in the way you can slam in those rock darks. Though I like the strength of the general effect, I see I've lost the fullness of the sunlight, the one big patch of it which was so evident in Step 2. This big whiteness will have to be reestablished.

Surf, Sun, and Wind (Step 4) I take to the rocks with my Magic knife and chunk them in with broad swipes, using several colors at a time. I rough them together, thinking of the texture and of where the sharp darks should go. In this knifework, I think I've realized in acrylic at least some of the variegated richness possible in oil. I pay special attention to the warm, sunlit areas on top, as they contrast with the dark, cool shadows; I consider, too, the cool gleam from the sky which gives a sense of wetness. It's time to recover that big, white unity I lost in Step 3. I use impasto acrylic, applied with the knife to lighten the main water

mass; very light acrylic drybrush scumbles also play a part. They're especially effective in that almost submerged rockledge covered with something which is part foam, part air. I lighten the wave, too, with a more foam-filled, more sunlit green. A last, aerial, unifying note has to do not with the lights, but with the darks. The shadows on those rocks seem pretty black, so, in happy inspiration, I sock in big block strokes of pure ultramarine blue, right from the tube, to cover those darks. Now we have air in deepest shadow; the picture can breathe everywhere. (See this final step in color on p. 135.)

10
A BROOK

When I paint I'm alone with myself, doing what I want, pleasing nobody, except—I'm always hoping—that critical nature sprite who always looks over my shoulder. Should she, or he, or it, criticize too much, I shove my knife at it: "Okay, so you paint it!" Nature often does just that—more and more of recent years. This is one of those pictures saved for me by nature's backseat driving, just in time, too, for it was a setting of diabolical difficulty. The brook had a late fall, metallic sheen—composed of what? And all the flickering of the tapestry colors of late fall—composed of what? This is no imaginary picture. My easel was right there. And I worked exultantly at first, then furiously, then desperately. Finally, I addressed my nature sprite, sticking my knife into its leafy hand: "So you do it!" And it did, revealing the process in stages. They follow here for your inspection.

Ira's Brook (Step 1) The composition is intricate and confused, with a lot of detail, but the brook whispers, "Compare the two sides, where water touches land." This unsticks me. I see the set of points between which the brook meanders and how they're placed inside a striking pattern of three trees. I get it down simply in a few sketchy lines.

Ira's Brook (Step 2) "What interests you most—paint that first!" whispers nature. What interests me is a kind of rich little picture just by itself: it's a patch of autumn woods just beyond the last turning of the brook. A remarkable kind of richness there, an old rug kind of richness, striking in its purples, deep yellows, and bluish notes of distant treetrunks. I don't know how to get it, but I begin at once and I do get it with old Mother Nature prodding me and guiding my hand; sometimes she paints with that knife herself. There are patches of dark on a closer tree, so I slam these in.

Ira's Brook (Step 3) Below that little patch of distant woods is the thing which gets me next: the quietly shining woods reflection, a large area of calm and mystery. Squinting my eyes to see the big masses, I note this reflection as really quite deep in tone and I spread a mix of it down, rather dark, intending to drift soft lights into it later. "Good," grunts Mother Nature behind my shoulder. She's passed me back my knife. I feel in full control now.

Ira's Brook (Step 4) The road to the picture's completion is now clear. I carry the large pool of shadow down, having a great time with the rugged textures of the leaning tree. Then the extreme forward trees on both sides begin to come into focus. "Now bring the whole thing together in one watery, leafy unit." It's Nature whispering again. I clean my knife, squeeze out some fresh paint. By this time, I know how to do it.

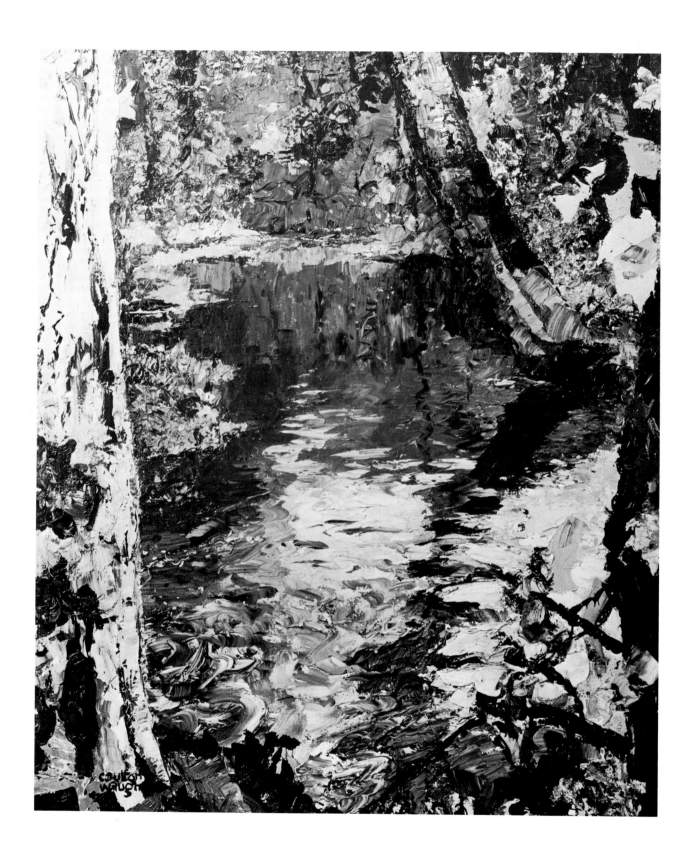

Ira's Brook (Step 5) Here's the final stage. Delicate reflections drift down through the shadow water, the rippling running part is being worked out, the forward trees captured, and the golden flutter of the fall established, binding woods and water. I think the brook and Mother Nature rather like this picture; at least, they seem willing to inhabit it. A little later, I showed the picture to a friend, Ira Newman. The genuine directness of his response makes the hard effort worthwhile and so, gratefully, I've named this picture *Ira's Brook*. (See this final step in color on p. 138, and detail, over.)

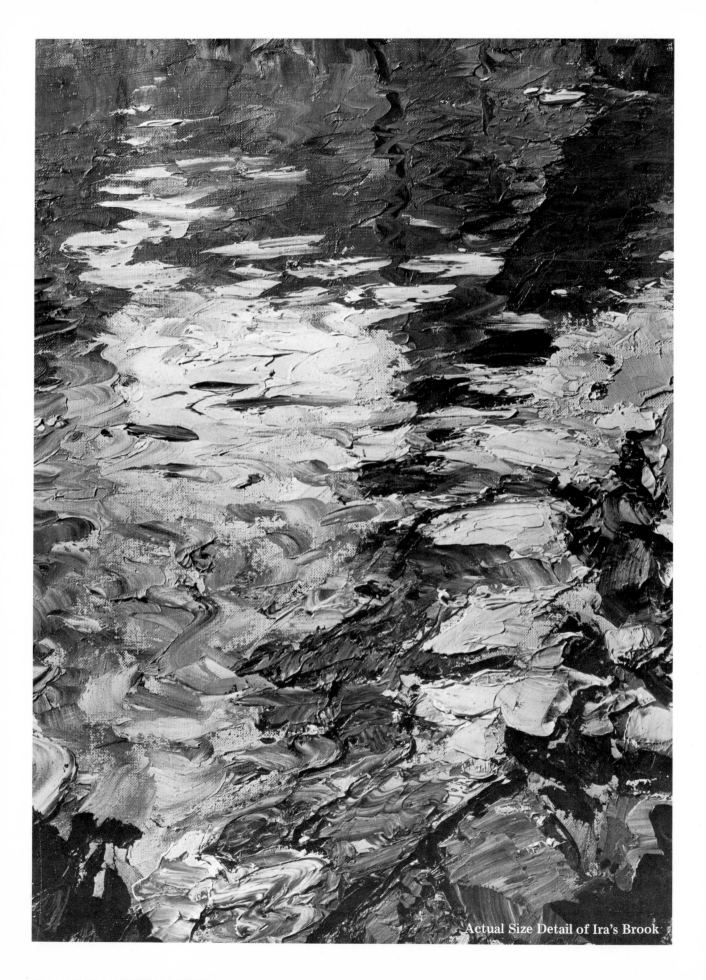

Actual Size Detail of Ira's Brook

A FIGURE OUTDOORS

The demonstration which follows is the harbor of Provincetown, Mass., a place that has drenched my life in memories of blue and gold. I sailed around in it for years and finally (in my Hudson River farm barn) built a little sailing pram called the Claude Monet. My son John, coming home tanned from a summer diving session with his college ocean research station, had somehow brought boats and the sea along—he looked good. I caught the boat fever again, posed John in the Monet, and this picture resulted.

At first, I outlined the forms in gold, but as I went on, the prevailing dazzle of the bluish air brushed over the lines and more or less dissolved them. I like to emphasize the usefulness of light cobalt blue in a situation like this. It's soft, ethereal, the true color of the air; it heals the painter's errors, takes him way out there, makes him happy. But I saw an exciting big color chord, too: John's tanned skin and sunburned hair against a set of different blues—the cerulean of his shirt, the deeper blue note of the blue water, the faint vibrating hazy blue of the sky. I said to myself, "Don't lose these big color contrasts as you paint."

John Sailing (Step 1) This may seem like an awkward position, but a sailor has to keep his feet apart when sailing such a tiny boat. About figure drawing: I consider the three immovable masses of chest, hips, and head in relation to each other and to the flexible spine. This gives me the key to the placement of arms and legs. In the head, I look for the main axis line, noting divisions for eye centers, bottom of nose, and mouth.

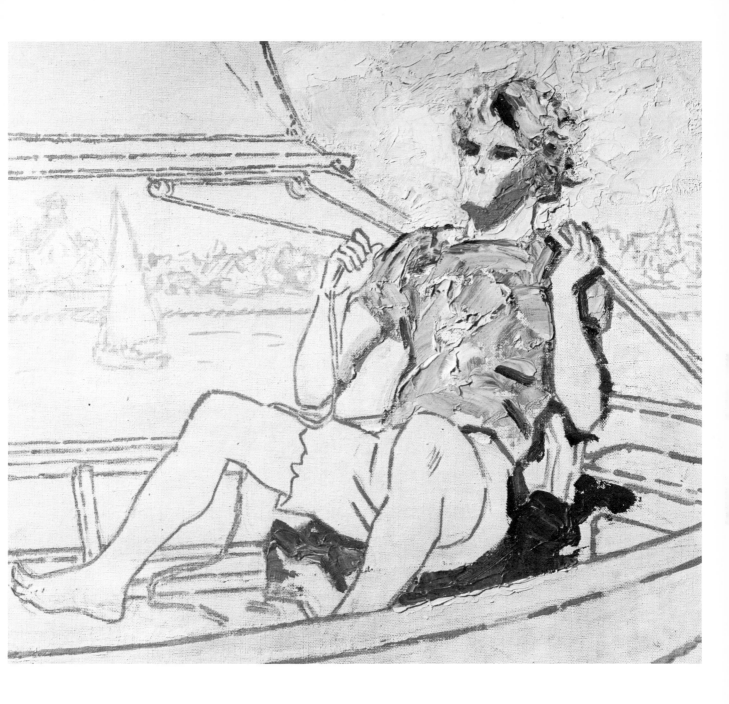

John Sailing (Step 2) That head with its sun-drenched quality against the airy sky is, above all, what I want to capture. And I go at it at once. First, I correct a bit of basic drawing—get the axis line of the head more upright and less tipped to the left, because a sailor keeps his head upright when sailing. Then I lay in blocks of light and shadow, using them as drawing tools; now I come to the tossed, burnished gold of the hair and the vivid cerulean blue shirt, a color combination which has excited me from the beginning.

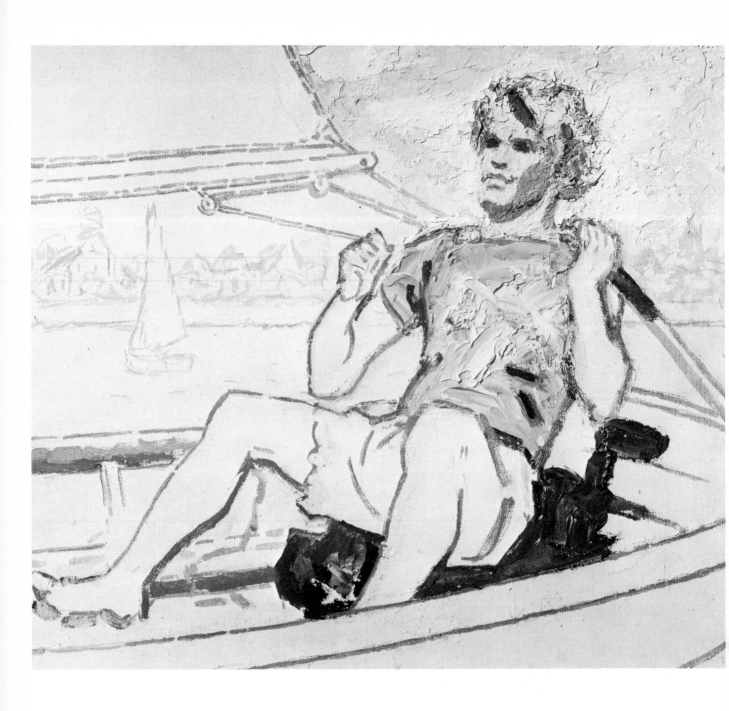

John Sailing (Step 3) This step is mostly occupied with going on with the head, trying for the feeling of rugged planes and the long jutting jaw (fortunately, John had discarded his freshman beard). One has to simplify in a situation like this, concentrating on the larger forms first. Once I feel secure about them, I can work away on the features, not itemizing them too realistically because I want them to swim in the blue air.

John Sailing (Step 4) Now I think about the rest of
the body and the boat. The sky has been lightened
for a more aerial effect. I'm working with bold,
rough strokes, trying to catch the masculinity of
this young man, telling myself I'll ease the rough-
ness of it down a bit in the final process. I'm
counting on blurring the sense of the town behind
in an impressionistic shimmer of houses and
churches—now you see them, now you don't. Pure
Magic knife stuff, this.

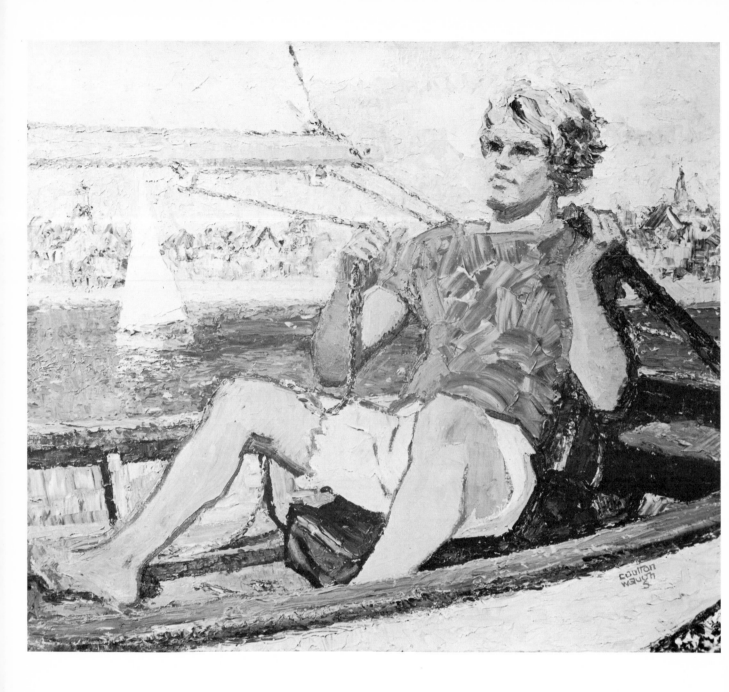

John Sailing (Step 5) This picture is the final step. Much living went into painting this picture, and, I want to add, much experiment. I want to reconcile John's youthful vitality with the impressionism of the background. While doing it, first I find that a kind of skein of light cobalt blue lines and touches can bind both closeness and distance together. Second, I realize again the power of straight lines, used when strength needs emphasis. Third, I realize the value of the rendering of such lines in color, tending again to bind a complex composition into one unit. Finally, I rediscover the importance of the big color chord I had planned on at first, and I return in the end to emphasize and strengthen it. I feel I've lived many years in making *John Sailing*, and, of course, I have. (See this final step in color on page 137.)

12
TEXTURES ON A SANDED GROUND

Some years ago, when I had a fine, earth-conscious old German helping me farm my place, we used to raise quite a bit of corn, cut it by hand, and put it up in shooks—some people would say corn shocks, but I prefer shook; it expresses the tall corn stalk better. How strong the shooks stood, rooted by their lower pyramids, the leaves and tassels higher up flying off downwind, wild and free! They were symbols of something brave and defiant, of the masculine power of the straight line topped by elegant feminine tracery. And one day I recognized a kind of basic glyph expressing these ideas and got it down in a few sparse charcoal lines.

Later, planning a demonstration picture on a sanded ground, I thought of my glyph, thought, too, how heavy paint forced over a sanded ground could catch the ragged intensity of the corn leaves, passionate even in their old age. So I arrived at my picture *The Brave Shook*, which I show here in its main stages.

In building a sanded ground, I use several coats of gesso and sprinkle medium grade sand over the last coat while still wet. Sometimes I swirl the sanded gesso around with a brush. Painting knife strokes are devilishly hard to drive over such a surface. So why try it? Because, in order to make the paint go on, you have to feel the adrenalin in your system, feel a sense of bravery and power, and that's a very good way to feel when you're painting a brave and powerful thing.

The Brave Shook (Step 1) This is the first elemental glyph of the corn shook. The two lines on the left show how it's pushed in by the prevailing wind; the strong lines at right symbolize its strength, its resistance. Leaves and tassels above stream away in terse shorthand. Feeling the height of the shook, I arrange it in a tall Japanese format.

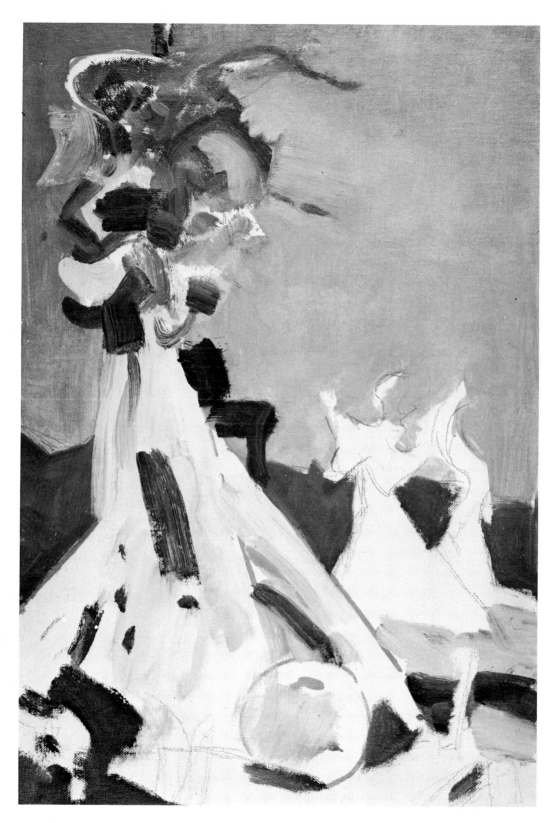

The Brave Shook (Step 2) Here's how I lay out the glyph on a sanded canvas. In this step, I show the underpainting, done in a few broad tones of transparent turpentine wash, which dries very quickly. I use a burnt gold on the near shook, white gold for the ghostly faroff ones, deep azure blue for the mountain, and lighter greenish blue for the sky.

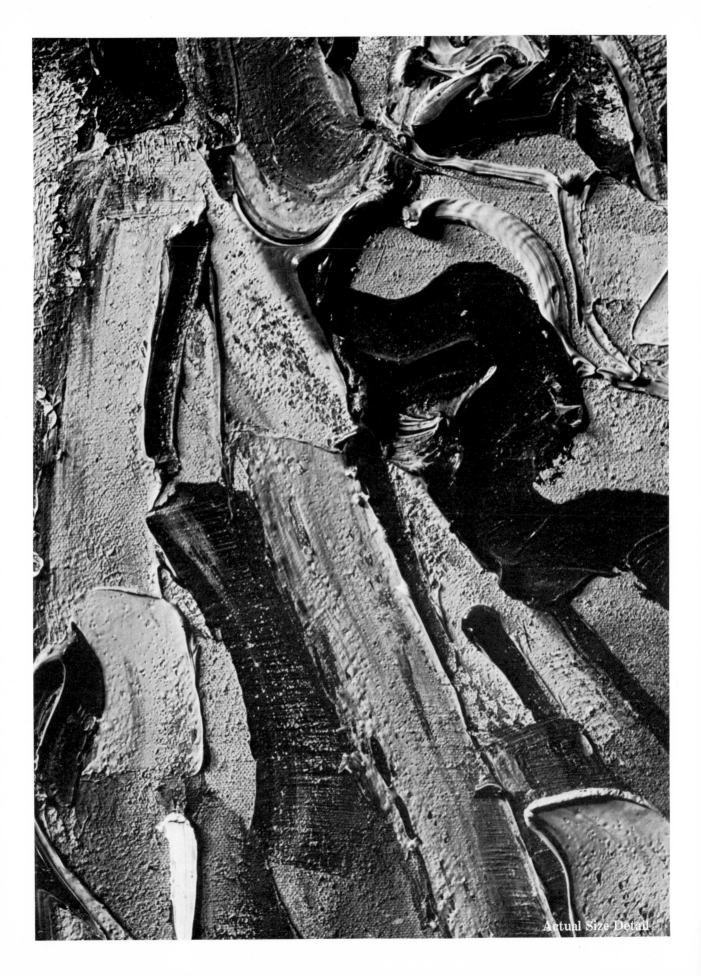

Actual Size Detail

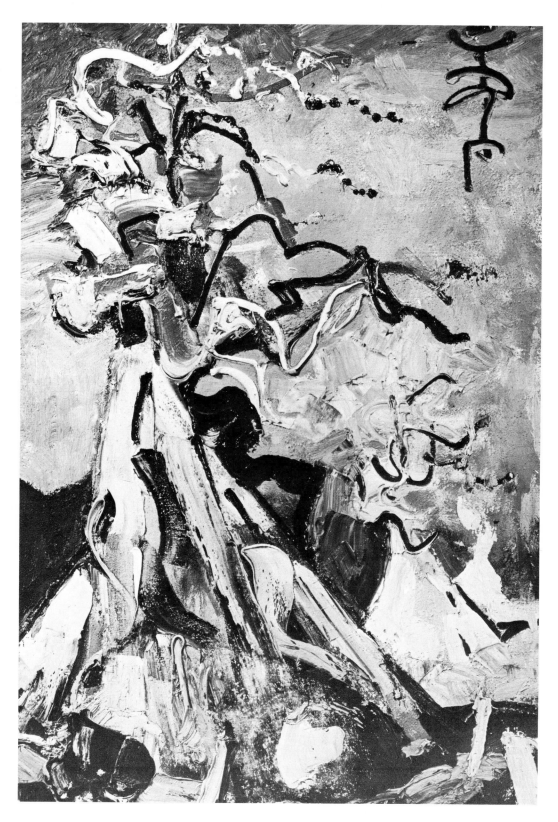

The Brave Shook (Step 3) In the final painting, I'm under several influences: the influence of the glyph, with its suggestion of primitive strength and splendor, the fight with the sanded ground giving the grain of the withered corn leaves, and the waving explosion of tassels at the top. For this last I need lines—no brush or painting knife would give me such forms over that sand. So I seize two tubes, one ultramarine, one yellow. My arm flings the lines into being, fingers squeezing at the same time. The Japanese format I'm using seems to call for a Japanese signature, so I invent one. Please don't ask any Japanese to translate it! (See this final step in color on p. 134, and detail opposite.)

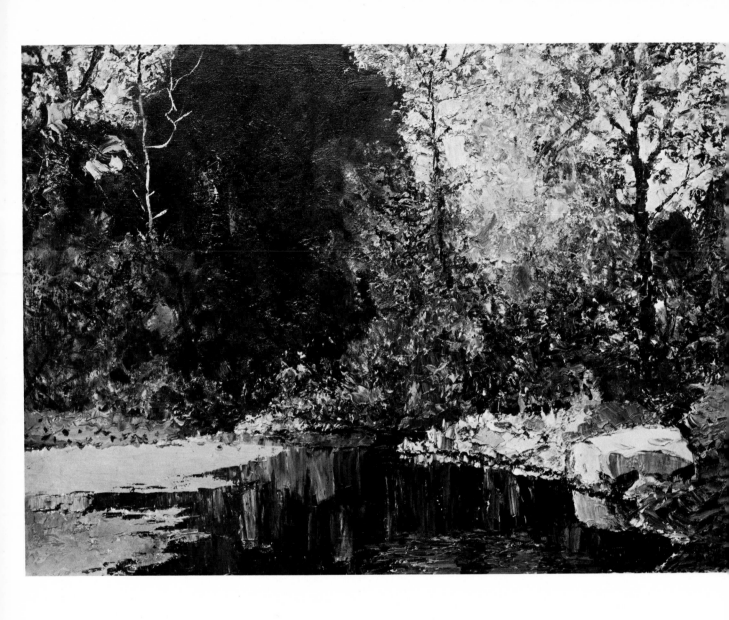

Waterway, 25" x 32". *Courtesy Grand Central Art Galleries, New York. This isn't the drowsy summer, it's the splendid, upstanding, late fall. The mood is heroic, the dark trees look huge and forbidding and the sky is snarled with traceries, half twigs, half leaves. Here's a case where there were so many textures I wanted to register that extreme speed wasn't the right procedure. I worked out the solemn edge of the pond to the right, with its highlighted stone, and bent the line so it disappeared in the woodland depth beyond. Note that the eye level is held very low. This is the secret of the somewhat cathedral look the picture has—the trees have plenty of room to tower way up.*

The painting knife responds to the moods in my temperament—it can be rough and exultant, tranquil and brooding; it responds to the childish intoxication of spring. These are moods of nature, and I'm a nature man; my moods are tied in with cloud shadows on mountains and cerulean blue air. Those who feel as I do will understand what I'm trying to say with my knife technique. The portrait artists, the still life artists, in fact all those dealing with some kind of reality seen through air, will understand what I'm getting at. But these areas of the visual arts are not the only ones, and I'd like to have my book be of value to workers in other art areas as well—the imaginative, the abstract—for the painting knife findings I've discussed and illustrated may be applied to any subject material at all.

I want to make it clear that I don't feel my personal predilection wraps up the whole art subject, and I'm not so knife-infatuated as to insist that this is the only way in which good painting can be done. Impasto with a big brush, tremendous! Shimmering, transparent glazes à la Renoir, divine! Wonderful! Cézanne-type color modulations, solid!

I regard the three approaches I've just mentioned as three painting methods which have been tossed into the general art pot, and I believe that as long as an artist doesn't copy them literally, each one has the right to dip into the pot and draw out both inspiration and procedural ideas. In all humility, I want to toss my own findings into the pot.

It's true that painting with the knife is not new; Courbet, Renoir, and many others used the knife at various times. But my particular way of painting with the knife is new, as far as I know. It's possible that other painters have discovered some or all the ways of working with the broad, springy little knife which I've detailed in this book; but if so, I don't know about it. No one taught me to manipulate a knife in the way I handle it—my findings are the result of individual research.

So, as I toss my book into the art pot, I'm hoping other workers may find something new and useful to them, which they can blend with other findings as they develop their individual styles. Knife painting can be blended with other methods in many creative ways—a number of my students have demonstrated this. One enlarged the knife stroke by using a plastic triangle over a sanded ground, with startling results. Another, finding her personal expression through developments of the square block stroke, evolved a highly distinctive mosaic style from it. Still another achieved a mother-of-pearl luster by using semiopaque scumbles over a rough knife underlay.

Great! This is just what I like to see happen. It points up my underlying feeling that art styles should not be dictated from the outside; they should be evolved by the artists themselves, should belong to them. Your own style! The pursuit of this is something I recommend to every one of you. Forget about fashions and sales pressures; go for what expresses your own personality, your truest, sincerest feeling. Get your own style, and you'll be able to sleep well o' nights. Maybe you won't become famous (though there's a good chance you will—all the famous artists had strong personal styles), but something even better will probably happen—you'll become happy, and what's more important, you'll remain happy!

Edited by Margit Malmstrom
Designed by James Craig and Robert Fillie
Set in 10 Point Century by J.D. Computer Type, Inc.
Printed and bound in Hong Kong by Toppan Printing Company (H.K.), Ltd.